# New Muses

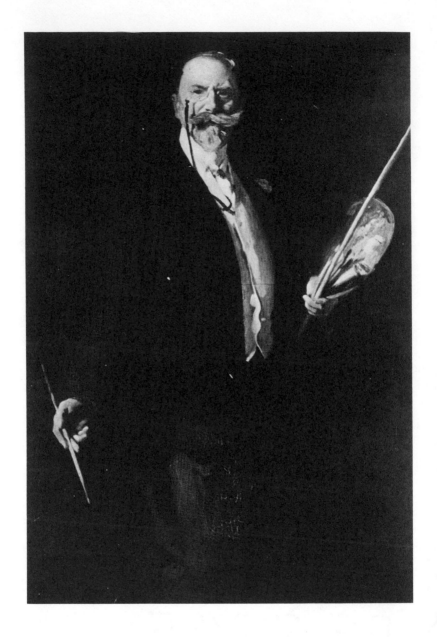

William Merritt Chase (1849–1916), from the portrait by his friend John Singer Sargent. *Courtesy Library of Congress*

# NEW MUSES

Art in American Culture
1865–1920

by H. Wayne Morgan

University of Oklahoma Press: Norman

## By H. Wayne Morgan

*William McKinley and His America* (Syracuse, 1963)
*America's Road to Empire: The War with Spain and Overseas Expansion* (New York, 1965)
*From Hayes to McKinley: National Party Politics, 1877–1896* (Syracuse, 1969)
*The Gilded Age* (editor) (Syracuse, 1970)
*Unity and Culture: The United States, 1877–1900* (New York, 1971)
*Yesterday's Addicts: American Society and Drug Abuse, 1865–1920* (editor) (Norman, 1974)
*Oklahoma: A Bicentennial History* (with Anne Hodges Morgan) (New York, 1977)
*New Muses: Art in American Culture 1865–1920* (Norman, 1978)

Library of Congress Cataloging in Publication Data

Morgan, Howard Wayne.
    New muses.

    Bibliography: p. 183
    Includes index.
    1. Painting, American. 2. Painting, Modern—19th century—United States. 3. Painting, Modern—20th century—United States. 4. Art and society—United States. I. Title.
ND210.M6              759.13              78-3524
ISBN 0-8061-1479-7

Copyright 1978 by the University of Oklahoma Press, Publishing Division of the University. Manufactured in the U.S.A., First edition.

for
**ANNE**

# Preface

This book is intended as a contribution to the history of culture in the United States. It deals with the context of art activities during a transitional period of intense debate on the role, meaning, and forms of art in the national life. Most studies of American art focus on famous paintings, and analyze their method of production and intellectual overtones. I have chosen a different approach, and this is not art history as it is usually written. My concern is not so much the individual artistic act, as the broad cultural context in which art was received, debated, and analyzed. The book is deliberately designed to sample themes common to the era's entire cultural development. If the art life under scrutiny were a cake, this treatment would be a slice rather than a layer. I hope I have demonstrated both the differences and similarities among layers.

My emphasis throughout is on painting, the responses to it, and what people thought it meant. In writing the book I unconsciously used the term "art" to describe painting and its audience, much as nineteenth century people did. On reflection, I decided to retain this admittedly inexact usage, with due warning to the reader that the book does not encompass all the art forms.

I have sampled a wide variety of contemporary sources, and found the commentary and concern about art impressive. Since the subject is little known, I included a full bibliography and copious footnotes as guides to the reader interested in more information. I hope throughout to give a strong flavor of the time with due regard for my obvious

retrospective historical judgments. I have usually allowed a contemporary quotation to express what would have required undue space on my part to say less well.

The major themes of the treatment seem evident. The broadening interest in artistic matters rested on a desire for an elevated standard of taste in the new industrial America. The arts were important to an increasing range of spokesmen concerned with directing the materialism and egalitarian standards of a democratic society. Art and the glamorous life it produced were important aspects of modernization and urbanization. There was also a growing demand for personal enrichment through production or appreciation of art. To the new generation of educated people, more alive to the world's events than their predecessors, art also offered an alternate life-style to more mundane careers. This desire for cultural expression and consumption reflected a need for a national unity that did not override America's historic cultural variety. And the concern to retain native qualities while entering the mainstream of world culture said much of the United States' emerging world roles. The contradictions, ironies, and ambitions in all these impulses reveal much about American life during this era.

These and other themes unify the material. Disliking books that constantly tell me what to think, I have tried to avoid hammering them home on every page in some ironclad thesis. A reader should bring to a book the right to form his own judgments on the material presented, and I hope he understands that I have not attempted to say everything possible about each subject I touch. On the whole I hope to be suggestive rather than comprehensive. Most of the subjects treated, such as muralism, criticism, the reception of modernism, and many more, obviously merit extensive study. I will be satisfied if I have intrigued the reader enough to explore further this neglected aspect of American history.

H. WAYNE MORGAN

*Norman, Oklahoma*

# Acknowledgments

Thanking all the people who helped make this book possible would require yet another book, but I wish to give special note to some people and institutions. Though I do not quote extensively from manuscript materials in the text, I surveyed many primary sources. I am indebted to the staffs of every depository mentioned in the bibliography for assistance. I am especially grateful to the following persons and depositories for permission to quote from unpublished materials: the Century Association for its own records at the Archives of American Art; Princeton University Library for the papers of Frank J. Mather, Jr.; the Frick Art Reference Library for the diary of Theodore Robinson; the American Academy of Arts and Letters for its own archives; the Pennsylvania Academy of Fine Arts and Mrs. Edward Anschutz for letters of Thomas P. Anschutz; the Avery Architectural Library of Columbia University for the papers of Kenyon Cox; Roger Storm for letters by William Merritt Chase in the Chase papers at the Archives of American Art. I owe special thanks to Garnett McCoy of the Archives of American Art. He and his staff expedited sending me much material on interlibrary loan, and were patient and courteous during several personal stays. He also discussed the work with me to my great advantage. The AAA is an outstanding example of what should be done to preserve and utilize the written record of America's artistic heritage.

As explained in the preface, I have not overtly analyzed the content of paintings in the text. Yet as with manuscripts, I surveyed a wide range of art drawn from every major

museum in the country, both in person and via the mails. I am especially indebted for slides, photographs, and personal attention to the staffs of the Metropolitan Museum, the Boston Museum of Fine Arts, the Philadelphia Museum of Art, the National Gallery, the National Portrait Gallery, the National Collection of Fine Arts, the Freer Gallery, the Corcoran Gallery, the Phillips Collection, and other major museums. I must thank the staffs of several smaller but no less important museums for specifically useful pictures. The California Palace of the Legion of Honor, for example, has unusual works by J. Alden Weir, Edmund C. Tarbell, and French impressionists. The Los Angeles County Museum has fine small canvases by Sargent and Duveneck, and an interesting Elihu Vedder, among many examples from the period. The Phoenix Art Museum has several important works, including a fine Chase portrait, and a canvas by Jean-Léon Gérôme, *Pollice Verso*, which was once of national interest. The Museum of New Mexico in Santa Fe possesses numerous examples of American impressionism and of the works of Robert Henri and others who lived in that city's art colony at one time or another. Their holdings of western painting, a genre derived from both academic and impressionist traditions, are important. My travels convinced me of the great vitality of American painting, and of the fact that many significant people and works do not ultimately find their way into the most familiar historical treatments.

In Europe I saw much of the art that influenced American students, and gained insight into the milieu in which they studied. The collections of the Louvre, and its special holdings of impressionist canvases, are highly significiant. In many ways, the most interesting objects of influence I saw were in the Musée des Arts Décoratifs in the Louvre complex, which reconstructs the daily life of several centuries, including the nineteenth. In London the collections of the National Gallery were important in establishing a sense of context. The Sargent works at the Tate Gallery added much to my understanding of the era. The Victoria and Albert Museum offers an endlessly fascinating view of life

and culture during the nineteenth century to the patient walker-viewer. The staff of the Imperial War Museum was especially helpful in finding portfolios of Sargent watercolors and sketches, and some correspondence.

    I thank my colleague James L. Goldsmith who gave me the helpful views of a nonexpert in the field. I appreciate the diligence and comments of Mrs. Josephine A. Gil, who prepared the manuscript. As always, my greatest thanks go to my wife, Anne, whose name justifiably appears on the dedication page.

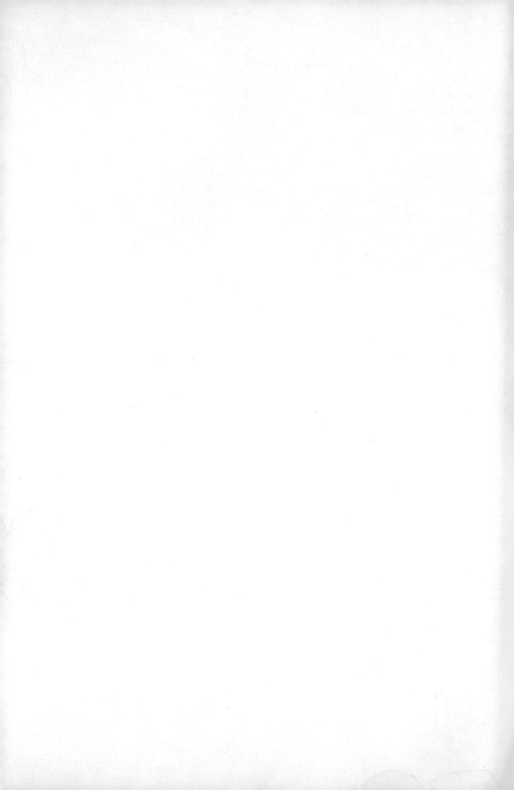

# Contents

# Illustrations

# New Muses

# Abbreviations

The following abbreviations have been used throughout to show the location of relevant manuscript collections consulted.

AAA   Archives of American Art, Washington, D.C.

AAAL   American Academy of Arts and Letters, New York City

AALCU   Avery Architecture Library, Columbia University, New York City

BLCU   Butler Library, Columbia University, New York City

FARL   Frick Art Reference Library, New York City

FGA   Freer Gallery of Art, Washington, D.C.

GM   Isabella Stewart Gardner Museum, Boston, Mass.

NYHS   New-York Historical Society, New York City

OCL   Oberlin College Library, Oberlin, Ohio

PAFA   Pennsylvania Academy of Fine Arts, Philadelphia, Pa.

PUL   Princeton University Library, Princeton, N.J.

# 1. A New Art World

Late in October, 1863 some of New York City's most promi-
nent citizens gathered at Twenty-third Street and Fourth
Avenue to lay the cornerstone of a new National Academy of
Design. The resulting structure, completed in 1865, com-
bined homage to the past in its exterior and concern for the
future in the interior. Bands of blue-grey marble, arched
windows, and lavish tracery ornamentation enhanced the
exterior's Moorish and Venetian effect. The interior pro-
vided light and space for modern art instruction and for
regular spring and fall exhibitions. The building cost some
$130,000, "raised chiefly by subscription, many of our most
intelligent, liberal and wealthy citizens uniting in the good
work," according to the New York *Times*.[1]

The interest in cultural matters which the ceremonies
symbolized seemed far-removed from daily reports of battle
casualties. Yet society's leaders did not doubt the war's
successful outcome and were already oriented toward a new
nation based on expanding industrial wealth and wider
contacts with world culture. Whatever the battle's daily
fluctuations, war had brought wealth to a growing class of
people interested in an urbane life-style with ample room
for the arts, especially painting. The New York *Tribune* mar-
veled at the "picture mania" that swept society in 1863.

[1] The New York *Times*, October 22, 1863, reports the cornerstone laying,
and George Parsons Lathrop recalls the ceremonies in, "The Progress of
Art in New York," *Harper's Monthly*, 86 (April, 1893), 740. An illustration
of the building appears in Oliver W. Larkin, *Art and Life in America*, 245.

3

Newspapers and magazines reported the lavish art balls, exhibitions, and studio receptions that symptomized a developing art public and an interest in pictures for both pleasure and investment.[2]

This concern and the facilities for enjoying art expanded after the war. The number of private dealers grew steadily, as did their clientele. The public saw more pictures in more places than ever before. Artists practiced their craft more easily, as painting interested a growing audience. By the 1860's, certainly in New York, Boston, and Philadelphia, specialized dealers served the painter's needs. No longer did he have to shuffle through brooms and shovels, pork pies, or cracker barrels to find a few colors, brushes, or canvas, as had been the case not many years before.

The war, of course, did not create these attitudes and institutions. But the conflict seemed to mark a new era of national development and was a dividing line between old and new concerns. Many commentators realized that the postwar generation would have to establish models of national culture while celebrating material power. Long before the war, there was a strong belief that viable cultural interests must accompany and temper wealth. There was a sense that progress in the arts, as in other endeavors, was cyclical, and that the future belonged to the United States. The country must prove that democracy could create and innovate for the eye and mind as well as for citizenship. In retrospect, the art critic S. G. W. Benjamin thought the war settled intellectual as well as political accounts and marked the beginning of "our era of mental development." "All the analogy of past history indicates that the energies called forth by a great struggle for national existence find in the following generation a full harvest of intellectual activity," he added. "In this way have been born the great schools of art and letters."[3]

[2] New York *Tribune*, April 4, 1863. The New York *Times*, April 2 and October 19, 1866, comments on the immediate postwar boom in art. M. G. van Rensselaer, "The New York Art Season," *Atlantic Monthly*, 48 (August, 1881), 193–202, recalls some of these developments.

[3] S. G. W. Benjamin, *Contemporary Art in Europe*, 7. See also Henry Tuckerman, *Book of the Artists: American Artist Life*, 11.

The arts were topics of concern nearly everywhere in the world. There were stirrings of interest in new art forms in societies with old traditions, such as Italy and Iberia. The same was true of new states like Germany and in emerging or isolated countries like Norway and Russia. Painting, music, and literature were signs of a people's vitality, proof of their claims to greatness and authority. A new renaissance of culture might accompany the flourishing technology and science that fueled industrialism.

The arts quickly became an aspect of the modernization which so many societies sought through nationalism and industrial growth. Artists seemed in the advance wave of new thought that would affect every aspect of society. And while American brashness and naiveté often irritated older peoples, many Europeans saw the nation's art potential. Karl Theodor von Piloty, teacher of William Merritt Chase in Munich, echoed a general sentiment on seeing the United States in the vanguard of artistic change, if it defined its goals. "Everything points to it. You have the space and you have the great inspiration of the place where life is being lived. Italy, France, Germany, Spain, England, these have had their day; the future is with America."[4]

Interested Americans hoped to fulfill these expectations. By the mid-seventies, painting in the United States was incorporating new world influences, heightening the sense of dynamic change in both its forms and aims. The Centennial Exposition of 1876, at which visitors from all over the country thronged the art galleries, warned Americans against parochialism or indifference to culture if they wished to be in the mainstream of modern life.[5]

The dual challenge of broadening art's appeals and of wedding American culture to world affairs was formidable.

[4] Quoted in "William Merritt Chase," *The Outlook*, 114 (November 8, 1916), 536.
[5] See Benjamin, *Contemporary Art in Europe*, 14; "Art Notes," *Appleton's Journal*, 9 (April 26, 1873), 572; "Art: The Academy Exhibition," *Appleton's Journal*, 11 (April 25, 1874), 540; S. G. W. Benjamin, "American Art Since the Centennial," *New Princeton Review*, ser. 5, no. 4 (July, 1887), 14–30.

Though much progress came before the war, most Americans probably remained indifferent or hostile to the arts. This reflected democratic suspicions of an artistic elite who claimed to know things denied to ordinary mortals. The nation was also inexperienced in the pleasures of seeing. A predominant British heritage always emphasized reading and writing over the plastic arts. But American utilitarianism was probably the basic obstacle to the art experience. Making and enjoying art did not seem worthwhile to many laymen. Reading might be educational, but looking at pictures, listening to opera, or attending the theater smacked of time wasting. A man might neglect his business to read and win a certain grudging approval, while earning only criticism for visiting art galleries.

Art spokesmen thus had a dual purpose in the postwar generation. They must improve the quality of art produced and enhance the artist's status. And they needed a broad-based constituency for art, especially among the educated younger generation. Despite the country's scope and diversity, the goal seemed attainable. The very lack of inherited dogmas added to the excitement and interest of searching for new art ideals. And the artist might become as great an individualist as the captain of industry or politician.[6]

Any new art ideal obviously depended primarily upon the work of painters, but creativity also had a dynamic. Art appreciation and the development of taste came chiefly from accumulated experience with art in a sympathetic milieu. The first need was an informed, inquisitive art public. "What we need is art-culture," a journal insisted in 1871, "not that which produces the artist, but that which educates the connoisseur."[7]

Talk of drawing the masses into the art experience always lingered and remained an ultimate major goal. But the drive for special status for art and for a special art audience dominated the long sweep of cultural development. Painting and

[6] Tuckerman, *Book of the Artists*, 28.
[7] "Table-Talk," *Appleton's Journal*, 6 (December 16, 1871), 695.

the art experience became ever more complex, and artists and their audience frankly sought to establish a model world in which that complexity reigned. The era favored specialization and organization. How were they to encourage, advertise, and institutionalize art production and experience?

The National Academy of Design was the most obvious model of the formal institution which so many spokesmen thought necessary to develop art appreciation. It was a multipurpose body, private in nature, but with aspirations for public influence through a self-perpetuating membership. It tried to have leading painters train new artists and hoped to give art a national focus. This role had its difficulties. Individualism was often a stronger lure than the Academy's corporate approach, so clearly modeled on European examples. Civic pride and regionalism dictated that similar institutions, with equal claims to authority, be developed in every major city. Few observers outside New York granted the Academy its pretensions to shape art appreciation for the whole nation.[8]

Most influential critics and new painters after 1865 accepted many of the Academy's goals while criticizing its operations. Given the sudden growth of interest in art, and of the number of painters, the Academy and similar institutions were hard pressed to show a cross section of current work. The temptation was strong to focus on established artists at the expense of new and sometimes irreverent talent. Academy shows soon reached monumental proportions, bewildering patrons and critics alike. "The good pictures are as good as they have ever been, and in one or two notable instances [are] better than ever sent by the same

---

[8] For assessments of the Academy at various stages during this period, see Susan Nichols Carter, "The National Academy of Design," *Appleton's Journal*, 8 (September 21, 1872), 325–28; Alvan S. Southworth, "The National Academy of Design," *Frank Leslie's Popular Monthly*, 26 (October, 1888), 385–94; John W. Alexander, "The Need of a National Academy, and Its Value to the Growth of Art in America," *Craftsman*, 17 (March, 1910), 607–18.

artists," a reviewer noted in 1867, "but these are almost lost among the crowd of nearly six hundred of no saving merit."[9] As the pressure to exhibit grew, some distinguished academicians and many potential new members showed their best work in studios or in the rapidly proliferating private dealers' galleries.[10] This added to the sense of decline and lack of discrimination that somewhat unexpectedly surrounded the Academy by the 1870's.

The standards of academicians also inevitably seemed elitist, as any original desires for innovation hardened into concern for respectability and an unwillingness to offend art patrons with new ideas. There were also predictable charges that academicians desired only to promote their own success.[11]

In due course, the Academy and the kind of certified art world it represented became the focus of rebellion. In 1877 a group of dynamic young painters, fresh from study abroad, established the Society of American Artists. They showed new work in private galleries, attempting to break up academic rules and to make the art public more aware of new trends. The formation of groups of painters with special interest, such as watercolorists and muralists, proceeded apace. In 1898 a prestigious group called "The Ten" focused attention on impressionism. By the turn of the century, numerous groups of "moderns" developed outside the academic system, which seemed old-fashioned even to sympathetic observers.[12]

The goals of the academic institutions were lofty indeed.

[9] "Fine Arts: Forty-second Exhibition of the National Academy of Design," Nation, 4 (May 2, 1867), 359. See also "Literature and Art," Galaxy, 7 (January, 1869), 138–39.

[10] "The Spring Exhibition of the National Academy," Appleton's Journal, 7 (May 25, 1872), 578–80; New York Times, December 1, 1872; Jervis McEntee Diary, May 7, 1886, AAA.

[11] New York Times, May 24, 1879.

[12] "The National Academy of Design," Appleton's Art Journal, 2 (1876), 157; Samuel Isham, The History of American Painting, 371–72; "Fine Arts: Society of American Artists," Nation, 50 (May 8, 1890), 380; Frank J. Mather, Jr., "The National Academy," Nation, 90 (March 24, 1910), 301.

They sought to train painters to express individuality within a tradition drawn from the past's greatest art. They desired equally to develop a culture emphasizing the love of art. They hoped to create a world of special interest for artists and to link it to the larger society. But an academic system was not suited to American life. The desire to order art clashed with the new generation's rising interest in diversity. Focus on American nationalism ran counter to cosmopolitan trends. Concern for form confronted the younger painters' need to experiment. And like all essentially bureaucratic institutions, academies became conservators rather than innovators.

Academic institutions throughout the country fulfilled some of their founders' desires. They added prestige to the arts and offered places to create and show painting. They were outlets for artistic ideas and fulfilled a need for companionship and intellectual stimulation among painters. But they were never as influential as either friends or foes thought. As early as the late 1860's most critics agreed that academic styles would not dominate American art because of the country's diversity. Academic tastes reigned for a time but did not rule. A more informal model of art life and expression quickly developed, based like other aspects of American life on diversity and individualism.

The private collector soon symbolized that varied art world as much as the painter he supported. Many forces other than the nation's sudden wealth lay behind the vogue for collecting. Some wealthy people wished to enrich their lives after a long struggle for success.[13] Others, building collections for posterity, combined a love of art with a sense of social stewardship.[14] The least initiated accepted the dealers' arguments that art works were safe investments, and picture prices generally fulfilled these expectations.[15] And there was always a certain defensive eagerness to dem-

[13] Frank J. Mather, Jr., "A Cycle of Art in New York," 82 (April 26, 1906), 338.
[14] Corinna Lindon Smith, *Interesting People*, 141–44.
[15] New York *Times*, December 18, 1870.

onstrate that America was as cultured as Europe. "At one time, in the Eighties," the critic Sadakichi Hartmann recalled, "wealthy New Yorkers were really forced to have a gallery," if only to ward off foreign criticism.[16]

Collecting art offered Americans several unusual rewards. Because of art's moralistic associations, they could acquire it without guilt, an important consideration to a puritanical generation. They could also invest in it for the future, with present enjoyment. Art was obviously more prestigious than money in many circles, a fact which those seeking new status did not forget. Art collecting also seemed to blunt the edge of egotism in the normal human desire for display. And many philanthropists intended their collections to edify and thus repay their communities.

By 1880 there were an estimated 150 significant private collections in the country. Those of rich men naturally received the most publicity along with loving or amused descriptions of the new castles that housed them. A critic occasionally scoffed at a millionaire's taste or questioned a work's legitimacy. But whatever the varieties of motive, the concern for art collecting grew. The newspapers' occasional focus on the wealthy collector obscured a more important trend. Art entered the homes and affected the lives of the growing middle class who were community opinion makers.[17] Its appreciation as a necessary part of life increased every year with improved education and growing publicity for cultural matters. Commentators marveled at the country's ability to absorb an ever-increasing quantity of painting. "If it means anything," the New York *Times* suggested in 1894, "it means that pictures are no longer a luxury of the rich, but a necessity of the less wealthy classes, like comfortable furniture and sanitary houses."[18]

Fashions in collecting marked changes in general taste in the art world. Americans at mid-century were chiefly in-

---

[16] Sadakichi Hartmann, *A History of American Art*, II, 284. This work first appeared in 1901.
[17] New York *Times*, December 27, 1874.
[18] *Ibid.*, April 1, 1894.

terested in familiar native works like those of the Hudson River school, landscape in general, and genre. Corot and the Barbizon painters, especially Millet, were among the first moderns to penetrate the postwar market. Collecting maintained a triple emphasis in the generation that followed: American productions, contemporary European works, and old masters.

The last category seemed dominant, as wealthy clients discovered that works of the Renaissance, and of Rembrandt, Velásquez, and lesser but important older artists were within easy reach. Upheavals in Europe brought an increasing quantity of such works on the market. Their appeal to collectors was obvious. Old masters had historic associations, and were comprehensible to almost anyone. Their numbers were ultimately limited, which inevitably increased their value. By 1900 many Europeans talked of forbidding the export of old masters, so great was the American demand for national treasures.[19]

The American art tourist became a stock figure in European reporting. He surveyed the dealers' galleries in London or Paris, or sought entry into the aristocratic homes of Italy and Iberia, which housed many premier paintings. With traditional American brashness he often thought nothing of calling on famous artists. These same artists soon kept open house, as did their brethren over the water. "The liberality of American travellers is well known to European artists whose studios they frequent for purchase . . . ," a critic noted as early as 1876.[20]

American painters residing abroad sometimes expedited the process. Mary Cassatt developed a network of contacts among aristocrats who wished to sell objects discreetly. She accompanied Mrs. Henry O. Havemeyer, wife of the sugar magnate, on numerous art-hunting forays into Spain and Italy. She also guided wealthy friends into purchasing

[19] For an interesting contemporary comment, see "The Consequences of the American Invasion," *Burlington Magazine*, 5 (July, 1904), 353–55.

[20] Philip Quilibet, "Art at the World's Fair," *Galaxy*, 21 (February, 1876), 272.

works of Degas, Manet, Corot, and the impressionists in general. J. Alden Weir, William Merritt Chase, and John S. Sargent also helped secure several major impressionist works for private collections, which ultimately enriched public museums.[21]

These collectors obviously worked for the future. Most of their collections became public property, often along with buildings to house them. A new kind of philanthropy, oriented toward endowing public cultural and educational institutions, arose in the period and paralleled many of the new art world's needs. These collectors were important to that art world for several reasons. They were fulfilling the traditional individualistic-competitive ethic in pictures rather than stocks. The activity thus did not seem unusual or outside the mainstream of life to other people. They also humanized a process of art appreciation which was otherwise abstract to most people, making it seem comfortable and normal. And their concern made art and artists seem more acceptable to a society that had always suspected the emotions in the art experience.

The collector helped sustain another institution vital to the new art world, the dealer with a private showroom. Though there was a market for imported pictures in the 1850's, art dealing became a large enterprise after the war.[22] Dealers opened businesses in every major city, as prosperity washed across the country, and as people became more aware of cultural matters through improved communications.

The dealer, of course, was a businessman, but with a special role as intermediary in the complex process of appreciating art. Critics lauded early dealers for importing foreign art works.[23] In the absence of museums, they

---

[21] Frederick A. Sweet, *Miss Mary Cassatt: Impressionist from Pennsylvania*, 162, 165, 172, 197; Louisine W. Havemeyer, *Sixteen to Sixty, Memoirs of a Collector*, 7, 83; Dorothy Weir (ed.), *The Life and Letters of J. Alden Weir*, 145, 169.

[22] Larkin, *Art and Life in America*, 151.

[23] See [Russell Sturgis], "Fine Arts: French and Belgian Pictures on Exhibition," *Nation*, 2 (February 1, 1866), 154.

functioned in some measure as educators to both public and artists. Their profits seemed only a reasonable aspect of business.[24] Will H. Low, like countless other fledgling artists, got his first view of foreign works in such a dealer's gallery.[25]

The genial view of the dealer as educator faded in the 1870's with rising prices and the influx of foreign pictures. The dealer who won brief praise in 1865 for introducing Americans to European culture, was often lambasted a decade later for selling French work at the expense of struggling Americans. His popularity, like any middleman's, declined with success. His commission represented lost income to the painter, and increased prices to the buyer. Will Low did not blame dealers for cashing in on fads but thought horse trading "fairly evangelical" compared to art dealing.[26]

Whatever the view from within the exchange process, the dealer's larger role was important to the art world. The informed dealer was able to emphasize innovations with a one-man or group show, a favorite device of "moderns" throughout the period. He was usually cosmopolitan, whatever the nature of his wares, since he had to understand a world market. And until communities developed museums, his showroom retained some educational functions. He was also a mediator, the "expert" so common to the era, between the patron and the complex world of art.

Multipurpose museums began to codify the trends which academic ideals, private collectors, and dealers typified. Every important city either built or planned a major art

[24] See New York *Times*, January 5, 1866; "Fine Arts: Pictures on Exhibition in New York," *Nation*, 5 (December 19, 1867), 508–509; "Art Notes," *Appleton's Journal*, 2 (November 6, 1869), 379; "Editor's Table," *Appleton's Journal*, 8 (December 14, 1872), 675; "Art Nooks," *Scribner's Monthly*, 5 (December, 1872), 265; David C. Preyer, "The Critic's Cogitations," *Collector and Art Critic*, 5 (February, 1907), 135–40.

[25] Will H. Low, "A Century of Painting," *McClure's Magazine*, 7 (September, 1896), 294–96.

[26] Will H. Low, "The Mural Painter and His Public," *Scribner's Magazine*, 41 (February, 1907), 254; Will H. Low, *A Painter's Progress* 221–22.

center to express its modernism and cultural authority. City consciously competed against city for cultural eminence, as with New York and Chicago or Pittsburgh and Philadelphia. By the 1890's a network of museums offered patrons a broad cross section of world art, both past and present.[27]

The museums represented many complex ideals. They reflected the generation's desire to codify, classify, and analyze complicated data, an attribute of the whole industrial process. Founders also hoped to compensate for the past neglect of culture. They usually combined public educational programs with display and storage functions. Local leaders saw them as part of a larger ideal of civic development and as ways to advertise community vitality. A museum, art school, park system, and library soon became standard fixtures of any city worth its pretensions to greatness.[28]

In more personal ways, museums enhanced the art experience and drew new people into the developing art constituency. Most of the new buildings were located in elegant parklike settings, which emphasized the ideal of art as a civilizing agent. They were almost always patterned after historic models, tying art's present functions to a rich inherited tradition.[29] Most boards of trustees were probably conservative, but management of art institutions quickly passed to a new class of professional experts, whose chief concern was the art experience. New techniques of lighting, display and restoration, and elaborate analysis in catalogues created special responses to the individual art object. That

---

[27] Boston, New York, and Philadelphia boasted museums at the time of the Centennial Exposition in 1876, but institutions proliferated afterwards. St. Louis, Cincinnati and Detroit, for example, established museums between 1879 and 1885. It became standard practice to make a permanent museum building part of the numerous fairs and expositions which the era staged.

[28] "The Future of the Metropolitan Museum," *Century Magazine*, 27 (April, 1884), 943.

[29] See Daniel M. Fox, *Engines of Culture: Philanthropy and Art Museums*, 27.

object in the total museum setting, in turn symbolized the special meanings of art and culture. Every museum, especially those of New York, Boston, and Philadelphia, inevitably displayed the art of the past. But most local institutions emphasized some aspects of regional culture and often became innovative collectors of contemporary painting. By the turn of the century the director of the Dresden Museum noted with some surprise that "the American public collections of modern pictures far surpassed any European collections with which he was acquainted."[30]

Like so many American phenomena the museum movement tried to unify diverse aspirations. It was part of an effort to develop and emphasize American culture, but within a world context. It hoped to delight and train the eye and improve the mind. Its agents wished to intensify the art experience for the initiated individual while expanding the community's broader cultural ideals. At its best, it preserved and explained man's general tradition but incorporated his present productions.

As the new museums illustrated, a desire for art flourished with regional growth and the rise of new cities. The "West," an area beyond the Hudson to most New Yorkers, seemed ready to challenge the claims of that metropolis to national cultural leadership. The cities of the Mississippi and Ohio valleys underwent enormous expansion and developed a new element of people interested in collecting and patronage. New museums there often outbid rival institutions in the East for important works.[31] Local newspapers,

[30] W. M. R. French, "The Chicago Art Institute Collection of Paintings," *Scribner's Magazine*, 40 (September, 1906), 380. See also "Museums of Art as a Means of Instruction," *Appleton's Journal*, 3 (January 15, 1870), 80–81; [Russell Sturgis], "Fine Arts: The Uses of a Museum of Art," *Nation*, 28 (June 19, 1879), 425; Lawrence W. Chisolm, *Fenollosa: The Far East and American Culture* 123–125; and Neil Harris, "The Gilded Age Revisited: Boston and the Museum Movement," *American Quarterly*, 14 (Winter, 1962), 545–66.

[31] "The Art Boom in the West," *The Collector*, 1 (August 1, 1890), 152.

such as one in Leadville, Colorado, in 1880, frequently urged their new millionaires to establish art academies as signs of progress.[32] And many western commentators saw their section or city as the model for a more democratic, dynamic, and expressive art than that of either Europe or the eastern seaboard.[33] Such expectations peaked when Chicago staged the World's Columbian Exposition in 1893.

These regional developments in the arts resembled growth and ambitions in other sectors of life. Regional culture remained vital, and many American cities created their own emphases on both the content of art and the quality of art life. But culture flourished best in the broadest urban setting, with abrasive give and take among thinkers and ample facilities for display and study. Those cities already well established by mid-century offered the greatest potential focus for the nation's disparate taste and gathering energies.[34]

As the country's oldest city, with ample wealth for patronage and an orientation toward both Asia and Europe, Boston was an obvious candidate for that leadership. She had many cultural institutions and even developed a modest bohemian world for the artist population. She also hosted a famous painter, William Morris Hunt, as chief spokesman for modern French art.

But Hunt's various frustrations reflected the city's limitations. He attained an enormous reputation for brilliant teaching, yet most of his students were genteel women with little influence on subsequent art except as enlightened patrons. His caustic remarks on the limitations of academic

[32] "The Art Season," *Scribner's Monthly*, 20 (June, 1880), 313.

[33] See Ida M. Condit, "Art Conditions in Chicago and Other Western Cities," *Brush and Pencil*, 4 (April, 1899), 7–11; Leila Mechlin, "The Awakening of the West in Art," *Century Magazine*, 81 (November, 1910), 76.

[34] "Art and Music," *Appleton's Journal*, 10 (September 13, 1873), 347; "Artists and Their Work," *Munsey's Magazine*, 15 (June, 1896), 316–18; Charles De Kay, "Organization Among Artists," *International Monthly*, 1 (January, 1900), 84–98.

training and established taste went the rounds an^
students everywhere. He won over a few collectors to moa-
ernism and was a potent force in advertising some of art's
needs. But he did not overcome Boston's hesitations about
the validity of new ideas, and the city remained more in-
terested in conserving than in innovating.[35] Boston was a
mecca for literature and music but never transferred that
enthusiasm to the plastic arts, especially as painting became
more controversial.

Philadelphia, the second obvious contender for cultural
hegemony, was a similar paradox. The scene of many fa-
mous historical events, it had an obvious interest in things
of the mind. A major port and *de facto* capital of a wealthy
state, it too had ample resources for patronage. It boasted a
major academic institution, the Pennsylvania Academy of
Fine Arts, and the greatest interpretive realist in American
painting, Thomas Eakins. Yet the Academy's output was not
generally innovative, and Eakins' fame was largely post-
humous. The City of Brotherly Love remained stubbornly
bourgeois, easily shocked at the modest nudes occasionally
shown in exhibitions.[36] The brightest young artists from
Boston and Philadelphia soon migrated to New York as
readily as did their counterparts from more distant prov-
inces.

Life in that city seemed at once more free and intense than
anywhere else in the country.[37] Long before the war it had
developed an expansive, almost imperial rather than merely
national, atmosphere. This rested not only on wealth,
though that was prodigious, but also on a varied population

[35] See Maude Howe Elliott, *Three Generations*, 124, S. R. Koehler, *Ameri-can Art*, 3; and S. G. W. Benjamin, *Life and Adventures of a Free Lance*, 293–94. Hunt's career is covered in Helen M. Knowlton, *The Art Life of William Morris Hunt*; and Martha A. Shannon, *Boston Days of William Morris Hunt*. Hunt's two *Talks on Art* (1875) and (1883) are delightful.

[36] William Innes Homer, *Robert Henri and His Circle*, 69; and Thomas P. Anschutz to Dear John [John L. Wallace?], October–November, 1884, copy in Anschutz papers, PAFA.

[37] See Philadelphia *Press*, March 19, 1873; S.G.W. Benjamin, "Present Tendencies of American Art," *Harper's Monthly*, 58 (March, 1879), 489–90.

and ties to the world. It was the nation's communication center, especially oriented toward the new, whether in finance, politics, or art. Its spokesmen always believed that New York's riches would fuel a great cultural expansion. They could boost the city as shamelessly as any enterprising reporter on the Great Plains praised his own town. "New York is destined to be the Venice of the New World," one critic exclaimed in 1869, "as famed for its distinction in the domain of art as it is in that of trade and commerce. Art cannot be said to flourish in any other American city." The "great metropolis" would be to the United States what Paris was to Europe.[38]

The city was endlessly fascinating to the artistic elements that arrived after the war. The rich variety of street life, the sense of growth and power were as important to artists as the bookshops, studios, and galleries. There were quarters of Chinese, French, Germans, and many other ethnic elements, where an artist might gain inspiration from local color, eat an exotic meal, or engage in spirited conversation with other unusual, questing people. And the desire for diversity, the challenge of many ideas rather than the security of one, animated the new art world. As an artist remarked in 1878, "In New York it is like taking part in a revolution."[39] Many fledgling painters in the provinces, or those returning from European training, agreed with Carroll Beckwith, "I determined to come on to New York, sink or swim, survive or perish, rather than rot in the miserable mediocrity of a western studio."[40]

[38] New York *Times*, February 2, 1869. See also Neil Harris, *The Artist in American Society*, 111–113; and Wanda M. Corn, "The New New York," *Art in America*, 61 (July–August, 1973), 59–65.

[39] *Scribner's Monthly*, 16 (May, 1878), 146–47.

[40] Quoted in Edgar P. Richardson, *Painting in America*, 279. For contemporary comment see "The Old Cabinet," *Scribner's Monthly*, 15 (April, 1878), 889; "New York Exhibitions," *Californian*, 2 (July, 1880), 89–90; G. P. Lathrop, "The Progress of Art in New York," *Harper's Monthly*, 86 (April, 1893), 740–52; Frank Fowler, "Opportunities for Art Study in New York," *Scribner's Magazine*, 48 (August, 1910), 253; and Florence N. Levy, "New York as an Art Center," *Scribner's Magazine*, 65 (April, 1919), 509–12.

These seekers found ready entry into a burgeoning "bohemia" derived chiefly from Henri Murger's *Scènes de la Vie de Bohème* (1857). The artists involved naturally looked to foreign models, which they had visited or heard about, but understood the difficulties of establishing an art life in America. The soft light of Florence would not fall on Chicago, nor would there be a Left Bank on the Hudson. But an exciting and creative artistic existence could parallel the workaday world. A sense of comradeship, shared hardships and hopes, and sympathetic support for lonely endeavor could soften the new artists' confusion. They wanted the educational vitality of coherent art talk, and a sense of the unusual which seemed impossible to attain in the world of factories and farms. The model art life of a special purpose within society's larger work was not a tangible thing anyway but a state of mind.

The new life-style of the art quarters offered alternatives to the reigning bourgeois ethic, yet did not seem threatening. This art life was a major part of a desire to enhance the artist's special status and authority. But it retained the promise of influence with the larger world once that society accepted the desire for beauty that animated life in the bohemias. Whatever the hardships of making a living, the artists' larger purpose remained generally positive through the century. Genuine estrangement from society usually awaited the disenchantments that followed after 1900, when political and literary radicals rather than painters dominated America's Greenwich Villages. As Henry Tuckerman said just after the Civil War:

But wherever found, there is a certain atmosphere of content, of independence, and of originality in their domiciles. I confess that the ease, the frankness, the sense of humor and of beauty I often discover in these artistic nooks, puts me quite out of conceit of prescriptive formalities. Our systematic and prosaic life ignores, indeed, scenes like these; but the true artist is essentially the same everywhere—a child of nature, to whom "a thing of beauty is a joy forever"; and, therefore, a visit to the New York Studios cannot fail

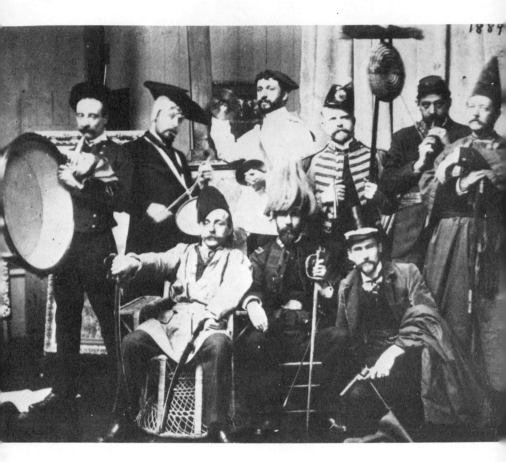

An artists' party, with aging bohemians, at the Sherwood Studio Building in New York City, 1889. *Courtesy Archives of American Art, Smithsonian Institution*

to be suggestive and pleasing, if we only go thither, not in a critical, but in a sympathetic mood.[41]

After the Centennial Exposition of 1876 and the landmark shows of work done under new foreign influence in 1877 and 1878, a sense of excitement filled the art world. Special publications began to report art matters. A growing number of informed critics lambasted or praised, but steadily publicized, the increasing range of art ideas. More people went abroad for training and returned to tell of fresh discoveries.

Individual artists discussed these trends. Their partying and debating were prodigious and they learned a great deal from each other. "Men in our line feel more than others the need, [and] it is a need, of being occasionally with their own kind," Thomas Anschutz counseled a friend.[42] This life of conversation in sympathetic surroundings became a way of ordering unusual and often bewildering experiences. It also favored the unexpected insight and the accidental moment of creativity over order and predictability. The desire for complex emotions became the most impressive aspect of this new art life to outsiders. Shoptalk was pervasive, adding to the artist's developing image as a harbinger of new levels and kinds of experience, which might become possible to everyone of like mind.

The artist's desire for creativitiy and commercial success coincided with a wish to live in unusual and challenging surroundings. He could create a private world and enhance his visible status in a studio that combined professional facilities and an exotic atmosphere. Shrewd landlords converted old structures or built new ones for artistic tenants. The best offered high ceilings and ample light. Artist tenants soon filled these quarters with exotic artifacts to impress visitors and to use as accessories in pictures. The newspapers made sure, of course, that these backdrops

---

[41] Tuckerman, *Book of the Artists*, 25.

[42] Thomas Anschutz to J. L. Wallace, August 25, 1884, copy in Anschutz papers, PAFA. The diaries of Theodore Robinson, FARL, detail very well this process of visiting and exchanging ideas.

figured in the artists' image as free, creative, or at least unusual spirits.[43]

Studios also had practical uses. The crowded exhibitions at the National Academy rapidly became more social than artistic events, and painters used their studios to show works in less-confused surroundings. Successful painters kept regular visiting hours, especially on weekends during the season. Long lines of fashionable equipage stood outside the studio buildings while well-dressed owners drank tea, marveled at the bric-a-brac, or debated art's manifold meanings under the skylights.[44]

After a day's work artists often carried their interests to different but still congenial settings. Every art quarter, especially New York's, boasted special restaurants, where the conversation rivaled the French, German, Mexican, or Chinese cuisine. There was some interchange with writers and newspapermen, but artists tended to talk to each other and knew much more about their private world than the world at large. Even at their special clubs, on group holiday outings, or at the beaux-arts balls, the conversation about art flowed as easily as the best wine.[45]

In due course, even some sympathetic critics wondered if the drive for a special artists' world had not succeeded too well. The seductions of success might be as great as the perils of failure. Lion catching could become lion taming, and promising young men might dissipate their talents into

[43] "At the Studios," *Appleton's Journal*, 13 (March 27, 1875), 409–10.

[44] There is a good description of a lavish National Academy reception in New York *Times*, April 17, 1866. The contemporary studio scene is well described in "Literature and Art," *Galaxy*, 8 (December, 1869), 858; the Diary of Jervis McEntee, March 30, 1873, AAA, which expresses some skepticism about studio receptions as a way of selling pictures; and Low, *Painter's Progress*, 129. The best historical description is Garnett McCoy, "Visits, Parties, and Cats in the Hall: The Tenth Street Studio Building and Its Inmates in the Nineteenth Century," *Journal of the Archives of American Art*, 6 (January, 1966), 1–8. Also useful are Mary Sayre Haverstock, "The Tenth Street Studio," *Art in America*, 54 (September, 1966), 48–57; Louise Hall Tharp, *Saint-Gaudens and the Gilded Era*, 178–79; and Albert Parry, *Garrets and Pretenders: A History of Bohemianism In America*, 256.

mere socializing.[46] Other critics deplored the tendency among artists to "politic" and vie for success and honors, especially as their numbers and public interest in art increased. Consciously or not, artists soon learned to use the special levers of influence so common to the wider society. Advertising, committees, special organizations, outlets in the news media were all used to emphasize or denigrate a style of painting or to challenge or promote a new idea. Observers quickly learned that quarrels among artists could be as bitter as fights between Republicans and Democrats, or even those among Democrats.[47]

The exciting life-style of the successful painter was the focal point of discussion about the new art world. But there was obviously not a market for the wares of every ambitious painter. Almost every newcomer worked in a satellite trade before "arriving" and thus added some special talent or turn of thought to art life in general.

The variety of jobs artists held revealed how much the United States had changed, and how many often unexpected new kinds of work industrialism created. Teaching in one of the new art schools was a logical step for many artists. But there were other outlets for talent. The book publishing industry absorbed a lot of art, both in illustrations and in binding designs. Manufacturers of greeting cards, posters, advertising flyers, and games and toys also employed artists. Many worked as set designers and scenery painters when a boom in theater-going engulfed the country in the 1880's and 1890's.[48] An expanding middle

[45] See C. M. Fairbanks, "The Social Side of Artist Life," *Chautauquan*, 13 (September, 1891), 746–51; Art Young, *On My Way*, 231–32; and James Montgomery Flagg, *Roses and Buckshot*, 112.

[46] "Art," *Atlantic Monthly*, 34 (October, 1874), 509; Aline Gorren, "American Society and the Artist," *Scribner's Monthly*, 26 (April, 1899), 628–33.

[47] See James Fairman's letter to the editor, New York *Times*, February 11, 1882, p. 2, col. 1; Cleveland Moffett, "Will H. Low and His Work," *McClure's Magazine*, 5 (September, 1895), 306; Russell Sturgis, "Art Societies and Societies of Artists," *Scribner's Magazine*, 30 (December, 1901), 765–68.

class, interested in unusual home decorations, supported artists in industries producing carpets, wallpaper, furniture, and home accessories.[49]

Many artists worked as illustrators for newspapers and magazines. A few, such as Edwin Austin Abbey, started in crowded newspaper offices and went on to fame and fortune. The period from 1890 to 1920 marked a renaissance in illustration of all kinds.

Those artists who hoped to paint portraits of wealthy clients or decorate public buildings with murals found working as illustrators onerous. And for every one who climbed the artistic hierarchy countless others remained at their drawing boards. Yet a few like Abbey, John Sloan, and William Glackens used the time to intellectual advantage while earning a living. Abbey recalled that his apprenticeship allowed him to learn about the world's new art interests:

To begin with, the "office" at Franklin Square, as we used to call it, was the dumping ground of the entire illustrated and foreign press. This mass of material—even in 1871—was prodigious; what it must be now—if the same custom is kept up—"passes" me; but one saw every week and every month *all* that was being done—good, bad, and indifferent . . . .[50]

[48] "Books on Art," *Scribner's Monthly*, 8 (August, 1874), 503; Art Young, *Art Young, His Life and Times*, 72.

[49] See "The Water Color Exhibition," *Appleton's Journal*, 13 (February 13, 1875), 216; Coleman E. Bishop, "American Decorative Art," *Chautauquan*, 5 (July, 1885), 582–84; Charles Barnard, "The Art Industries," *Chautauquan*, 7 (March, 1887), 335–37; "The Arts and Crafts Movement," *Artist*, 24 (April, 1899), lxv–lxvi; Joseph Moore Bowles, "The American 'Arts and Crafts,'" *Modern Art*, 5 (Winter, 1897), 17–20; Alvan F. Sanborn, "The Scope and Drift of the American Arts and Crafts Movement," *Forum*, 40 (September, 1908), 254–64; Low, *Painter's Progress*, 107.

[50] E. V. Lucas, *Edwin Austin Abbey*. I, 22. The same point is made in "Foreign Art Journals," *Scribner's Monthly*, 16 (October, 1878), 906–907. See also William A. Coffin, "American Illustration of Today," *Scribner's Monthly*, 11 (January, 1892), 106–17, and 11 (February, 1892), 196–205; William Herbert Hobbs, "Art as the Handmaid of Literature," *Forum*, 31 (May, 1901), 370–82; and Michael Schau, *J. C. Leyendecker*, 21.

And an illustrator often reaped some advantages from having to work quickly with an eye trained for movement. The medium emphasized spontaneity, suggestion, the bold stroke, qualities rapidly emerging at the forefront of the new art.

The development of and popular interest in this complex new art world paralleled new definitions of the artist's status and social roles. There were numerous great artist figures in the American past. Some, such as John S. Copley and Gilbert Stuart, were identified with the nation's beginnings. Others like the Peale family, George Caleb Bingham, and Thomas Cole had codified many aspects of the American experience. Yet their personal images had not penetrated deeply into American society. The post–Civil War generation was at once more turbulent, curious, and ready for a broader definition of the artist's role.

Yet broad-based, popular understanding of the artist's needs and ambitions lagged behind the new generation's rising interest. Many people retained the image of artist as sign painter, inherited from a period when the painter's apprenticeship was often rustic and his livelihood uncertain. This fear of economic want kept many parents from encouraging their children's artistic ambitions. As John White Alexander, successful portraitist, recalled: "Like all children, when I was a boy I was constantly asked this question by well meaning friends of my family: 'What are you going to be, my boy, when you grow up?' And to my invariable reply: 'I want to be an artist,' came the instant and disgusted rejoinder: 'And starve in a garret.' "[51]

The American's traditional demand for quick success also penalized those in arts and letters whose work required reflection and analysis. The art student's family was "disgusted if there are not some great results at the end of two or three years," Will Low recalled wryly. "European parents, knowing more about art, are more reasonable. What is really

[51] John W. Alexander, "The Art Outlook," *Art and Progress*, 3 (May, 1912), 574. See also Rockwell Kent, *It's Me, O Lord*, 65; Adam E. Albright, *For Art's Sake*, 3; and Low, *Painter's Progress*, 44–45.

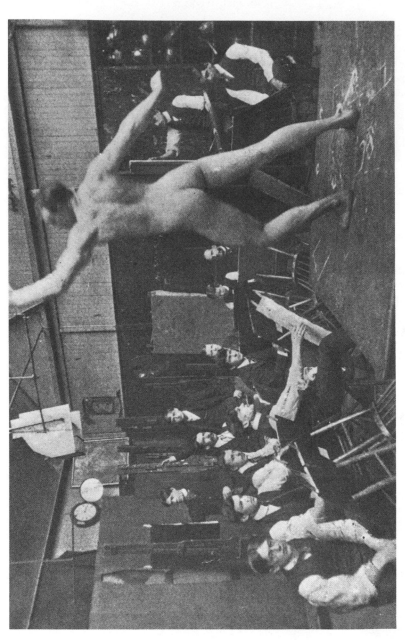

Men's life class, with model posed as athlete, *ca.* 1900. *From The Bookman, 12 (November, 1900)*

necessary in America is the founding of scholarships for the instruction of American parents in art matters."[52]

The new artists also began to seem part of the more general social changes accompanying industrialism, a fact which alarmed many people. "Artists were 'different,' made a point of being so, insisted that in such difference the merit of their artistry was established," the writer Mary Austin recalled of her sober midwestern childhood. "And to be different implied a criticism of what was established, orthodox, 'normal.'"[53]

This general unease included fears of new kinds of personal behavior in the art colonies that might radiate out into society at large to threaten established norms of conduct. Many people opposed studying nude models, especially when the artist and model were of different sexes.[54] Others saw the artist's role as essentially feminine and passive, unsuited to the young man who was supposed to develop masculinity as well as a fortune in combat with the workaday world. Steady growth in the number of women students, both at home and abroad, increased this anxiety about changing sexual roles.[55] Critics regularly chided art-

[52] Cleveland Moffett, "Will H. Low and His Work," *McClure's Magazine*, 5 (September, 1895), 306–307.

[53] Mary Austin, *Earth Horizon*, 123–24.

[54] The most celebrated case against using the nude model involved the dismissal of Thomas Eakins at the Pennsylvania Academy for allowing women to draw the undraped male. Eakins posed many difficulties for the Academy directors, who probably seized on this controversy to dismiss him. But the concern was real, as revealed in one outraged woman's comments at the time: "Do you wonder why so many art students are unbelievers, even infidels? Why there is often so much looseness of morals among the young men? Is there anything so effective in awakening licentiousness as this daily and *nightly* study of woman's nudity! Can't it be helped! Can Christian men, members of the church, deliberately aid in demoralizing the young in this manner and not be guilty!" Cited in Sylvan Schendler, *Eakins*, 90–92.

[55] See Charles H. Caffin, *American Masters of Painting*, 119. On women, see New York *Times*, November 12, 1866, and February 9, 1908. Ezra Tharp, "T. W. Dewing," *Art and Progress*, 5 (March, 1914), 155–61, makes the interesting point that throughout the period, women appeared in an

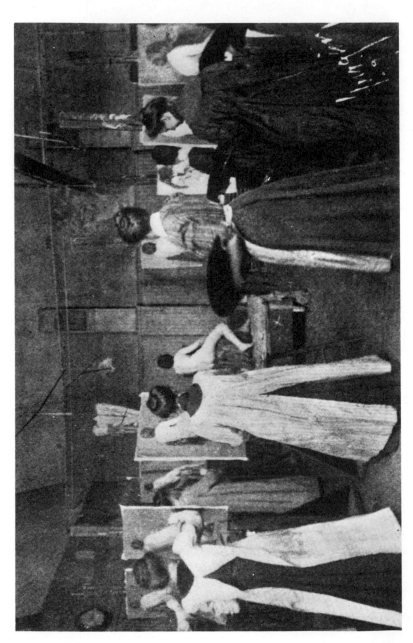

Women's life class, *ca.* 1900. *From* The Bookman, 12 *(November, 1900)*

ists for childish bickering over each other's works and success. Art life thus seemed a way of prolonging adolescence and of rejecting parental standards.[56] In many ways the new art life finally seemed to critical outsiders a form of revolt—young against old, sex against sex, old against new.

Artists naturally had different self-images. They accepted the hardships of training and the uncertainties of making a living. But the booming art market seemed to promise a growing demand for pictures. There was a chance for a living and even for fortune, as the success of a few painters demonstrated. "Then again in the hard struggle for life that some of us knew," Will Low remembered, "whispers of the prices paid for their pictures, fabulous as they seemed, served to give us hope that someday we might hope to share in the golden flood."[57]

There was also the prospect of a life developed at the individual's pace and according to his talents. The successful painter could work in a pleasant studio during the season and spend the summer filling his sketchbook at a rural retreat or ramble around the countryside with friends.[58]

On the grandest scale, he might aspire to an international reputation and be known to famous people in every walk of life. What politician was better known than the singer Nellie

---

increasing number of roles as subject matter in painting. William Dean Howells, *The Coast of Bohemia*, 202–204, has an amusing fictionalized description of determined women bohemians, obviously drawn from life.

[56] For typical complaints of this "childishness" throughout the period, see "Literature and Art: Fine Arts, The Academy of Design," *Galaxy*, 7 (January, 1869), 138; "The Academy Exhibition," *Scribner's Monthly*, 8 (June, 1874), 245; "Art," *Atlantic Monthly*, 33 (June, 1874), 753–55; New York *Times*, March 15, 1879, February 13, 1882, and May 19, 1907; E. A. Taylor, "The American Colony of Artists in Paris," *Studio*, 53 (July, 1911), 103–104.

[57] Low, *Painter's Progress*, 132; and "Prices of Pictures," *Appleton's Journal*, 8 (July 6, 1872), 26.

[58] See typical entries of January 27, February 18, 1873, Diary of Jervis McEntee, AAA; New York *Times*, November 29, 1867; and "Art and Music," *Appleton's Journal*, 10 (September 20, 1873), 379.

Melba, the actress Sarah Bernhardt, or the painter John Singer Sargent? The truly successful artist on any of these scales could live well while seeming above mere materialism. He might also work out a drive for power or fame without the overtones of crassness the same effort provoked in business or politics.[59] Few artists attained these heights, but those who did refuted the stereotype of the lonely painter starving in a cold garret.

Fame and money were all very well, of course, but most artists desired a different sort of status and personal fulfillment. Art life for many was an alternative to business or politics, a way of expressing things more enduring than railroads or cattle ranches. As industrialism homogenized American life, the artist also saw his work as a bastion of individualism set against conformity.[60]

At the highest emotional level, the artist saw himself as a synthesizer and creator of eternal truths. He would alter society and men's minds through truly imaginative insights, made real in art objects and communicated through "appreciation" to a constituency of like mind. The artist as holy man, seer, or prophet, revealing fundamental realities, making order of chaos, certainty out of uncertainty, dominated theoretical discussions of art. "A great artist of any kind is nothing but a great personality using a given artistic

[59] "Art Notes," *Appleton's Journal*, 10 (December 6, 1873), 731; New York *Times*, October 1, 1882.

[60] This theme of individualism merits extended study, which lack of space prohibits developing here. On the whole, the artist had few critics as long as this individual expression did not threaten cultural stability and seemed a logical outgrowth of the past. But as time went by and "modernism" dominated the scene, many critics attacked individualism as "egotistical" and therefore a cause of fruitless chaos and eccentricity. The modern artist, increasingly removed from society at large, has tended to accept and even glorify that individualism as necessary to progress, even if it appeared self-centered. For contrasting comments, see M. G. van Rensselaer, "Corot," *Century Magazine*, 38 (June, 1889), 271; Royal Cortissoz, "Egotism in Contemporary Art," *Atlantic Monthly*, 73 (May, 1894), 646; Frank J. Mather, Jr., *Modern Painting*, 3; and the same author's "The Present State of Art," *Nation*, 93 (December 14, 1911), 585.

medium to convey its impressions of the universe," a writer noted in 1895.[61] Will Low was more poetic and sweeping:

The artist remains today [1888] almost alone the embodiment of an idea. The warrior, except upon some miserable question of territory, stands idle. The priest no longer leads a crusade, or by fasting and vigorous penance, serves as a beacon-light for weary seekers after the truth. Kings govern by consent of a parliament largely elected from the common people; and "noble lords of high degree" become farmers and ranchmen, confounding themselves with the average man. The artist, who has coexisted with all of these in the heyday of their power, alone remains . . . .[62]

The artist might thus embody and control many conflicting desires in American life: a need for romance and the love of reality; faith in order and curiosity about change; a drive for distinction and individual expression that did not threaten other men's freedom.

Society used individuals to typify subtle and complex ideas. No artist embodied the often contradictory trends in American art better than William Merritt Chase. Born in Indiana, in 1849, Chase early displayed an artistic temperament. He studied briefly at Indianapolis and New York, but longed for the inspiration of a wider art world. Four sympathetic friends helped finance his study abroad. Between 1872 and 1876 he worked at the popular Munich academy, traveled through Europe looking at art, and met many leading painters.

The young Chase showed work at the National Academy

[61] Mary Logan, "The New Art Criticism," *Atlantic Monthly*, 76 (August, 1895), 270.

[62] Will H. Low, "A Letter to the Same Young Gentleman," *Scribner's Monthly*, 4 (August, 1888), 381. See also M. G. van Rensselaer, *Six Portraits*, 1; Theodore Child, *The Desire of Beauty*, 28–33; Birge Harrison, "Subjects for the Painter in American Landscape," *Scribner's Magazine*, 52 (December, 1912), 767; Willard H. Wright, "Notes on Art," *Forum*, 55 (June, 1916), 699–700; John C. Van Dyke, *Art For Art's Sake*, 9–10. The implications of this theme are explored in Ernst Kris, *Psychoanalytic Explorations in Art*, 64–84.

of Design after 1875 and at the Centennial Exposition in 1876. His painting made a strong impression in the famous Society of American Artists show of 1878, which emphasized the work of young foreign-trained people. Returning to New York in 1878, he established a style of living and painting that typified many changes in the art world and influenced a generation of artists and art lovers.

His studio and the life that flowed through it symbolized the desire for vitality and variety that animated the whole generation. Well into the 1890's, Chase ran a salon as well as workshop in his studio, where famous lights of the musical and performing arts mingled with painters and patrons. Connoisseurs visited the studio to buy or commission works, and often became subjects for the artist while they waited. The rooms were filled with things gathered on Chase's many travels. Persian carpets covered the floor, and tapestries and hangings interspersed with modern works, decorated the walls. Standing armor, ancient altars, brasswork vied with exotic plants and Peruvian shrunken heads for the visitor's amusement or alarm. These accoutrements were to "foster the owner's passion for color, to give him the inspiration he draws from the sense of dignity and sumptuousness in his surroundings—surroundings such as the old masters loved so much . . . ." [63] Chase meant the artist's role to be special, with clear ties to the masters who might give both inspiration and legitimacy.

Chase's person also emphasized many art ideals. "A Beau Brummel with the vitality of ten men . . . ," as a student put it, he became the picture of grace and charm.[64] He loved attention but also shrewdly advertised the appeals of elegance in art. "They say I am conceited," he remarked. "I don't deny it. I believe in myself, I do and I must."[65] He also

[63] See Elizabeth Bisland, "The Studios of New York," *Cosmopolitan*, 7 (May, 1889), 4–22; New York *Times*, March 25, 1882; Gifford Beal, "Chase—The Teacher," *Scribner's Magazine*, 61 (February, 1917), 255–56; Candace Wheeler, *Yesterdays in a Busy Life*, 243–44; Mary French, *Memoirs of a Sculptor's Wife*, 161.

[64] J. Walker McSpadden, *Famous Painters of America*, 344.

[65] John C. Van Dyke, *American Painting*, 118.

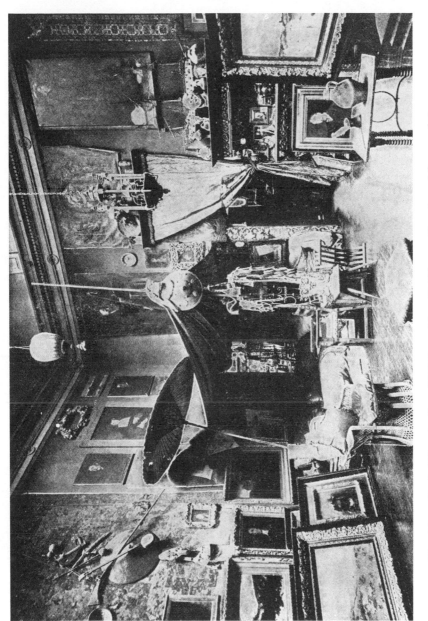

The New York City studio of William Merritt Chase. *Courtesy Library of Congress*

believed in the exciting new art his career typified, and wished to intensify the artist's image and status. Impatient with the studied bohemianism that often covered a lack of talent, Chase painted in a white suit or Prince Albert to show that good work reflected a composed and elegant personality. As a student recalled: "His dress was a part of his art psychology. As students it made us respect him the more and, in turn, respect ourselves."[66]

Amid busy rounds of teaching, traveling, and socializing, Chase kept the ambition to create and encouraged others to express themselves through a truly dynamic art. His role reverberated through the world of both painters and patrons. "Chase's role in society was of tremendous value to American art," the painter Guy Péne du Bois recalled. "He was filled with the importance of the artist and could defend him with clipped, witty, biting sentences, could even make him acceptable to men convinced that art was an effeminate pastime, the last resort of incompetents. Some may even have shivered a little, seeing him approach."[67] Chase thought a wealthy clientele important to art, and could mix a shrewd appeal to the American love of success with a charming naiveté: "Look at me. Beginning as a shoe clerk trying on ladies' shoes, I have come to be the guest of kings."[68]

Chase was as famous for teaching as for painting. Whether at the Art Students' League, his studio, or at one of his popular summer workshops at Shinnecock Hills, Long Island, or Carmel-by-the-Sea, California, he spread a gospel of beauty through art. Urging students to avoid the academic way of both painting and seeing, he emphasized the need for experiment, gesture, and the unusual so vital to any changing art. "Don't be too conscientious about your work," he warned fledglings. "Play with it more; be more artistic and free."[69] His quickness of touch became a

---

[66] Beal, "Chase—The Teacher," *Scribner's Magazine*, 61 (February, 1917), 255–56.

[67] Guy Péne du Bois, *Artists Say the Silliest Things*, 85.

[68] Kent, *It's Me O Lord*, 77.

[69] Lillian Baynes, "Summer School at Shinnecock," *Art Amateur*, 31 (October, 1894), 91–92.

byword. "Papa, come quickly!" his daughter once called out, "here's a cloud posing for you."[70] Chase's students and admirers saw him as a wizard, emphasizing motion, color, and delight while searching for artistic truths to enliven ordinary life.

Though he disliked theories and 'isms,' Chase codified his general approach as both a painter and connoisseur. A picture's first need was truth, "the impression of a thing well seen." Interesting treatment, "the interest of the artist, and an interest which shall express itself in his manner of treatment," then gave a subject both individualism and importance. The last category of excellence was quality, "a perfect balance of all the parts [which] may be manifested in colour or line or composition."[71] Chase believed that these qualities of both performance and perception developed as much from seeing art as from study. A familiar figure in Europe's museums, he taught a generation of students and painters to learn discrimination simply through looking at art.

Even while becoming a celebrity, Chase had critics who thought he emphasized the painterly mode at the expense of ideas. By the end of the century his rich brushwork and sumptuous color often seemed somehow unsatisfying, however lovely. But as "the pioneer advocate of the beauty of the painted canvas" in America, Chase summarized the basic aims and needs of the new art world of his youth and middle years.[72] His pictures, like the life he represented, commanded an eclectic audience at a moment in American art history when transition toward the new and exciting was fortunate for him. As a shrewd critic, Clarence Cook, noted in 1878, at the beginning of Chase's fame: "The pictures by Chase have the good fortune to please alike a larger part of the general public and the artists themselves. The public

---

[70] Lorinda M. Bryant, *American Pictures and Their Painters*, 117.

[71] *Ibid.*, 118–19.

[72] Ernest Knauff, "An American Painter—William M. Chase," *Studio*, 21 (December, 1900), 158. See also Katharine M. Roof, *The Life and Art of William Merritt Chase*, 183; Wheeler, *Yesterdays*, 247; Kenyon Cox, *Concerning Painting*, 181; John Sloan, *The Gist of Art*, 109–10.

cares for the subject, the artists care for the treatment, the color, the drawing and handling: . . . ."[73]

A vital and expanding world of art was well established by the time Chase and the tendencies he represented became prominent. That world was obviously rooted in the past and would change in time, but a sudden sense of newness made it seem unusually exciting. Communities expected art to be part of their lives. Facilities for art developed everywhere along with intensified discussion in the daily press and specialized journals. An increasing number of the older generation accepted art as a career for their children. Often as not, as in Chase's case, sympathizers underwrote a young artist's training. "Respectable fathers who had respectable grandfathers now allow their sons to adopt the profession of art even before they have made failures at several other professions or trades," an observer noted dryly in the 1880's, "and supply them, where they can, with paid masters, and send them abroad, with liberal allowances, patiently waiting, year after year for their talent to develop by the long routine of study, not setting them down as failures if their wonderful genius does not blaze out immediately."[74]

In addition to expanding facilities, the 1870's saw a steady increase in the audience for art. The "sea of upturned faces" in the art galleries of the Centennial Exposition seemed to symbolize a new general interest in art and culture.[75] Within the art community, each new season after the mid-

[73] New York *Tribune*, March 16, 1878. For two other contemporary assessments, see Mariana G. van Rensselaer's remarks in Walter Montgomery (ed.), *American Art and American Art Collections*, I, 229; and "Sketches and Studies," *Art Journal*, 6 (1880), 106.

[74] Henry Bacon, *A Parisian Year*, 53–54.

[75] Quoted in Allen Thorndike Rice, "The Progress of Painting in America," *North American Review*, 124 (May, 1877), 451. See also Charles W. Elliott, "Art Applied to Life, Seen at the Centennial," *Galaxy*, 22 (October, 1876), 489–98; Philip Quilibet, "Growth of American Taste for Art," *Galaxy*, 23 (February, 1877), 268; Charles H. Caffin, "Some American Figure Painters," *Critic*, 44 (March, 1904), 223–24.

seventies offered a widening array of the world's painting, better standards of criticism, and broader appreciation.[76] The feeling of change and growth focused on the exciting new canvases which young people trained abroad had painted. These were exhibited at the National Academy in 1877 and at the Society of American Artists exhibition of 1878. "The more one studies the pictures of the present [National Academy] exhibition, the more one is convinced of fresh life in the art world," the New York *Times* reported.[77] In the lively debates that followed, most of America's inherited art seemed suddenly old-fashioned, appropriate to an earlier stage of the country's history, but certainly not "modern" like the dynamic canvases from the Munich students. On a general level, a sense of open-ended progress came to the arts.[78] In more personal ways, individual painters took fresh heart, alive to the chance of developing their talents and living an interesting life among other painters, while they were earning a living.[79]

The most challenging aspect of this new art sense was its intellectual scope. It would broaden and deepen individual experience yet try to add a dimension to the national life for everyone. It reflected curiosity about the world at large. And amid the rush of technological change, it offered aesthetic

---

[76] See "The Art Season of 1878–1879," *Scribner's Monthly*, 18 (June, 1879), 310–13. There were even charges that the art interest was too fashionable and not deeply rooted: "A Broad View of Art," *Century Magazine*, 31 (January, 1886), 474–75; and William A. Coffin, "Twenty-five Years of American Art," *Scribner's Magazine*, 32 (July, 1902), 125–28.

[77] New York *Times*, April 15, 1877.

[78] On the new painters and the first impact of their work, see three articles by the critic Earl Shinn: "Fine Arts: Fiftieth Exhibition of the Academy of Design, II," *Nation*, 20 (April 22, 1875), 281–82; "Notes," *Nation*, 24 (April 5, 1877), 207, and 24 (June 14, 1877), 352. See also "The Academy Exhibition," *Appleton's Art Journal*, 3 (1877), 157; "The National Academy Exhibition," *Scribner's Monthly*, 14 (June, 1877), 263; S. G. W. Benjamin, "Present Tendencies of American Art," *Harper's Monthly*, 58 (March, 1879), 496.

[79] Wyatt Eaton to J. Alden Weir, June 5, 1877, in *Life and Letters of J. Alden Weir*, 127–28; *Art Amateur*, 2 (December, 1879), 68.

comforts and a sense of attachment to the stabilities of the past.

An internal dynamic and set of directions were equally clear in the special art world that grew with industrial America. They changed and varied over time but dominated the general thrust of American art for the foreseeable future. The definition as well as production of art passed rapidly into the hands of artists instead of amateurs. Artists and their sympathizers established a definable milieu in which the art experience reigned and could be expanded or intensified. Whatever the residual power of inherited art ideals, a new kind of art quickly dominated the scene and resembled changes in other aspects of national life. It frankly emphasized sensual appreciation through color and light. It widened the scope of subject matter to include aspects of daily life and then abstraction. And it emphasized the individual artist's vision and methods, lessening the appeal of academies and unquestioned traditions. In general, it emphasized motion, change, and variety.

These were dominant trends, of course. No one idea or style covered the always uneven and shifting pattern of American cultural life. The growing concern for art was a widening stream of consciousness with many tributaries. One bore an inherited desire for the comforts of realism— both of subject and emotional intent—safe, predictable, derived from average experience. Another carried a demand for a decorative art chiefly to enliven and enrich daily life. But the most impressive new trends, already gathering strength as "modernism," were related to intellectual excitement, the challenge of things unseen but felt beyond observable reality. These were agents of the new muses in American culture.

# 2. Ideals and Conflicts

Lively discussions of the role of art in American culture accompanied the development of a model art world. Enriching the individual's life was all very well, but cultural spokesmen saw broader purposes in the new emphasis on the arts which was so obviously affecting the life of every nation. They especially hoped to broaden the appeal of art as it became identified with an expanded life-style, modernization, and national eminence.

The American penchant for self-criticism that so often surprised foreigners carried over into the arts. An expanding newspaper and periodical press offered outlets in reviews and columns to a growing number of professional critics. The cub reporter sent out in haste to look at the landscapes on show rapidly yielded to the informed critic. The new critics were often grimly determined in the 1860's to improve American art through technical analysis, however painful for the painter. They also meant to explain painting's larger implications to a growing audience of educated and interested people. The critical wars testified to the importance of art in American life.

These new critics influenced numerous readers who in turn commanded respect and molded opinion in their communities and professions. The views of a man like Clarence Cook of the New York *Tribune* carried out into society. A few men such as Royal Cortissoz of the same paper, James Gibbons Huneker, and the painter-critic Kenyon Cox ultimately became cultural institutions.

The new critics were determined to encourage the best painters, enlarge their audience, and develop canons of taste to sustain art into the future. Though few in number, they were highly conscious of a cultural mission, and meant to keep art in the forefront of American life.[1] Like the painters whose works they criticized, of course, they had multiple ambitions. They wished to equal the prestige and influence of counterparts in literary criticism, a better-established discipline. They realized that American art in the 1860's was old-fashioned, bound to change on the rising wave of new styles and intentions which they meant to ride to authority. They were also defensive, as educated people, about the Old World's cultural superiority. And they were eager to make art an important aspect of the national power they saw coming to the new industrial America.[2]

Many early nineteenth-century critics had encouraged artists with praise, often allowing the painter's good intentions to obscure the poor quality of his work. Postwar critics reacted against this tendency with the weapons of technical analysis and a firm sense of professional responsibility. They meant to become as important in the cultural process as the works they analyzed. This required evidence of authority and expertise.

The times supported demands for added depth in art criticism. The art of the past acquired fresh meanings under new analytical skills developed among scholars. Contemporary painting seemed unusually complex and varied, laden with subtle and ambivalent meanings susceptible to

[1] For background on the prewar period, see Neil Harris, *The Artist in American Society: The Formative Years, 1790–1860*; and Lillian B. Miller, *Patrons and Patriotism: The Encouragement of the Fine Arts in the United States 1790–1860*. John P. Simoni, "Art Critics and Criticism in Nineteenth Century America," Ph.D. dissertation, Ohio State University, 1952), is rather narrowly focused but contains valuable information.

[2] See "Another Look at Foreign Pictures in New York," *Nation*, 2 (January 11, 1866), 55–56; C. P. Cranch, "Art Criticism Reviewed," *Galaxy*, 4 (May, 1867), 81; "French and English Art-Writers," *Atlantic Monthly*, 24 (July, 1869), 119; and the influential English critic's prescriptions in Philip Gilbert Hamerton, *Thoughts About Art*, 151–65.

critical definition. There was also a need to explain fresh ways of painting, as the realistic manner familiar to most Americans yielded rapidly to broader painterly styles. The eye and mind both required the critic's guidance. Amid all the din of comment, the best critics sought to analyze truthfully without rancor, but with it if necessary to make a larger point. They hoped to be informed, sympathetic to the painter's dilemmas and limitations, reasonably neutral, but never without the passion that underscored art's importance.[3]

More than any other sphere of life, art tended to be chaotic. It was composed of people claiming to be the next wave or those claiming to be the final wave. In a search for balanced coverage the most influential critics after the 1860's emphasized three general aspects of painting. They first examined the individual qualities of the painter's intentions. Comparisons with predecessors or competitors were valid only when they clarified the individual's intentions. The critic also looked for technical ability. And while not denigrating the inherited tradition, he focused on new tendencies to clarify the ongoing development of art and to emphasize America's position in world culture. This enhanced the critic's controversial role. "The critics are almost always on the side of novelty and originality," the New York *Times* noted in 1881. "The buying and admiring public seems to have a horror of originality."[4]

Critics argued that the public's conservatism revealed a special need for written analysis of all the arts. "Our own people are perfectly obtuse to the beauty and merit of pic-

---

[3] A succinct statement of the new criticisms' ambitions appears in Russell Sturgis, "What is Art Criticism?", *Nation*, 2 (April 19, 1866), 504–506. See also S. G. W. Benjamin, "Art-Criticism," *Art Journal*, 5 (January, 1879), 29; "Art Criticism," *Scribner's Magazine*, 18 (May, 1879), 135–136; Mary Logan, "The New Art Criticism," *Atlantic Monthly*, 76 (August, 1895), 265; and David C. Preyer, "The Critic's Cogitations," *Collector and Art Critic*, 5 (February, 1907), 135–40.

[4] New York *Times*, July 24, 1881. See also Titus Munson Coan, "Critic and Artist," *Lippincott's Magazine*, 13 (March, 1874), 355–63; "Art," *Atlantic Monthly*, 38 (December, 1876), 754–59; M. G. van Rensselaer, *Six Portraits*, 139.

tures, even of landscapes, unless they have been helped by the newspaper critic," a journal noted impatiently in 1869.[5] The American's traditional reliance on the mediating expert and written word to explain sensation increased the art critic's importance. "It seems that language is the only final and sufficient means of expression, common and accessible to all, by which music and painting and sculpture and architecture become intelligible to us."[6]

Like the early art dealers, the new critic was an educator, developing a broad base for art understanding among an audience ready to learn but frankly ignorant of art's general cultural intentions.[7] After the first shock of the critical wars passed, and the art idea entered the national consciousness, many observers welcomed the critics into good fellowship, though with a wary eye on their sharp pens.[8]

The best critics understood and sought the role of cultural arbiter. Their opinions became part of the art process for both painter and patron. A desire for reasonable caution accompanied the critics' rising importance through the century. "Criticism is therefore no longer dogmatic, but analytical and appreciative," a writer noted in 1892, "it seeks to understand a painter's temperament and to see his work from his own point of view; it [criticism] may have preferences, but those preferences derive their value only from the personality of the critic who expresses them."[9]

---

[5] "French and English Art-Writers," *Atlantic Monthly*, 24 (July, 1869), 125.

[6] *Ibid.*, 119; and Norman Hapgood, "American Art Criticism," *Bookman*, 6 (September, 1897), 47.

[7] Sturgis, "What is Art Criticism?", *Nation*, 2 (April 19, 1866), 505.

[8] "Editor's Table," *Appleton's Journal*, 10 (November 15, 1873), 634; "A Broad View of Art," *Century Magazine*, 31 (January, 1886), 475.

[9] Theodore Child, *Art and Criticism*, 80. See also M. G. van Rensselaer, "Some Aspects of Contemporary Art," *Lippincott's Magazine*, 22 (December, 1878), 711; "Picture Criticism," *Art Amateur*, 13 (August, 1885), 46; "Art Criticism," *Californian*, 1 (June, 1880), 572–73; "Art Criticism," *Scribner's Monthly*, 18 (May, 1879), 135; Carleton Noyes, *The Gate of Appreciation*, 138–39.

Artists in the thick of controversy and eager for approval naturally took a less sunny view of the critical establishment. Peter Moran summed up the attitude of many with a painting of jackasses amid canvases, titled *The Critics* (1873). The critic as pedant, bore, or frustrated painter was the companion image so popular with caricaturists of the artist as dilettante or misfit. Until about the late 1860's most criticism was occasional or at least haphazard in the daily press, whose reporters became targets of bitter abuse from offended artists. The average newsman sent out to an art show for "filler" was usually more interested in personalities than painting. Specialized art journals and the genteel monthlies dominated art discussion by the late seventies, but many people saw the press as a major force in shaping the new art constituency. In 1912 the eminent critic-historian Frank J. Mather, Jr., in recalling his younger years, missed the combat. "I regret a little that I am out of journalism. It is the 'fighting line' after all." [10]

Most artists tried, or pretended to ignore criticism, but an occasional fray broke out in the newspapers and magazines. A letter to the editor of an offending organ was a favorite device for venting spleen. Some artists denied the critic's right to speak for anyone but himself, tacitly hoping that no one else had heard him in any event. " . . . the true artist would sooner trust to the verdict of the uncultivated masses of the people than to a jury of litterateurs," a friend of William Morris Hunt's remarked loftily. [11] Hunt, as usual, was more acerbic. "If the birds should read the newspapers they would all take to changing their notes, the parrots would exchange with the nightingales, and what a farce it would be!" A devotee of the emotional response in art appreciation, Hunt also denigrated the experts who used

[10] Frank J. Mather, Jr., to Kenyon Cox, January 16, 1912, Cox papers, AALCU.

[11] Helen M. Knowlton, "Fine Arts," *Old and New*, 10 (October, 1874), 525.

scientific methods to understand painting: "It dissolves diamonds, and obtains—gas!" [12]

Clarence Cook of the New York *Tribune* won a reputation for sharp criticism in the 1860's and 1870's. A fellow writer at the *Tribune* once remarked impatiently: "Cook, are you through with that desk? If you are, scrape off the blood and feathers and let me come." [13] Cook's tart admonitions to offended painters revealed some of the dilemmas in reviewing. As he said of one challenge, "It was plain that if they put their pictures in a public place and asked people to look at them, there could be no law either written or unwritten, forbidding the public to look and speak its mind." The artist who questioned his motives got as good as he gave: " . . . there are many artists who can be as persistent, as pushing, and as brazen in their efforts to secure [the critic's] praises as the keeper of a Chatam Street clothing store could be in the pursuit of a customer." [14] And the quantity and range of criticism complemented the amazing growth of art interest. "The tone of criticism, as we said, is severe," a journal admitted in 1880. "What else could it be when such a mass of art, claiming to be of the highest rank, is filling our galleries?" [15] There was always a last word to this familiar human dilemma: " . . . it is pretty certain that artists will never acknowledge the competency of critics except when the critics praise them. . . ." [16]

A few painters wrote criticism, but most observers held that artists did not usually explain their work well. [17] Critics

[12] William Morris Hunt, *Talks on Art*, 6; "Table-Talk," *Appleton's Journal*, 5 (January 14, 1871), 54; John Moran, "Artists' Life in New York," *Art Journal*, 6 (1880), 122–23; Bruce St. John (ed.), *John Sloan's New York Scene*, 114, entry of March 21, 1907.

[13] Joseph B. Bishop, *Notes and Anecdotes of Many Years*, 8–9.

[14] Clarence Cook, "The Cry From the Studios," *Galaxy*, 3 (February 15, 1867), 436–38.

[15] "The Art Season," *Scribner's Monthly*, 20 (June, 1880), 313.

[16] "Art," *Atlantic Monthly*, 34 (October, 1874), 508–509.

[17] Frank Fowler, "Art Criticism From the Standpoint of the Painter," *Scribner's Magazine*, 37 (January, 1905), 125–28; Frank J. Mather, Jr., "The Artist as Critic," *Nation*, 85 (November 28, 1907), 487–88.

were necessary, however inconvenient, in the increasingly complex art world. Other sympathizers noted that the public's memory was short-lived, and that reviews were at least free advertising. They also created public interest and helped develop a present and future clientele.[18] Henry James amplified the theme:

When critics attack a bad picture which the public shows signs of liking, then they are voted an insufferable nuisance; but their good offices are very welcome, when they serve to help the public to the appreciation of a good picture which it is too stupid to understand. It is certain that painters need to be interpreted and expounded, and that as a general thing they are themselves incompetent to the task.[19]

And during a fierce debate over modernism in 1910, Frank J. Mather reminded everyone that good art outlasted bad criticism, as the career of James McNeill Whistler amply demonstrated.[20]

Critics like artists became ever more specialized in the twentieth century, oriented toward elites rather than a mass audience, with a special language that few outside the charmed circle comprehended. The Gilded Age critic had pretensions, but his ambition to influence society and to promote good art was a saving grace. The best of these critics had a breadth and humanism lacking in later counterparts. They started in a world passing rapidly from order to change, flooded with the new sensations of an open-ended artistic process that required intelligent analysis. Their gropings and occasional shrillness matched that confidence tinged with uncertainty so characteristic of the era. Some merely continued to describe art; others praised favorites; still others took no stands. But the emerging majority felt too deeply about culture to draw back. They were

[18] "Minor Topics," *Nation*, 2 (March 22, 1866), 357.
[19] Henry James, *The Painter's Eye*, 36.
[20] Frank J. Mather, Jr., "Authority in Art Criticism," *Scribner's Magazine*, 48 (December, 1910), 767.

determined to encourage good painting and urged the interested observer to extend his experience through risking knowledge of the new arts.[21]

A wide range of assumptions about the role and importance of art in the new nation governed the critical debates. Many were inherited from the prewar period, and had more ancient roots. But the role of art seemed to be a new question to most of the postwar generation, who entered into the subject without much knowledge of precedent. This apparent suddenness of interest enhanced the subject's importance and sharpened debate over culture's role in the lives of both individuals and the nation.

Art appreciation obviously offered a way of softening the materialism which engulfed new classes of people and sections of the country. "Art is needed to embellish life," the New York *Times* warned in 1875, "and now that wealth is accumulating in masses, this great civilizing agent should assert its power, so as to prevent opulence from falling into extravagant display or vulgar ostentation, far removed from true dignity, and by bad example [be] a corruptor of public morality." Concern for nonmaterial culture would also temper man's dual inclinations toward domination of others and sensuous self-indulgence. "We shall have less brutality, cruelty and vulgarity when people are brought up to a standard of life that is not wholly sordid and sensuous," the same paper noted.[22]

Many cultural spokesmen also understood the pleasure inherent in the new art's appeal, and some worried over the dangers of releasing those feelings into the expanding art constituency. They quickly sought to ally art's appeals to the spirit rather than the "baser passions" it might stir in the

[21] Royal Cortissoz, *Art and Common Sense*, 6; Kenyon Cox, *Artist and Public*, 78–79; Guy Pène du Bois, *Artists Say the Silliest Things*, 163–64. Mather may have had the last word: "To read contemporary criticism after fifty years is usually to thank God that we are not as other critics were." Frank J. Mather, Jr., *Estimates in Art II*, 294.

[22] New York *Times*, February 21, 1875.

uninitiated. Art as a moralizer was an old theme, and explained the running debate over studying nude models and displaying nude figure paintings. More than prudery was involved, though it had a role. "The aspiration of noble art is to give us the charm, the sweetness of beauty without its temptations," a genteel commentator summarized the moralist's position in 1876.[23]

And in the broadest sense, art became identified with an image of "civilization" that was especially attractive to a rich, expansive, but uncertain generation. Emphasis on art and culture in general seemed part of a higher stage of development in every nation's history. The United States's turn had come, and failure to embrace culture might arrest her general progress. Material success was never enough to assuage doubts about the nation's intrinsic goodness and destiny. "Something spiritual must enter our everyday life or we are savages," a public official noted in 1897.[24]

Art as a unifying force seemed especially necessary to the United States. The country's great diversity of people, geography, and stages of development worked against cohesion. Culture might thus unify where politics or economics had divided people. The nature of art appreciation in an essentially egalitarian society divided cultural leaders throughout the period. Many insisted that a democracy especially needed and could incorporate the best of art and culture in general. These spokesmen were confident of the American's ability to profit from and control art emotion, and saw this

[23] Titus Munson Coan, "People and Pictures at the Fair," *Galaxy*, 22 (December, 1876), 764; H. W. French, *Art and Artists in Connecticut*, 3–4.

[24] Carroll D. Wright, "The Practical Value of Art," *Munsey's Magazine*, 17 (July, 1897), 562–68. Wright was the commissioner of labor, arguing here specifically against a tariff on imported art works, holding that art benefited the entire community and should not be taxed. See also "The Struggle for Wealth," *Scribner's Monthly*, 8 (August, 1874), 495–96; Mary E. Nealy, "The Real and Ideal in Art," *Appleton's Art Journal*, 2 (1876), 287; "The Study of Art," *Chautauquan*, 3 (April, 1883), 416; Walter Crane, "Modern Life and the Artistic Sense," *Cosmopolitan*, 13 (June, 1892), 152–56; Child, *The Desire of Beauty*, 85–86; Robert Henri, *The Art Spirit*, 86.

democratizing process as one aspect of America's liberal stance in the world. " . . . this is the only new country that has at all successfully vied with art in Europe," one noted in 1877.[25] Another continued the theme in 1898: " . . . art is the answer to a need felt in the popular heart. The people create; they furnish life for art's impulse, freedom for its atmosphere, patronage for its support. From them alone can come the impulse that shall hasten the production of a genuine democratic art."[26] The refusal to reserve art appreciation to an elite persisted into the new century:

We know today that the vision of beauty belongs to all mankind, and not to any clique or coterie, priestcraft or royalty. The poorest among us has the same right to enjoyment as the richest; character alone, not rank, determines the right to enjoy. The clearest and most ecstatic vision belongs inevitably to the pure in heart.[27]

This belief in a broadly based art public dominated the 1870's and 1880's but weakened with the advent of the "modernistic" trends of the new century. As new art became complex and unusual, the chances of expanding its audience indefinitely lessened. And the critical confusion and bitterness surrounding "modernism" bewildered many patrons. While broad-based appreciation of traditional styles of art continued, successive waves of innovative art quickly became the province of those with specialized taste or knowledge.[28]

The insistence that art appreciation as well as art production was an individual matter paralleled the desire to elevate

[25] Allen Thorndike Rice, "The Progress of Painting in America," *North American Review*, 124 (May, 1877), 462–64.

[26] Oscar Lovell Triggs, "Democratic Art," *Forum*, 26 (September, 1898), 66–79.

[27] William Ordway Partridge, "The Demands of Art in This New Republic," *Arena*, 30 (September, 1903), 225–30. See also Noyes, *Gate of Appreciation*, 19, saying: "Everyman may be an artist in his degree; and every man in his degree can appreciate art."

[28] About 1913, a jaundiced Royal Cortissoz noted: "While the catholic appreciation of art is partly a matter of experience and education, it is also

democratic culture. It reflected the belief that some exalted sensations required unusual sensitivity. These basic truths were not accessible to every man; art's chief function was to edify those special people whose insights might become an example to others of like mind. The artist's basic aesthetic purpose was thus to link the appreciative viewer to the unique vision in his work, not to change the world. This was an elitism of intelligence, not of rank or money.

The prospect of intense emotional response to art also appealed to people dissatisfied with their lives, or with their complex society. It could fill a vacuum that material success did not affect and stabilize personalities with few attachments to the world. Art thus was not a mere refuge or place of withdrawal, but a dynamic creative process of unifying conflicts within the individual. The "pining of poetic minds for a simpler and more serene existence" amid the abrasions of industrial-urban life was clear to one commentator in 1867.[29] The unhappy personality might thus declare independence and make a separate or at least manageable world from art appreciation. "The cultured soul is necessarily egotistic," a critic said frankly in 1892 in urging this kind of individualism:

Its credo is the indefinite perfectability of the ego; its aim is happiness, the pursuit of which is itself happiness, inasmuch as the means in this case are more precious than the end. Convinced that things have only the importance which we deign to attribute to them, the cultured soul, seeking to live harmoniously, does not allow its serenity to be at the mercy of eventualities. Self-possessed, duplex, bilateral, the cultured soul's existence is passed in seeking incessantly new motives of aesthetic activity,

---

a matter of instinct and one may possess that instinct or not, by the whim of nature, as one may possess or lack an ear for music. There are people who could not be lured by years of a patient mentor's loving kindness to comprehend even the rudiments of a fine picture." *Art and Common Sense*, 5.

[29] Moncure D. Conway, "The Great Show at Paris," *Harper's Monthly*, 35 (July, 1867), 251. He was referring to European as well as American life.

and in finding delicate pleasure in the perpetual contemplation of this activity as it is manifested in states of soul with their concomitant emotions and sensations.[30]

These parallel ambitions for art to affect both the individual and society helped inspire a major effort to make mural painting part of the American scene. Formal decorations in public buildings were uncommon in the United States except in churches. But mural painting in Europe took on fresh life at mid-century especially in France where a major renovation of Paris and the expansion of many provincial cities provided outlets for muralists. Paul Baudry's decorations for the lavish new Paris Opera became a major example of the modern form. By the end of the century, Pierre Puvis de Chavannes' combination of classical themes and a somewhat abstract manner of painting had influenced muralists everywhere.

The demand for mural paintings in public buildings grew after the 1870's. Many painters without special training produced them, indicating the strong attraction of the form. William Morris Hunt painted two murals for the Assembly Chamber in the new state capitol at Albany. John La Farge, and associates, decorated the new Trinity Church in Boston and numerous other churches in New York City. The World's Columbian Exposition of 1893, however, sparked a boom in mural painting. The artists and architects who planned the Fair commissioned decorations for almost every likely space. An eclectic range of treatment resulted from such diverse painters as Mary Cassatt and J. Alden Weir, as well as trained muralists.[31]

---

[30] Child, *Desire of Beauty*, 14–15. See also the interesting paragraph in Tuckerman, *Book of the Artists*, 25, which sees art appreciation as relief from the tensions of urban life as early as 1867.

[31] Mural painting, which produced a surprisingly large literature, deserves extended treatment. For present purposes, however, the following works are important: Pauline King, *American Mural Painting*; Edwin Howland Blashfield, *Mural Painting in America*; Royal Cortissoz, "Mural Decoration in America," *Century Magazine*, 51 (November, 1895), 110–21; Russell Sturgis, "Mural Painting in American Cities," *Scribner's Monthly*,

In the following decades, the federal government included mural decorations in new public buildings, especially the Library of Congress, completed in 1897. Many local structures, such as the Boston Public Library, contained murals. The numerous new state capitols constructed after the 1890's also presented complex decorations worthy of an expansive era.

The demand for decoration carried over into private sectors. Bankers felt almost obliged to make their money temples display cases for murals. New hotels, clubs, and university buildings also became settings for them. Wealthy clients commissioned decorations for homes and apartments. The rage for decoration extended to screens, pianos, and furniture as well as wall and ceiling panels. By the turn of the century the prominent critic Russell Sturgis could say that "year by year, it grows more plain that mural painting is what we can do best in America."[32] Muralism became part of the broader demand for a planned "City Beautiful." On the eve of the World War, a foreign observer agreed that the drive for public art was impressive and successful.[33]

A long building boom in the cities sustained decorators, but muralism also reflected changes in artistic thought.

---

25 (January, 1899), 125–28; Ralph W. Holbrook, "An Important Quartet of Mural Paintings," *Brush and Pencil*, 11 (November, 1902), 161–77; Will H. Low, "Mural Painting—Modern Possibilities of an Ancient Art," *Brush and Pencil*, 11 (December, 1902), 161–77; Selwyn Brinton, "Modern Mural Decoration in America," *Studio*, 51 (December, 1910), 175–90. On Puvis, see Cecilia Waern, "Puvis de Chavannes in Boston," *Atlantic Monthly*, 79 (February, 1897), 251–57.

[32] Russell Sturgis, "Mural Painting," *Forum*, 37 (January, 1906), 383. On decoration in homes, see "The Cliff Dwellers of New York," *Cosmopolitan*, 15 (July, 1893), 354–62; Barr Ferree, "Artistic Domestic Architecture in America," *New England Magazine*, 12 (June, 1895), 451–66; "A Decorated Piano," *Scribner's Magazine*, 20 (October, 1896), 517–20; and Will H. Low, "The Story of a Painted Ceiling," *Scribner's Magazine*, 29 (April, 1901), 509–12.

[33] Guglielmo Ferrero, "The Riddle of America," *Atlantic Monthly*, 112 (November, 1913), 702–13.

Historical painting, of which murals seemed a part, fell from favor at mid-century because it seemed inapplicable to modern life.[34] The lofty decorative theme yielded to the intimate easel canvas suitable for the middle-class home. Realistic subject matter and an emphasis on daily life gained momentum through the century. The critical reaction against storytelling painting helped make allegorical works seem old-fashioned or suited only for religion until late in the century.[35]

But as artists gained self-confidence with the growth of art appreciation, muralism revived. Many painters, especially those trained in France and Italy amid great decorations, were ambivalent about the new scientific-industrial order's concern for mundane subject matter and individual technique. They retained a lingering need for grandeur and symbolism in art, even as they supported individualistic painterly expression.

Mural painting also promised a new level of prestige for its practitioners. It had ancient lineage, dating from cave paintings, not to mention the Egyptian, Greek, and Roman eras. Artists seeking the comforts of tradition viewed it as "the oldest, most inclusive, and the most exacting of the arts."[36] Muralists commanded a large audience. The painter who felt isolated, or who needed public acclaim, could use mural painting as a personal link to society. Will Low believed the muralist moved outside the hothouse studio and an elite patronage to affect the larger society. "The decorator, in a word, works for the world."[37]

[34] "Historical Art in the United States," *Appleton's Journal*. 1 (April 10, 1869), 45–46.

[35] Charles H. Caffin, *The Story of American Painting*, 330–31, a reprint of the 1907 edition; and Blashfield, *Mural Painting in America*, 176.

[36] Blashfield, *Mural Painting in America*, 27

[37] Will H. Low, "National Expression in American Art," *International Monthly*, 2 (March, 1901), 241. Low began as a figure painter of modest talent, and with indifferent success, and gravitated toward decoration, partly for its apparent prospects of income and status.

The muralist Will H. Low (1853–1932) in his Paris studio, at work on a ceiling panel for the Waldorf Hotel in New York City. From **McClure's Magazine**, 5 (September, 1895)

Mural painting thus enhanced the artist's status with attachments to past masters and large, exalted themes. But it also offered him some challenges with curiously modernistic overtones, despite the traditional appearance of most murals. "For it is on the lines of decoration that a high standard of drawing is maintained, a great breadth and simplicity of painting demanded, and that splendid power of deduction and synthesis called for which divests the forms of nature of all that is not inherently large and noble," a critic noted in 1895. "It is thus that the highest qualities of art are conserved and protected from the littleness which, in its more restrictive practice, too often creeps in to degrade."[38] The most effective murals thus emphasized both abstract form and abstract thought. In avoiding literalism, they seemed somewhat unexpectedly "modern." Their sense of timelessness was also future-oriented despite reliance on historical symbolism. As painting they were often beautiful, with a large, stately effect that taught the viewer to concentrate on masses rather than details.

Professional muralists insisted that their work was suitable to a modern democratic society, despite its associations with older aristocratic impulses. In part they reacted against divisive personalism in art; appreciation must go beyond "the benefit of any closed corporation, even of artists."[39] Others saw murals as a way of instructing a future audience. They would temper materialism, and bring home to the masses "the idea that the strictly necessary is not enough for the glory of a great nation. . . ."[40] The demand to decorate banks, hotels, and public buildings was also a way of making corporations and governments support art. Most critics and artists saw murals as a way to unite artist and public, and to close any divisions between individual and mass

[38] Frank Fowler, "The Outlook for Decorative Art in America," *Forum*, 18 (February, 1895), 690.

[39] Blashfield, *Mural Painting in America*, 3.

[40] Cleveland Moffett, "Will H. Low and His Work," *McClure's Magazine*, 5 (September, 1895), 307–308.

response to art.[41] Muralism's ultimate goal of expanding the art audience remained as large as its artistic designs.

Mural painting always had an air of certified taste, but this ironically was part of its multiple ambitions. The artist's desire to fuse modern life with classical symbols was an effort to accept materialistic democracy. Contemporary men and events seemed small beside art's professed eternal purposes. Allegory drawn from history thus became the only unifying theme for all men at all times. The mixture of antique and modern symbols, the goddess seated upon a huge cog to symbolize Industry, was simply an effort to unify past and present experience, and to invest modern life with dignified lineage. The use of classical figures to typify Democracy, Progress, or Wealth, reflected a need to legitimize and humanize abstract forces that often seemed threatening or at least uncertain in direction. Whatever its protests to the contrary, America needed the sense of stable growth that came with attachments to the past and to world culture.

In more personal ways, muralists wanted to unify the disparate arts that went into architecture. The perfectly decorated building was thus an example of harmonious interaction among painting, space, and structure. Monumental art expressed a desire for mystery and generalized emotion in an age devoted to the specific fact and tangible achievement. Numerous artists and architects believed classical models applicable to the American experience. The abiding qualities of law, justice, and knowledge were thus symbolized in buildings or figures drawn from Greek or Roman precedents. And many artists also hungered after the ideals which these forms represented: order, repose, and a sense of past achievement and future success.

The themes and ambitions of mural painting com-

---

[41] Herbert Small, *Handbook of the New Library of Congress*, 122; and Charles H. Caffin, "Municipal Art," *Harper's Monthly*, 100 (April, 1900), 655–66; "Mural Painting—An Art for the People and a Record of the Nation's Development," *Craftsman*, 10 (April, 1906), 54–66.

plemented a larger demand to make a vital culture evidence
that the United States was a great nation. This desire was as
old as the country, but took on new momentum throughout
the industrial expansion of the late nineteenth century.
Americans sent both art and machinery to the numerous
expositions that became showcases of progress for modern
nations. By the 1870's and 1880's cultural spokesmen and
artists expected art to be a major aspect of America's national
power.[42]

The debate over America's role in world culture was often
sharp, but all parties agreed on some basic postulates.
America could not be stable unless the arts tempered mate-
rialism. She could not be influential in the world without a
culture other peoples accepted as evidence of her intrinsic
worth. Nor would a democracy seem successful unless its
people aspired to ideals beyond those of the countinghouse
and polling booth. The debate thus centered on what form
American art and culture should take, not on its necessity.
America was rich, dynamic, apparently fulfilling the prom-
ises her founders had made. Would she now lift a lamp
beside the golden door of culture as well as that of oppor-
tunity?

The fresh identification of art with national greatness was
partly defensive patriotism, covering a certain sense of in-
adequacy. But it also reflected the sense of special provi-
dence that always informed American life. "As the heirs of
all the ages we had a right to expect that our intellectual
activity should demand art expression . . . ," S. G. W. Ben-
jamin noted in 1880, in calling for some kind of special
American emphases in the arts.[43] By the 1890's, other

---

[42] New York *Times*, November 22, 1875; Edwin Austin Abbey to
Charles Parsons, February 17, 1880, in E. V. Lucas, *Edwin Austin Abbey*, I,
99–100.

[43] S. G. W. Benjamin, *Art in America*, 13. See also William Ordway
Partridge, "A National Art Exhibition," *American Review of Reviews*, 22
(August, 1900), 198–201. Cf. Russell Sturgis, "American Painters: The
National Academy Exhibition," *Galaxy*, 4 (June, 1867), 226–27; and Wal-
lace Heckman, "What is the Use of Art?", *Brush and Pencil*, 4 (July, 1899),
191–96.

spokesmen added a popular racial explanation. They believed that each "race," so often confused with an ethnic or national group, produced distinctive art. As an amalgamation of all "races," the United States had a dual artistic mission: to be cosmopolitan without abandoning the intellectual overtones uniquely "American."[44]

These national qualities seemed obvious to commentators throughout the period and explained the distinctive differences in the art of the past. Mediterranean people were thus expressive and demonstrative, the North Europeans reserved and precise, the English cozy or intimate, and the French formal and elegant. These artistic qualities supposedly expressed deeper national traits formed under the weight of geography, climate, history, and racial mixture. As a *Scribner's* critic noted in 1875: "An American, an Englishman, a Dutchman, an Italian, and a Frenchman, called upon to plant an umbrella, one after another, in the same spot, and paint the same scene, will produce pictures so different from each other, in handling and effect, as to warrant their being presented and preserved in a group upon the same wall."[45] Defining and expressing these national aspects could be as innovative as using new techniques of painting.[46]

Many observers urged fledgling artists to study abroad but return before their Americanism weakened under the onslaught of foreign taste. "Beyond a certain time for study and for the gain of the best sort of impressions, a further stay in Europe only harms an American artist," the New York *Times* warned in 1877. "He neither becomes an Italian, a

---

[44] George W. Sheldon, *American Painters*, 9; "The Future of the Metropolitan Museum," *Century Magazine*, 27 (April, 1884), 943; Herbert Croly, "American Artists and Their Public," *Architectural Record*, 10 (January, 1901), 260; Christian Brinton, "Art and Ideas," *Putnam's Monthly*, 2 (April, 1907), 123.

[45] "About an American School of Art," *Scribner's Monthly*, 10 (July, 1875), 380–81.

[46] See S. G. W. Benjamin, "The Exhibition. V. The National Academy of Design," *American Art Review*, 1 (1880), 306–307.

Frenchman, or a Belgian, nor does he remain an American. He drifts into that most hopeless class, as far as achievement go—the European-American."[47] In a time of such change and innovation, people needed the security that came with national identity in art as well as politics.

Demands to emphasize American qualities in art paralleled the attractions of cosmopolitanism. "We shall never have any great art in America unless it is done in our way and is distinctively American," the popular art writer John C. Van Dyke noted in 1894. "We shall never be accounted great because of our doing something like some other people, nor by fashioning that which is best in others into an eclectic cosmopolitanism."[48] Similar ideas reigned in Europe where national pride was even stronger in the arts, and where critics expected Americans to form another national school.[49]

Special national qualities were easier to seek than to find. No style of art was native to a country developed in segments over widely separated periods of time, with sharply differing geography and climate and a population as diverse as Europe's. Even the quality of light and the colors it produced varied markedly from west to east and north to south. The resulting range of subject matter and styles of painting was confusing, however interesting. "The bane and the blessing of our art have been in the enormous variety of influences which have controlled its action," S. G. W. Benjamin said in 1880.[50]

This varied taste and subject matter fueled eclecticism, a tendency to praise an array of diverse art and to believe in combining different styles and purposes. The trend was

[47] New York *Times*, April 8, 1877, and December 12, 1878.

[48] John C. Van Dyke, "Painting at the Fair," *Century Magazine*, 48 (July, 1894), 446.

[49] See Clarence Cook's letter from an international exhibition in Munich, New York *Times*, July 23, 1883.

[50] Benjamin, *Art in America*, 41. See also "Why No American School Exists," *Art Interchange*, 2 (April 16, 1879), 60; "Art in Boston," *Art Amateur*, 13 (November, 1885), 111.

most visible in architecture, where designers long tried to disguise industrial functions with historical ornament.

Eclecticism was part of some basic American traits which foreigners had noted since the eighteenth century. It reflected the American's expansive curiosity about many things rather than a desire to focus on a few. It was inevitable in a democratic society that resisted cultural authority and hoped to raise the taste of everyone. It suited sectional needs for variety and was bound to increase as unsophisticated newcomers sought culture. "Both our desire of novelty and our impatience of discipline encourage eclecticism," an architectural review warned in 1876. "The fact that eclecticism suits with the desire for extended culture which is spreading everywhere, makes it fashionable."[51]

Eclecticism also rested on the assumption that only the best survived competition. If experimentation was progressive in economics or science, why not in art? And it appealed to the American penchant for variety and action. "Furthermore, there exists among us an incorrigible propensity to live life rather than to represent it, or to discuss it, or to speculate upon it," a critic noted in 1899.[52] These eclectic tendencies, representing basic national attitudes, blurred unifying "American" characteristics in art.

Similar emphases lay beneath the taste for realism. Realistic treatment and finished details satisfied an old American concern for hard and special labor. Its apparent simplicity also complemented the democratic ideal of art comprehensible to everyone. The realistic approach bespoke confidence in contemporary life and the desire to record it for posterity. It was an inevitable outgrowth of the era's concern for verisimilitude. But it also indicated the belief that there

[51] "Eclecticism in Architecture," *American Architect and Building News*, 1 (January 15, 1876), 18.

[52] Henry Brown Fuller, "Art in America," *Bookman*, 10 (November, 1899), 221. See also S. G. W. Benjamin, "The Exhibitions. VII. The National Academy of Design," *American Art Review*, 2 (1881), 23–24; Oliver W. Larkin, *Art and Life in America*, 262.

was something special in the American scene, which artists could condense in details.[53]

The realistic approach always continued but weakened in influence about mid-century. Its first purpose was to widen art's appeal and to train the eye. The time came to train the mind and senses to a broader kind of interpretation. And photography inevitably undermined its appeal, while new critical theories emphasized synthesis and suggestion rather than realism in painting.[54]

The desire for national qualities in American painting also affected the long-standing love of landscape work. American landscape work absorbed many new emotional and technical qualities and remained suited to national ideals.[55] An array of landscapes filled department-store windows, galleries, and museums. And urbanization increased the demand for scenes which might remind the city newcomer of the rural bliss he left behind, or promise the hardened urbanite that concrete and granite were not the world's sum total.[56] Foreign observers also noted a penchant for strong colors and expansive scope, which often overmatched an already vivid natural view, satisfying a need for drama and emotion in the average patron.[57]

[53] "Painting and a Painter," *Lippincott's Magazine*, 11 (January, 1873), 112; Charles H. Caffin, "Some American Landscape Painters," *Critic*, 45 (August, 1904), 125.

[54] "Art and Artists," *Californian*, 4 (December, 1881), 535; Dwight W. Tryon to Charles Lang Freer, April 5, 1900, Freer papers, FGA; Nancy Hale, *The Life in the Studio*, 204–205. On photography, see Alexander Black, "The New Photography," *Century Magazine*, 54 (October, 1902), 813–25; James Lawrence Breese, "The Relationship of Photography to Art," *Cosmopolitan*, 18 (December, 1894), 137–44; Charles H. Caffin, "The New Photography," *Munsey's Magazine*, 27 (August, 1902), 729–37.

[55] Philip Quilibet, "Art at the World's Fair," *Galaxy*, 21 (February, 1876), 272; New York *Times*, June 2, 1878; John C. Van Dyke, "Painting at the Fair," *Century Magazine*, 48 (July, 1894), 446; Hugo Munsterberg, *The Americans*, 480.

[56] D. Maitland Armstrong, *Day Before Yesterday*, 142–43; Lucas, *Edwin Austin Abbey*, I, 193; "The Landscape Painters and the Summer," *Scribner's Magazine*, 23 (June, 1898), 765–68; Joseph T. Keiley, "Landscape—A Reverie," *Camera Work*, 4 (October, 1903), 46.

This was not surprising, since nature and the land filled special roles in American life. In one sense, they took the place of history and "civilization" in Europe. Nature was "real" to the eye, but reminded men of life's past achievements and future momentum. It was a constant, and thus reassuring, but changed within a reasonably predictable order. It was emotionally appealing yet not decadent or sensuous. The land and its symbolism thus combined materialism and uplift, emotion and reality, grandeur and the sensibility of the average man.

Landscape painting inevitably developed formulas to sustain its popularity. Critics increasingly accused landscapists of filling the public's simplest needs with clever scenes and views, or with the opposite, grandiloquent canvases. The form was among the first to suffer accusations of being "academic." [58] But fresh painterly approaches helped keep landscape at the forefront of American art life. Mystical painters like George Inness steadily emphasized mood rather than content and invested landscape with emotions that pleased both the eye and mind. Impressionism later allowed the landscapist to be both modern in technique and traditional in subject matter, and made his pictures seem intimate and tailored for each viewer. Landscape painting steadily incorporated scenes of contemporary life, which humanized an inherited desire to depict impersonal nature and her secrets.[59] And the cityscapes that became popular at the turn of the century retained many overtones from land-

[57] Edmund Ions, *James Bryce and American Democracy, 1870–1922*, 65; Elizabeth Robins Pennell, "The Anglo-American Exposition," *Nation*, 99 (July 9, 1914), 53–54.

[58] [Earl Shinn], "Fine Arts: Fiftieth Exhibition of the Academy of Design," *Nation*, 20 (May 27, 1875), 352; S. G. W. Benjamin, "Present Tendencies of American Art," *Harper's Monthly*, 58 (March, 1879), 482; S. G. W. Benjamin, "The Tendencies of Art in America," *American Art Review*, 1 (1880), 109; Frank J. Mather, Jr., "The Present State of Art," *Nation*, 93 (December 14, 1911), 585.

[59] Charles H. Moore, "Materials for Landscape Art in America," *Atlantic Monthly*, 64 (November, 1889), 670–71.

scape technique. The variety of their subject matter, power-ful technique, and the city's very mass and tall buildings all hinted at landscape antecedents.

The search for special qualities in American art usually emphasized "meaning" rather than subject matter. The con-trasting appearance of farmhouses in Brittany or Tuscany to those in New Hampshire or the Dakotas was obvious. The effects of the sea were not the same off Britain and Maine. And the "view" in France differed markedly from that in Illinois.

The very lack of a long history seemed an advantage in defining American art, especially in an era that prized mo-tion away from fixed standards and static social rules. The American orientation toward the future allowed the artist to develop a strong personal vision. Though some Europeans thought this reinforced American naiveté, others saw it as positive. "You Americans have one advantage over all others," a French painter remarked. "You have no tra-ditions. You can look straight at nature out of your own eyes, while our vision is clouded by the inheritance of a thousand years." [60] This unfettered curiosity would sharpen the view of both reality and the symbolic meanings in art. "This accuracy of looking at things, this freshness of view, seems to be a deep and abiding quality and comes near to being the outstanding [American] characteristic," Sada-kichi Hartmann noted at the turn of the century.[61] European critics saw this phenomenon in the American portrait painter's desire to depict the character of a sitter, rather than social status or public role. John Singer Sargent typified a general American tendency toward "unusual directness and clarity of vision, coupled with a corresponding simplicity of statement." [62]

The earnestness which often accompanied this angle of vision first seemed evidence of insecurity to Europeans. But

[60] Birge Harrison, *Landscape Painting*, 241. The painter is not named.
[61] Sadakichi Hartmann, *A History of American Art*, II, 354.
[62] Birge Harrison, "The Future of American Art," *North American Re-view*, 189 (January, 1909), 27.

they came to regard it as an effort both to be faithful to external truth and to clarify hidden meanings. It was meant to heighten rather than avoid emotion through emphasizing essentials which could be conveyed to a larger audience long after the surface aspects of a subject lapsed. Americans often complained of the European's lack of "conviction" or "sincerity," believing that surface phenomena, however well depicted, were less important than the "real truth" in a subject. Critics continually urged Americans to avoid a fashion and to make their work "unassuming and straightforward, penetrated with realism and often tempered with poetic feeling . . . . ," as Charles Caffin said of Winslow Homer.[63]

Scope of feeling as well as subject became an American hallmark. Critics commented on the "vastness and loneliness which are continually impressing the imagination of the American artist. . . ."[64] This came from the hugeness and variety of the land itself, but was also rooted in the sense of open-ended development in national ideals and expectations of life. Americans, and many Europeans, expected this tone to survive all changes of subject matter or technique. "For when the truly American artist arrives, it will be found that his Americanism will not be declared so much in his choice of subject, as in the largeness of his outlook upon Life and the grandeur of his spiritial horizon."[65]

The need for great emotion without loss of explicable reality fused in the paintings of Winslow Homer. He attained early approval and became the most "American" of painters. Critics often lamented his crude technique, especially early in his career, but praised the clear vision of individual character and the lofty emotions in his scenes of nature, particularly of the sea. They quickly perceived that Homer's approach could link American qualities and the

[63] Charles H. Caffin, *American Masters of Painting*, 72–73; New York *Times*, March 1, 1891.

[64] Conway, "The Great Show at Paris," *Harper's Monthly*, 35 (July, 1867), 258.

[65] Charles H. Caffin, *Art for Life's Sake*, 126.

scope and power of the American landscape to a larger tradition. Homer was equally adept in genre work or in showing the enveloping emotion of winter woods deep in snow or rough seas. The human and animal subjects in his paintings were usually contrasted to a basic concern for abstract natural power. His long effort to depict the individual's courage in relation to nature caused many of Homer's works to fuse with the national consciousness.[66]

By the beginning of the twentieth century, critics had established a set of characteristics that contrasted American and European art. The European artist supposedly emphasized form, elegance, composition, and restraint to develop complex and sophisticated results. The American favored individualism and spontaneity that might produce new insights, economy of means, and an emphasis on reality used to develop sharp emotion. The American was also expansive, perhaps even crude, in his search for the individual gesture that highlighted broader experience. Whatever the validity of these views, they affected much of the art community. They granted to American art a sense of special purpose within the broader framework of world art, which remained as attractive as the native scene.[67]

The postwar art community inherited a tradition of study-

[66] For a variety of contemporary comment on Homer's work, see "The Academy Exhibition," *Appleton's Art Journal*, 3 (1877), 159; "Art," *Atlantic Monthly*, 35 (April, 1875), 509; "Fine Arts: The Seventh Annual Exhibition of the Artists' Fund Society of New York," *Nation*, 3 (November 15, 1866), 395–96; Henry James, "On Some Pictures Lately Exhibited," *Galaxy*, 20 (July, 1875), 89–97; "Art Notes," *Critic*, 7 (December 19, 1885), 298; van Rensselaer, *Six Portraits*, 237–74; William A. Coffin, "A Painter of the Sea: Two Pictures by Winslow Homer," *Century*, 58 (September, 1899), 651–53; Kenyon Cox, *Concerning Painting*, 191–94. Willard Huntington Wright, "Modern American Painters and Winslow Homer," *Forum*, 54 (December, 1915), 661–72, is an early effort of a modernist to trace Homer's influence on modernism in general, especially through his use of mass, cropping, and other techniques.

[67] For further development of aspects of this subject, see John W. McCoubrey, *American Tradition in Painting*; and Betty Chmaj, "The Double Attraction: A History of the National Artistic Will, 1890–1917," Ph.D. dissertation, University of Michigan, 1961.

ing abroad while working out American destinies. Before the Civil War many painters and sculptors learned their craft and sharpened their ideals in Paris, London, and Rome. But artists were probably the first clearly defined postwar group to seek wider contacts with the world. This seemed both desirable and inevitable, given the country's development. "In the natural order of things we Americans ought to be the most cosmopolitan people in the world," a critic noted in 1891.[68] Modern communication, easy travel, and the constant interchange of thought within the art community all provided a "free trade in ideas, resulting in a kind of cosmopolitanism. . . ."[69] The painter-critic Kenyon Cox registered these changes after the fact in 1905. "Art in the past has been traditional, national, and homogeneous; art in our day has been individual, international, and chaotic." Reproductions, photographs, and the printed word "brought the ends of the earth together and placed the art of all times and countries at the disposal of every artist."[70]

That array of art had various appeals to Americans. The first national art to affect Americans in mid-century was Japanese, a mixture of the antique and modern that fascinated the art communities. The American government helped open Japan to the West in the 1850's, and many people were familiar with Japanese goods. Japanese prints were influential by the 1860's. Visitors to the Centennial Exposition in 1876 marveled over a model Japanese home, workshops, and some real Japanese, who found the Americans inscrutable. The uninitiated first thought Japanese art unsatisfying. It did not seem serious and remained "curious and amusing, rather than ennobling, inspiring . . . ," an almost predictable complaint to those looking for obvious uplifting emotion in art.[71]

Artists and critics thought otherwise and found in

[68] W. W. Crane, "Cosmopolitanism and Culture," *Lippincott's Magazine*, 47 (March, 1891), 406–407.
[69] Charles H. Caffin, *The Story of American Painting*, 121.
[70] Kenyon Cox, *Old Masters and New*, 135.
[71] New York *Times*, June 24, 1877.

Japanese art solutions to many puzzling problems of both purpose and technique. Japanese art seemed most important in expressing mystery and undefined feeling. "There is an indefinable suggestiveness about these pictures, like those mental processes which evade analysis, those memories of something one cannot recall yet feels to have been full of charm," a reviewer noted of the pictures at the Centennial Exposition.[72] The Japanese artist suppressed details in favor of larger effects and remained suggestive rather than definitive. The subtle coloration, abstraction of forms, and use of empty space also excited many artists seeking refinement without abandoning substance.[73]

Of all European nations, the art of Britain had the most obvious attractions for Americans. British painting, most familiar as a companion to literature, historically was attuned to observation rather than analysis. The illustrated anecdote, pleasant landscape, and animal picture typified British art in the popular imagination.

The new critics generally guided artists away from British models in spite of their popularity in the drawing room or schoolbook. Henry James gently praised the British artist's emphasis on feeling, provided it did not become sentimentality.[74] Other critics were more harsh. "The English picture is as devoid of all vital and spiritual significance as a watermelon, although it may be carefully drawn and well finished . . . ," one noted in 1880.[75] On the whole, the new

[72] "Characteristics of the International Fair," *Atlantic Monthly*, 38 (July, 1876), 89–90.

[73] See the comments in the Diary of Theodore Robinson, November 30, 1893, February 11, 1894, February 17, 1894, FARL; and "A History of Japanese Art," *International Monthly*, 3 (May, 1901), 590–96; Frank J. Mather, Jr., *Estimates in Art II*, 269–315; Richard Muther, *The History of Modern Painting*, III, 81–104; Walter M. Cabot, "Some Aspects of Japanese Painting," *Atlantic Monthly*, 95 (June, 1905), 804–13; Caffin, *American Masters*, 25.

[74] James, *The Painter's Eye*, 204; William Dean Howells, "A Sennight of the Centennial," *Atlantic Monthly*, 38 (July, 1876), 95; Will H. Low, *A Chronicle of Friendships*, 465.

[75] "Pictures," *Scribner's Monthly*, 21 (November, 1880), 153.

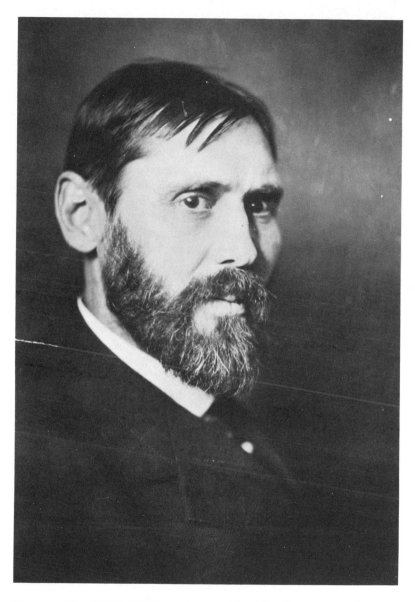

Kenyon Cox (1856–1919), painter and critic. *Courtesy Archives of American Art, Smithsonian Institution*

critics tended to see Britain as a "Nazareth of art . . . ,"
whence came little that was new, complex, or invigorat-
ing.[76] However familiar or comforting, British art seemed
tangential to the American seeking new depths of feeling or
breadth of painterly expression.

Americans applied a somewhat similar critique to the
attractive art of the Low Countries. The works of Rem-
brandt, Hals, and other masters were well known. And
Americans admired Dutch sturdiness and "character."
Dutch painting traditionally emphasized that character in
portraiture and in a wide range of still life, miniature views,
and genre. Many American students visited Dutch art gal-
leries but went on to more exciting training in Paris or
Munich. The Dutch inheritance seemed to be a solid foun-
dation but did not promise a new beginning. It was not
"modern."[77]

The art of Spain was more challenging. A Roman tradition
and the echoes of former imperial power combined with a
native vitality to give Spanish art the rare combination of
"character" and emotion so appealing to Americans. The
work of her early masters seemed to radiate a grand view
based on knowledge of men and the world, while more
recent painters like Goya revealed a moving passion in the
control of painterly ambitions. Spanish masterworks were
simultaneously realistic, symbolic, and well painted.

A new school of modern Spanish painters, such as

[76] "Point of View," *Scribner's Magazine*, 9 (February, 1891), 263. New art
came to Britain but was not generally original "modern" work as Ameri-
cans and Europeans conceived it. The work of Turner was not well known
until late in the century, and was then often considered an antecedent of
impressionism. The Pre-Raphaelites had some vogue but again seemed
peculiarly English to Americans. Like other nationalities, the British did
develop a style of impressionism and some more radical modernism,
much of which is conveniently illustrated in J. B. Priestley, *The Edwar-
dians*. Other aspects of British painting are covered in Jeremy Maas,
*Victorian Painters*, a sumptuous treatment. Roger B. Stein, *John Ruskin and
Aesthetic Thought in America 1840–1900*, is important.

[77] See Eugene Benson, "A Dutch Capital and Dutch Art," *Appleton's
Journal*, 6 (August 19, 1871), 215; *Life and Letters of J. Alden Weir*, 146; van
Rensselaer, *Six Portraits*, 181; Caffin, *Art for Life's Sake*, 42.

Mariano Fortuny and Joaquín Sorolla became popular in the late nineteenth century. But Spain's older artists were more influential and affected such diverse Americans as William Morris Hunt, John S. Sargent, and William Merritt Chase. The young Thomas Eakins delighted in the pictures he saw during a visit to Spain in 1869. "Oh, what a satisfaction it gave me to see the good Spanish work, so good, so strong, so reasonable, so free from every affectation," he wrote home.[78] Despite unsettled politics and primitive accomodations, an increasing number of tourists, students, and collectors penetrated Iberia. Many major works of Velásquez, Goya, and El Greco ultimately went to American collectors and museums.[79]

Interest in Spanish art centered on Diego Velásquez, whose reputation as an old master began a rapid ascent in the 1870's and 1880's. Younger American painters admired the masterful technique in the service of controlled emotion that infused his work. His concern for character and for the echoes of lost emotions moved many people. As early as 1874, critics praised the "noble gravity and solidity . . ." in his canvases.[80] Velásquez' example solved for many painters the problem of combining broad technique and clarified emotion. His economy of means produced a profound effect. "He had an unerring feeling for essentials, his most characteristic works being singularly sparing of detail; a cultivated instinct for the silent gesture and expression, and a rarely economical method of achieving them," the critic Charles Caffin noted in 1910 in a popular history of Spanish art.[81] Velásquez' subdued palette, emphasizing

---

[78] Quoted in Lloyd Goodrich, *Thomas Eakins: His Life and Work*, 28.

[79] Louisine W. Havemeyer, *Sixteen to Sixty: Memoirs of a Collector*, 130–79; Frederick A. Sweet, *Miss Mary Cassatt: Impressionist from Pennsylvania*, 85–90, 172–75.

[80] "Art," *Atlantic Monthly*, 34 (November, 1874), 635. This is a review of the collection of the Duc de Montpensier's Spanish pictures then on tour.

[81] Charles H. Caffin, *The Story of Spanish Painting*, 94–95. See also William Morris Hunt, *Talks on Art II*, 35; John La Farge, "Velásquez," *McClure's Magazine*, 19 (October, 1902), 513; Blashfield, *Mural Painting in America*, 190.

rose, gray, and black, produced a sumptuous effect without being garish or reducing intellectual content.[82] In combining simple means and complex ambitions, Velásquez linked old and new, seeming ultimately "more modern than all the moderns; more modern than tomorrow."[83]

The art of every nation offered some special emphases of technique or purpose useful to Americans. Traditional British painting was comfortable and familiar. Holland infused her realism with emotion and rich artistic qualities. Japanese art seemed traditional, yet modern in technique. The art of Spain set a high example of both technique and purpose. But the art of France was pre-eminent. Her painting, system of training, and much of the general cultural aspirations they represented obviously would dominate western art for the foreseeable future.

William Morris Hunt of Boston became the first great spokesman of modern French art in the United States. Through forceful teaching, blunt comments on the art scene, and his own painting, Hunt extolled the virtues of emotional response to art. His activism lent a cubit to the American artist's stature. Though his own work never quite fulfilled its apparent promise, Hunt attempted to balance many national and cosmopolitan ideals in his life and painting.[84]

Hunt believed that the Barbizon painters, whose paintings he saw and purchased in the 1860's, and the tendencies toward broad expression which they represented were the

[82] Caffin, *The Story of American Painting*, 238–42.

[83] James Gibbons Huneker, *Promenades of an Impressionist*, 110. This influential critic expanded the theme: "Today the impressionists and realists claim Velásquez as their patron saint as well as artistic progenitor. The profoundest master of harmonies and the possessor of a vision of the real world not second to Leonardo's, the place of the Spaniard in history will never be taken from him."

[84] Benjamin, *Art in America*, 194–96; "Boston Art," *Appleton's Journal*, 11 (June 13, 1874), 764–65; "Art," *Atlantic Monthly*, 36 (August, 1875), 249–52; "'Talks on Art,'" *Scribner's Monthly*, 10 (October, 1875), 787; "Art," *Atlantic Monthly*, 39 (February, 1877), 252.

light of the future. He lived to see this group of figure painters and landscapists profoundly affect the American scene. A whole generation of Americans grew up with prints of Millet's *The Angelus* and *The Sower* on the walls.

Millet's paintings satisfied the emotional needs of many people. His peasants were realistic enough to be familiar, but were clearly allegorical in intent. They symbolized man's relation to nature and to past time, but their lives had a momentum that promised a successful future. Their attitudes and activities seemed genuinely spiritual to a generation with waning religious impulses. And all the Barbizon painters satisfied urban-industrial man's nostalgic longings for the apparent order and simplicity of rural life. The pictures were also broadly painted, with ample room for both the gesture and emotion that united artist and connoisseur.[85]

The Barbizon painters presaged a gathering swell of French prestige. By the 1870's critics admitted "the overmastering French influence . . ." in contemporary art.[86] The French soon dominated painting, sculpture, architecture, and general decoration, with a range of individual styles within each form. And France had no equals in joining disparate talents into a compelling art life that seemed to flavor her entire national existence. This scope and diversity, and the intensity of French concern for the arts and the life of the mind, were the basic attractions of the French

[85] On the Barbizon influence, see Eugene Benson, "The Peasant-Painter—Jean Francois Millet," *Appleton's Journal*, 8 (October 12, 1872), 404–405; Russell Sturgis, "The Paris Exposition X. French Painting. II," *Nation*, 27 (October 10, 1878), 224; Walter Cranston Larned, "Millet and Recent Criticism," *Scribner's Monthly*, 8 (August, 1890), 390–92; Jenkin Lloyd Jones, "Jean François Millet," *New England Magazine*, 1 (December, 1889), 367–71; Kenyon Cox, "The Art of Millet," *Scribner's Magazine*, 43 (March, 1908), 328–40; John La Farge, "The Barbizon School," *McClure's Magazine*, 21 (June, 1903), 115–29, and 21 (October, 1903), 586–99.

[86] Russell Sturgis, "The Paris Exposition XV. The United States Fine Arts Exhibit," *Nation*, 27 (November 28, 1878), 332.

model. "Good pictures had been painted here and attempted there, and here and there an interesting isolated personality was revealed," Mariana G. van Rensselaer wrote in 1889, as the French government staged another immense exposition. "But a great *Art*—a collective movement marked by force, character, and accomplishment—nowhere showed itself except in the galleries of France."[87] Paris was already the mecca of modern painters, and French culture bore every hallmark of the cosmopolitanism that attracted Americans.

The desire to enjoy the manifold pleasures of world culture was as strong in the late nineteenth century as the demand for a national emphasis in art. A revolution in communications established a new consciousness of the world that older Americans could not ignore, and which younger people embraced. The ideal of a powerful national art existed alongside an equally compelling need to broaden individual and collective contacts with the culture of the world, especially Europe. Americans were often naive and ill-equipped to analyze the art of older cultures. But the scope of their ambition spoke well of their desire to learn. Whatever their limitations, they sought only the best art and taste for their country in its world context.

The cosmopolitan ideal was especially compelling to that generation of artists, since Europe seemed in the midst of astonishing cultural growth. This cut across all forms and involved both a sense of renewed tradition and modernistic experimentation. In musical composition Brahms and Wagner typified these parallel trends, but many composers also spoke for equally interesting local tastes—Dvořak, Grieg, Smetana, and a Russian school. The novel deepened its perceptions and widened its scope in the hands of major writers in every country. The drama gained new impact in nations as varied as Sweden, Germany, and Ireland. It was an era of celebrity status for numerous artists of all kinds.

[87] M. G. van Rensselaer, "Impressions of the International Exhibition of 1889," *Century Magazine*, 39 (December, 1889), 317.

Nellie Melba, Mark Twain, or James McNeill Whistler were more familiar than many kings and presidents.

The term "cosmopolitan" which so many commentators used did not mean copying European models or grafting older styles onto a native art. The term implied at its best a synthesis of timeless emotions and ideals without destroying local variations of touch and subject. The Japanese and impressionist approaches came close to this ideal and were easily assimilated into existing nationalism, because they were seen as ways of painting rather than as changes in subject matter or purpose.

American artists wanted inspiration and examples from the art of other peoples, but the cosmopolitan ideal this effort represented had other overtones. Broadness of view and catholicity of taste marked the artist as a special figure in society, adding legitimacy to his claim to have a superior vision of reality. And an art drawn from the past and present, reflecting many national cultures and aspirations, would educate and uplift a broader range of people than any parochial ideal or style.

Many of these trends and desires joined in the life of America's most celebrated painter, John Singer Sargent. Born in Florence, Italy, in 1856 of cultured parents, Sargent bore the marks of artistic genius from youth. A prodigy at drawing, he entered the École des Beaux-Arts in Paris in 1874. He also studied with Carolus-Duran, most fashionable new Parisian portraitist of the time. At any early age Sargent attained fame at the Salon, in London drawing rooms and galleries, and in the art worlds of Boston and New York.

Sargent's facility with the brush became legendary while he was still a youth. As Henry James noted, he presented "the slightly 'uncanny' spectacle of a talent which at the very threshold of its career has nothing more to learn."[88] An astonishing facility at portraiture ultimately made him rich and famous. He specialized in the *portrait d'apparat*, catch-

[88] Quoted in Larkin, *Art and Life in America*, 302–303.

ing a subject in a casual yet characteristic moment, with a tone that delineated a whole life-style and cultural setting without losing the individual. His obsession with depicting character, often at some pain to the sitter, was typically American, but a rich palette and broad brushstroke made him a "Paganini of portraiture. . . ."[89]

Sargent was equally comfortable in other forms of painting. He decorated the public library and other buildings in Boston with complex and sumptuous murals. The outdoor watercolor became almost a passion, and many examples of his work in this delicate medium became as famous as the portraits and murals.

The sources of Sargent's painting symbolized multiple ambitions. Like Chase, he was an inveterate gallery-goer, believing that seeing was the best educator of mind and eye. He admired the Italian masters and was trained in the French tradition. He knew the art of Holland and Britain, and drew much obvious inspiration from Velásquez. He knew several of the original impressionists, and toyed with a style keyed to light rather than form. But he sought a grander manner, and never became a true impressionist, however "impressionistic" some of his paintings seemed.

The desire for that grand manner kept Sargent from becoming truly "modern." Yet the effort to balance majestic, contained emotions with a rich, nervous technique marked him as a transitional figure. His desire to depict the critical moment in captured motion was very modern and bespoke the atmosphere of the time. "His art stands today as the most conspicuous example of that alert restlessness which is the dominating spirit of our day," the critic J. Nilsen Laurvik noted in 1915.[90] Sargent came to seem old-fashioned, but the emphasis on motion and essentials in his best work outlasted the surface elegance his contemporaries prized so

[89] Brinton, *Modern Artists*, 160.
[90] J. Nilsen Laurvik, in John E. D. Trask and J. Nilsen Laurvik (eds.), *Catalogue de Luxe of the Department of Fine Arts, Panama-Pacific International Exposition* . . . , I, 9.

John Singer Sargent (1856–1925) in his Paris studio.
*Courtesy Archives of American Art, Smithsonian Institution*

highly. In that respect, often without knowing it, he symptomized art's general movement toward expressing condensed emotions.

Sargent influenced a generation of painters in their craft, but his personal role was equally important to them. By the 1890's he was "that typically modern product, a citizen of the world."[91] At his death in 1925 he was clearly an elder statesman of art and culture.[92] His career in sum typified the ambitions of his generation of artists, who steered a passage between the desire for native qualities and cosmopolitan forms, for personal expression and ongoing tradition, and for elegant style that did not override truth to life.

[91] M. G. van Rensselaer, "John S. Sargent," *Century Magazine*, 43 (March, 1892), 798.

[92] For a cross-section of contemporary opinion on Sargent, see Henry James, "John S. Sargent," *Harper's Monthly*, 75 (October, 1887), 683–91; William A. Coffin, "Sargent and His Painting . . . ," *Century Magazine*, 52 (June, 1896), 163–78; Charles H. Caffin, "John S. Sargent, The Greatest Contemporary Portrait Painter," *World's Work*, 7 (November, 1903), 4099–4116; "John Sargent, Painter," *Nation*, 77 (November 26, 1903), 426–28; Christian Brinton, "Sargent and His Art," *Munsey's Magazine*, 36 (December, 1906), 266–84; Royal Cortissoz, "Sargent, The Painter of Modern Tenseness," *Scribner's Magazine*, 75 (March, 1924), 345–52; Frank J. Mather, Jr., "The Enigma of Sargent," *Saturday Review of Literature*, 3 (February 26, 1927), 605–607.

# 3. Studying Art at Home and Abroad

The individual artist naturally confronted and developed in his career the varied ambitions and attractions in the larger art life. The number of young people determined to define both their art aims and the country's general cultural aspirations increased after the Civil War. The rise of special art institutions, and especially of a defined art world, reinforced this urge.

The desire for a new level of art appreciation reflected changes in the nation's larger life. The longstanding questions of slavery and sectional power seemed settled, and the residual "southern problem" had an anachronistic air to the younger generation. Progress and modernity were equated with world developments and with an enlarged sense of possibility in individual life, now that the nation's direction was settled. Many younger people found public issues less interesting than private aspirations.

The postwar generation was also affluent, with leisure time for the arts. Despite fluctuations in industrial prosperity, long-term expansion seemed assured. This was especially true for the middle-class families who produced a good proportion of the young people interested in art. The new generation was more knowledgeable of the world and wanted to sample the culture of older civilizations. The number of young people maturing in the 1870's and 1880's was large, and more of them than ever found art attractive as a possible career or means of self-development.

American optimism enhanced the budding art student's

self-confidence. The era's desire to organize complex data for simple presentation underlay the sudden increase in educational facilities for art. Earlier artists had usually studied with an established master on a model derived from the Renaissance workshop. This often retarded new ideas and methods of painting. It was characteristic of the Gilded Age to organize art instruction on the assumption that codified knowledge coupled with intensive preparation would develop ability. Special training and certification also would increase the artist's status in a technological society that respected the expert.

There was a clear understanding in the art communities that inherited American training and technical skill were inadequate and old-fashioned, compared to the new art emerging from Munich and Paris. Any effort to practice or comprehend that art, which clearly would dominate the immediate future, or to be in the vanguard of modern culture required new special training.[1] The postwar generation of would-be artists seemed to be born with that understanding. Impatient with past masters and armed with an unusual sense of security and self-confidence, they looked outward and were willing to risk through experimentation. Earlier art students had asked basically what to paint. This generation seemed concerned with how to paint, and, above all, with what the act and product meant.

The fresh information about art that flooded the newspapers, magazines, and books, that were read all over the country, sharpened the desire for special expression through training. Within the urban art communities, the endless discussions in cafes, studios, and special societies tried to put American culture into the modern mainstream, whatever its special characteristics might be. The number of art students departing for European study increased annually. Many teachers and critics visited the salons and inter-

---

[1] See the retrospective comments in John C. Van Dyke, *American Painting and Its Tradition*, 187; and Royal Cortissoz, *American Artists*, 160.

A student duel with Prussian blue and crimson lake paints in a Paris classroom-studio. *From Frank Leslie's Popular Monthly*, 35 *(September, 1892)*

A visit from the professor in a Paris classroom-studio.
*From* Frank Leslie's Popular Monthly, 35 (*September, 1892*)

national expositions, returning with news of the Old World's excitements.[2] This sense of a revitalized tradition combined with experimentation fed the younger generation's excitement about culture. Art offered adventure as well as expression and harmony.

As the rage for art education grew during the 1870's and 1880's, some critics were cautionary. So technical a subject should not be entered lightly; such an important role required a life commitment.[3] This view reflected a feeling of awe toward art and at least some understanding of its complex functions for both the individual and society. Other commentators warned against the traditional American impatience of detail and protracted study. "The method of art is toilsome and slow," the New York *Times* said in 1874, "and the lack of repose and patience in the American character ill fits it to submit to the hard discipline of the many years of study needed to lay a solid foundation of knowledge."[4]

Still others feared that aspiring painters would see in art only another avenue of worldly success. Study, reflection, and analysis would be useless unless they tamed this ambition. "The haste to be rich is the curse of the day in the artistic walks of life, as it is in politics and trade."[5] There was also an alternate fear that art was indeed seductive and might inhibit rather than promote individual growth and enrichment. The aging "art student," appropriately clad in a spattered smock, frequenting the cafes and exhibitions, content to live either on scraps or a private income, but lacking talent in any event, became a stock figure of the art scene.[6] And by the turn of the century artists trained in the 1870's warned newcomers that success had created new

[2] Louise Hall Tharp, *Saint-Gaudens and the Gilded Era*, 27.

[3] "Art," *Atlantic Monthly*, 31 (January, 1873), 116.

[4] New York *Times*, May 24, 1874.

[5] "National Academy of Design," *Appleton's Journal*, 1 (June 5, 1869), 307.

[6] See Will H. Low, *A Chronicle of Friendships*, 109.

problems. The increasing number of painters sharpened the competitive struggle within the art world.[7]

Some observers clung to the master-apprentice ideal as a way of focusing individual effort and of winnowing out marginal talent. Certification would not in any event guarantee any real artistic ability or cultural perception. Perspiration would not overcome lack of inspiration. All these apprehensions paid homage to the idea that the true artist had special talents at defining the world and perceiving hidden truths. The quest was lifelong, his moto *Ars longa, vita brevis.*[8]

The stream of art instruction flowed in several channels. It began earlier in the century as one of the activities in an artist's studio or workshop. It then became a function of formal institutions such as the National Academy of Design. The new museums of the postwar era usually contained teaching facilities. Special art institutes developed in most major cities, either as private schools or as part of some community activity. Many of the new universities incorporated art appreciation and instruction courses in their curricula in the twentieth century. And art students sometimes organized schools with a combination of private and public support. A few major painters, such as William Merritt Chase, conducted private classes.[9]

In mid-century teaching staffs usually consisted of painters wedded to the formal methods inherited from their own training, emphasizing either a classical or naturalistic

[7] See Will H. Low, "A Letter to the Same Young Gentleman," *Scribner's Monthly*, 4 (August, 1888), 381–84; and "The Education of the Artist, Here and Now," *Scribner's Monthly*, 25 (June, 1899), 765–68.

[8] H. W. French, *Art and Artists in Connecticut*, 22, 27; New York *Times*, August 10, 1877; "The Teaching of Art in Universities," *Nation*, 75 (August 7, 1902), 106–107.

[9] See "The Art Schools of the United States," *Appleton's Art Journal*, 1 (1875), 28–30; W. C. Brownell, "The Art Schools of New York," *Scribner's Monthly*, 16 (October, 1878), 761–81; Charlotte Adams, "Artists' Models in New York," *Century Magazine*, 25 (February, 1883), 569–77; and John C. Van Dyke, "The Art Students' League of New York," *Harper's Monthly*, 83 (October, 1891), 688–700.

approach. But by the 1870's an increasing number of younger people with foreign training entered art education. The steady growth in enrollment at all kinds of art institutions helped support many painters. Chase commented ironically that "whereas it is very difficult for an artist to make his living by practicing his trade, it is quite easy for him to make a living by teaching others to practice it." [10]

The National Academy of Design had the most visible art instruction in this developing network of study. In 1875 the students included 131 men and 120 women. An increasing number of women found art an attractive career that did not detract from their established feminine role, yet allowed them self-expression and community influence. Those who did not have the skill or drive to become self-supporting artists, often used the training to enhance their authority as patrons of the arts later in life.

But a desire for professional status founded on special study quickly dominated the scene. "All the students this year appear to be young men and women who have made up their minds to make art their profession," the Academy president noted in 1875, "[as compared] with many who crowded our schools formerly, who to all appearances were chiefly anxious of the reknown of passing through the Academy Schools in order to get places to teach in seminaries or elsewhere. . . ." [11]

Academic instruction long emphasized drawing to develop both discipline and subtlety. Students began with plaster casts or oil copies of masterworks, then graduated to live models. The approach to instruction broadened rapidly in the 1870's under tutors with foreign training. The pencil and brush moved from the hard outline to the broad stroke that encompassed more color and movement. The grand canvas fraught with details yielded to the smaller picture that allowed simpler expression. The focus turned from

[10] Frank J. Mather, Jr., *Estimates in Art, II*, 309.
[11] Quoted in Eliot C. Clark, *The History of the National Academy of Design*, 91–93; and "Art," *Atlantic Monthly*, 34 (October, 1874), 506–509.

affecting an indiscriminate audience to using art as individual self-expression that might move people of like mind.[12] As in other aspects of art life, the emphasis in training changed from affecting the external world to clarifying the internal ideals of both artist and patron.

Change came slowly to the other great academy in Philadelphia. Despite a lavish new building, dedicated in 1876, the Pennsylvania Academy of Fine Arts remained more in control of well-to-do laymen than artists.[13] The emphasis was still on realistic methods and on developing a cultured public through art appreciation.

Fidelity to the larger truths in realistic observation made Thomas Eakins the Academy's most famous teacher. His students dissected corpses and observed animal motion. Eakins used an electrical apparatus to illustrate involuntary muscle behavior and strongly advocated studying the nude model.

Eakins was not wedded to the observable reality that still fascinated many people, but to the deeper realism of construction and operation. "He dissects simply to increase his knowledge of how beautiful objects are put together to the end that he may be able to imitate them," a critic noted in 1879.[14] Eakins' work often seemed old-fashioned to new artists, partly because of his dark palette. But he resembled the emerging "moderns" in seeking the sources and significance of arrested motion. His chief concern was the "character" and symbolic meanings gained from emphasizing the essentials in a person, object, or action. The forthright, often abrasive Eakins resigned from the Academy's school in 1886, after a sharp debate over using the nude male model in women's classes. His subsequent influence came from the example of his work rather than his teaching.

[12] See "The Art Season of 1878–79," *Scribner's Monthly*, 18 (June, 1879), 312–13.

[13] [Earl Shinn], "Fine Arts: The Pennsylvania Academy," *Nation*, 22 (May 4, 1876), 297–98; E. V. Lucas, *Edwin Austin Abbey*, I, 13.

[14] W. C. Brownell, "The Art Schools of Philadelphia," *Scribner's Monthly*, 18 (September, 1879), 737–50.

The two great academies in New York and Philadelphia did not dominate art instruction any more than they controlled the direction of painting. In traditional American fashion, art students faced a broad range of competing theories, methods, and facilities. Pragmatism and experimentation and curiosity about foreign standards and methods prevailed. But several basic aspirations united most art educators and pupils. First and foremost, they wished to improve the technical quality of American painting. They hoped to broaden individual painterly expression within the reasonable restraints against egotism in a viable tradition. Emotional response to color and line became ever more important in art education. An emphasis on motion, change, and variety quickly dominated art education. Drawing from live models, studying the anatomy of movement, painting with a loaded brush rather than making outlines, and finally going outdoors all emphasized motion and spontaneity and a sense of open-endedness.

By the 1870's the time was ripe for some new "modernism" frankly based on sense delight. On the simplest level, the new industrial society could afford and sought richer display and creative leisure. But new discoveries in every phase of life pointed toward a general widening of experience, especially for the educated elements already attracted to art. This sense of optimistic change fortified the desire among younger painters to study abroad.

The older generation often remained defensive about American culture in relation to more complex European models. They were reared to suspect the Old World's social system and values. But the younger painters leaving for Europe took an optimistic view. They did not wish to copy European art but wanted to make their country's culture the equal of any, as befitted its professed ideals in politics and diplomacy. The first generation of "moderns" remained positive about their odyssey, which gained added force from the challenge of integrating American culture into modern life.

There was little doubt in the art world that Americans

needed better technical facility. The Academy shows alone revealed how uncertain and halting painters were about the next step. Many dissatisifed students simply left for Europe when savings permitted, and often when they did not. They seemed obsessed with the fear of missing the vitality flowing through Europe's modern art. Asked if he would like to study abroad, the young William Merrit Chase gave a classic reply: "My God, I'd rather go to Europe than go to Heaven!"[15]

The prospect of improving technical skills was not the only motive involved. The younger generation appreciated the developing American art world, but longed to speed up the process. They sought richer cultural surroundings to test and develop their talents and force competition in "a most illustrious fraternity."[16] They might also shape a generation of American art and culture once they returned with improved skill and the certification of study in Europe. Those who had followed older masters might now become leaders.[17]

Choosing a place to study abroad was as challenging as deciding which foreign art tradition was most useful to American ambitions. England again was an obvious choice. Her values were familiar to almost all Americans through a rich literary heritage. London was a world capital, with numerous outlets and honors for art. At least two major American painters, Whistler and Sargent, resided there by the end of the century. Yet the English example of study was not compelling. The system of instruction reflected the insular forms and limited aspiration of British art. Both lacked

[15] Quoted in Abraham David Milgrome, "The Art of William Merritt Chase," Ph.D. dissertation, University of Pittsburgh, 1969, 16. See also Jervis McEntee Diary, May 11, 1873, AAA; Will H. Low, *Painter's Progress*, 159, 162; Henry C. White, *The Life and Art of Dwight William Tryon*, 34.

[16] "Art and Artists," *Californian*, 4 (July, 1881), 88. See also John La Farge, "The American Academy at Rome," *Scribner's Magazine*, 28 (August, 1900), 256.

[17] S. G. W. Benjamin, "The National Academy of Design," *American Art Review*, 2 (1881), 21–22.

A model falls from a horse. *From* Century Magazine, *25*
*(February, 1883)*

verve, whatever their apparent modernism, and were not attuned to the expansive self-expression American students thought they wanted.[18]

Italy seemed an equally logical choice for art study. The examples of her spirit and masters had long captivated many American writers and artists. The ancient culture of Rome, and the Renaissance heritage of Florence and the north combined with a new demand for Italian unity that appealed to Americans. There was also the spell of Italy's golden light, the charm of a varied population, and a *dolce vita*, especially in Rome, that seemed alluring in contrast to the American penchant for hurry and inattention to cultivated emotion. The Italians now appeared ready to accept modernization without abandoning an older cultural context that enriched and ordered life.

American art colonies were well established in Rome and other cities early in the nineteenth century. Living was cheap, even on a grand scale, and a few sculptors and writers kept palaces with appealing historical associations. They entertained lavishly and attended all the great Roman events. For a time Americans and their art became a vogue.[19]

American sculptors maintained studios and foundries to produce statuary and decoration for the home market. A few painters, most notably Elihu Vedder, had permanent residences. Many students passed through the Italian cities en route elsewhere, as winter tourists or merely to soak up the peninsula's fabled influences. The sun was comfortable and the associations exalting. "We ate at queer 'trattorias' and

---

[18] See Benjamin Champney, *Sixty Years' Memories of Art*, 148; George Moore, *Modern Art*, 67; Kenyon Cox to Robert Underwood Johnson, September 29, 1911, Century Association papers, AAA; Ian Dunlop, *The Shock of the New*, 124–25.

[19] See Paul R. Baker, *The Fortunate Pilgrims: Americans in Italy, 1800–1860*; Van Wyck Brooks, *The Dream of Arcadia*; Tharp, *Saint-Gaudens and the Gilded Era*, 47; Maude Howe Elliott, *Three Generations*, 257–70; D. Maitland Armstrong, *Day Before Yesterday*, 193.

drank chianti, and every night were characters in 'La Boheme,' " one artist recalled.[20]

Americans generally applauded the movement toward Italian unity and liberty. But the country was in an awkward transition from old to new, both in creature comforts and attitudes. Transportation was poor, public services often nonexistent, and health itself precarious. The very tradition that appealed to many Americans also inhibited modernization. Sympathetic observers could only hope that unification and industrialization would improve daily life and revitalize the country's art and culture.[21]

The Italian life-style was appealing as a form of creative relaxation, but the approach to painting and education finally attracted few Americans. The continuing Italian tradition of master-apprentice training clashed with the typical American student's desire for experimentation and self-expression. "Artists are denationalized here," an observer noted in 1873, "and scanning the product, we soon find traces of the shop."[22] This seemed especially inapplicable to modern painting. Italy remained more attractive to students of sculpture and architecture than of painting.[23]

In the end, Americans attracted to Italy usually missed the sense of drive toward the future that flavored art training in Munich or Paris. Americans needed and sought the harmony that came with a sense of tradition. But they did not wish to repeat the past or revise inherited models in the name of a false modernism. They wanted a real departure of both technique and aim in painting. They could learn much

---

[20] Quoted in William W. Ellsworth, *Golden Age of Authors*, 78. See also "Art Life in Rome," *Art Amateur*, 13 (July, 1885), 30; Elihu Vedder, *The Digressions of V*, 146, 292.

[21] Ernest W. Longfellow, *Random Memories*, 120–21.; Clara Waters and Laurence Hutton, *Artists of the Nineteenth Century and Their Works*, I, xxii; "Art, Music, and the Drama," *Appleton's Journal*, 4 (August 13, 1870), 200.

[22] "Art," *Atlantic Monthly*, 31 (April, 1873), 503–505; and Henry Tuckerman, *Book of the Artists*, 447.

[23] May Alcott Nieriker, *Studying Art Abroad*, 77ff.; Nathalie Dana, *Young in New York*, 144.

about formal construction and coloration from the Italian heritage. They could also see its combination of grandeur and familiarity. But the easy, seductive living threatened the drive needed to make a fresh statement. Other capitals and countries seemed more appealing to the American student. "In Italy he will live among the treasures of bygone ages," a critic advised in 1881, "here [in Paris] though surrounded by representative works of all time, he is at the center of the most active, earnest effort of the present."[24]

The newly united German states beyond the Alps attracted many American art students. Formal unification in 1870–71 did not eliminate the regional cultures that had enriched Germanic culture for centuries. Rulers of the remaining semi-independent kingdoms, such as Bavaria, also patronized the arts. And the chief cities of each region retained distinctive qualities built on heritages of great variety. German culture also blended tastes from northern and southern Europe.

Unlike Italy, the new Germany seemed to be born modern, committed to industrial and technological ideals that would change every phase of life. German wealth and productivity underwrote innovations in science, education, and the arts that made the new empire important in world culture almost from its inception. Many Americans remained skeptical, or apprehensive, about the directions and implications of this new power, yet admired the scope and vigor evident in German life. Modern Italy seemed to blend old and new, with the old predominate. But Germany radiated confidence that it could combine old and new, with the new prevailing. It thus offered a curious but attractive combination of the reassurance drawn from tradition balanced with the excitements of modernization.

---

[24] Phebe D. Nott, "Paris Art-Schools," *Lippincott's Magazine*, 27 (March, 1881), 269. See also James Jackson Jarves, *The Art-Idea*, 178–79; Frank Millett to Elihu Vedder, February 18, 1879, cited in Regina Soria, *Elihu Vedder*, 130–31; John C. Van Dyke "Painting at the Fair," *Century Magazine*, 48 (July, 1894), 439; Champney, *Sixty Years' Memories*, 114–15.

Düsseldorf Academy were among the
rks to affect American taste. A gallery
ses of this school became a favorite
w Yorkers between 1849 and 1862.
viewer could see paintings that com-
b ote, usually with Biblical or historical
associations. They were detailed enough to impress with
workmanship, broadly enough conceived to prompt emo-
tion. For a decade they seemed to epitomize modern art;
prints and copies of these works adorned countless parlor
walls. But like all things new, they aged. By the late 1860's
the younger generation of painters thought that the Düssel-
dorf style was too formal, static, and divorced from modern
life. Its works also seemed overly dramatic, loaded with an
emotion that easily shaded into the sentimental or banal.
"The Düsseldorf school always strikes *twelve*," one com-
mentator noted. "You see the brush and the palette. You see
not the mind, the soul of the painter." [25]

An emphasis on other kinds of emotion was more evident
in Bavaria, whose capital began to attract American art
students in mid-century. Munich was well known for a
relaxed life-style that blended a Germanic work ethic with a
desire for beautiful surroundings. The kings of Bavaria
complemented their realm's mountain scenery with impres-
sive buildings, parks, and art collections. Their patronage
extended to music and the theater as well as painting, and
they drew heavily on Italian inspiration to make the capital a
combination of traditional taste and modernity. Painters
came from all over Europe as well as the United States to
study the new "Munich manner." The total atmosphere was
both charming and challenging. As Will Low noted in 1896,
after the first wave of Munich art students had passed into

[25] Quoted in Neil Harris, *The Artist in American Society: The Formative Years, 1790–1860*, 136. See also Brother Cornelius, *Keith: Old Master of California*, 42; S. G. W. Benjamin, *Art in America*, 98; James Thomas Flexner, *That Wilder Image*, 119–26; *The Düsseldorf Academy and the Americans*; Axel von Saldern, *The Triumph of Realism*; Kermit Champa and Kate Champa, *German Painting of the 19th Century*.

fame: "In the placid city of Munich the traveller finds himself out of the busy current of life as conceived by the nineteenth century. The strenuous, material tendency of the age has given place to interests almost purely intellectual. . . . No other city I know, save Florence, has this artistic character so strongly marked." [26]

The poor student could live cheaply and take advantage of numerous free public facilities for amusement and instruction. Access to the other German states and to Italy was easy, and the mountainous countryside beckoned to the artist armed with a sketchbook and knapsack. The country inn with a jolly keeper and attractive daughter became as interesting as the city streets or galleries. Americans likely to find London and Paris bewildering especially liked Munich. The city was small enough to be manageable and offered good food and lodgings in or near the art quarter. [27] Americans who felt unready for the notorious competitiveness of the Paris atelier liked the easier atmosphere of instruction in Munich. Many thought this life style would be more productive in the long run than the alternating pressures and releases in French art life. "I went to Munich instead of Paris because I could saw wood in Munich, instead of frittering in the Latin merry-go-round," William M. Chase recalled candidly. [28]

By the late 1870's, Munich was clearly "the most formidable rival of Paris as a centre of art, so far as its power to

[26] Will H. Low, "A Century of Painting," *McClure's Magazine*, 7 (July, 1896), 161–62. See also Eugene Benson, "A German Art-City: Munich and Its Art," *Appleton's Journal*, 7 (February 17, 1872), 182–83; Schele De Vere, "Art Schools in Southern Germany, *Appleton's Journal*, 8 (November 30, 1872), 606–607.

[27] "The American Art Club of Munich," *Art Amateur*, 11 (September, 1884), 75–76; Copley Society of Boston, *The Art Student in Paris*, 50–52; Nelson C. White, *The Life and Art of J. Frank Currier*, 19–36; Josephine W. Duveneck, *Frank Duveneck, Painter-Teacher*, 35–48.

[28] Katherine Metcalf Roof, *The Life and Art of William Merritt Chase*, 30–31.

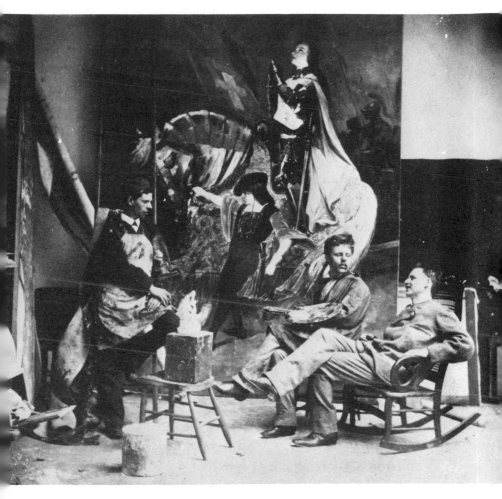

Frank Duveneck (1848–1919), center, with painter friends in his Munich studio, *ca.* 1870's. *Courtesy Archives of American Art, Smithsonian Institution*

draw off the young students of America is concerned."[29]
The number of Americans studying there rose from twenty
in 1872 to forty-three in 1884, with many others moving
through the art world on the fringes of formal study. Some of
this group attained fame, including Chase, Walter Shirlaw,
John Twachtman, J. Frank Currier, John W. Alexander, and
Frank Duveneck, who became the principal symbol of the
Munich style in the United States. Many of these Ameri-
cans, with some Germanic ties, came from the Midwest and
returned to make the style influential in that area.[30]

While learning to paint, these genial refugees talked end-
lessly of art, whether in the city's cafes or in colonies like the
one at the village of Polling. In typical American fashion
they organized clubs and societies as soon as a quorum
appeared. They met regularly after a day's work, or on
weekends and holidays, to debate art, compare progress,
and sample the famous beer and sausages. As in Paris,
though with a different tone, cafe life became important in
defining the artist's role.[31]

The art these students discussed was a dramatic part of
modern painting. The Munich style seemed to satisfy many
of the new generation's artistic desires. Its hallmark was the
broad brushstroke, heavily applied, designed to create an
impression rather than depict literal reality. The colors
tended to richness, emphasizing reds and browns, with
suitable highlights. The American students did not follow
their European masters' taste for historical subject matter,
and adapted the technique to individual purposes. They
were modern in depicting daily life, especially a wide range
of human types, yet retained a comforting old masterish

[29] Edward Strahan, *The Masterpieces of the International Exhibition*, I,
26–27.

[30] See G. Henry Horstmann, *Consular Reminiscences, 311*–12; John Doug-
las Hale, "The Life and Creative Development of John H. Twachtman"
Ph.D. dissertation, Ohio State University, 1957, 15; White, *J. Frank
Currier*, 16.

[31] S. G. W. Benjamin, "Present Tendencies of American Art," *Harper's
Monthly*, 58 (March, 1879), 484–85.

appearance in their canvases. They emphasized motion, fluidity, and the individual painter's gesture. Above all, their work was frankly sensuous, with a rich surface, aimed at delighting the eye. S. G. W. Benjamin summed up the effects well:

The leading characteristics of the new Munich School seem to be, therefore, greater breadth in the treatment of details, preferring general effect to excellence in parts of a work, greater boldness and dash, and consequently more freshness in the handling of pigments, the suggestion of texture and substances by masses of paint, handling the brush in accordance with the nature of the object represented, and, finally, a more correct eye in perceiving the relations of colors to each other—the quality of subtle tints in flesh, for example—and therefore a more just representation of the mysterious harmonies of nature, while there is everywhere apparent a masterly skill in the rudimentary branches of art.[32]

The first works of these Americans trained in Munich went on display in Boston and New York between 1875 and 1880 and took the art world by storm. The public was ready for the rich look and emotional effect of these new old masters. The "Munich men" became the first liberators of American painting and returned home to influence both art instruction and production for a generation. Modernists in the art world were divided between those favoring the broad expression and color in Munich work and those desiring the more detailed and careful art of Paris.[33]

The popularity of the Munich paintings reflected changes of taste and aim in the art world. Patrons and painters both responded to their rich surfaces and sense of motion, indicating new demands for eye appeal and sensual emotion rather than old-fashioned uplift in art. This was clearly art

[32] S. G. W. Benjamin, *Contemporary Art in Europe*, 125.

[33] "The Academy of Design," *Scribner's Monthly*, 10 (June, 1875), 251–52; Jervis McEntee Diary, March 31, May 1, 1877, AAA; Kenyon Cox, "William M. Chase, Painter," *Harper's Monthly*, 78 (March, 1889), 551; Royal Cortissoz, "Frank Duveneck and His Munich Tradition," *Scribner's Magazine*, 81 (March, 1927), 216–24.

for the home as well as the museum. Its frank delight in painterly expression prepared the public for a generation of modern art, which emphasized these qualities in many different ways. The "Munich manner" came to seem old-fashioned and limited in scope, especially as the canvases darkened with time. But the first generation of artists and patrons who felt a shock of recognition on seeing it always remembered the style's emotional appeals.

The painters trained in Munich never forgot the city or the new beginnings its art represented. Like those enamored of its rival Paris, the Munich men often returned to the scene of their first inspiration, even as fame enfolded them. In middle age Chase responded to the atmosphere that had framed his most formative years. The buildings, statuary, and boulevards; the galleries, cafes, and parks; the light among the trees, all vividly reminded him of the revolution of artistic effect Munich produced on his generation.[34]

Munich was important both as an art center and as the symbol of a new style of painting, but remained a secondary art capital. Paris was the chief magnet for aspiring painters, sculptors, and architects from the world over. French life had been the model of external grace in clothing, food, manners, and furnishings since the late Renaissance. A pervasive emphasis on the arts as companions to daily living also made the country a model for people seeking to develop both national and cosmopolitan tastes.

Franco-American ties reached back to 1776, and Americans generally admired many nonartistic aspects of French culture. Whatever the vagaries of her politics, France's rhetorical insistence on liberty and equality appealed to many Americans.[35] By mid-century she was amid industrial modernization yet retained an attractive sense of grace and elegant living. Americans indicated their curiosity and approval with tourism and expanding trade. At the beginning of 1866 the visiting Elihu Vedder found Paris exciting, yet

[34] See his letters to Mrs. Chase from Munich, June 18, 19, 22, and 24, 1903, in Chase papers, AAA.
[35] New York *Times*, May 20, 1888.

comfortable because of the many fellow countrymen he could talk to. By 1874 an estimated 30,000 Americans passed through the City of Lights annually on business or pleasure, and permanent American colonies had developed. The process of learning was not reciprocal. The French remained self-assured about being arbiters of western culture. They found Americans amusing but knew little of their country beyond a set of clichés concerning its size, rawness, and the Indian wars. Even in 1911 a visiting American noted a travel bureau map that depicted the area west of the Mississippi to the California border as "Kansas." The only cities appearing were New York, Boston, Washington, Philadelphia, and Newport, which apparently bought enough French goods to merit attention.[36]

American commentators tended to approve of France and dislike her government in the 1860's. Napoleon III and his Second Empire appeared as lavish anachronisms amid an explosion of scientific knowledge, technology, and industrial wealth. Paris offered the operettas of Jacques Offenbach, a saucy theater life, fine cuisine, as well as more serious arts. Its literary life and critical wars were equally vivid. Yet this seemed strained to many visitors—a complex life of amusement and debate that diverted people from the regime's hostility to free speech and representative democracy. "The world of amusements is a substitute for political freedom," one critic noted in 1867.[37] Others thought the fabled French life-style a surface phenomenon, carefully tended like fine veneer to cover insoluble tensions. Americans combined a desire for the elegance in French life with a fear that it was superficial.[38]

Paris, of course, was France to most tourists. Much of it

[36] Elihu Vedder to his father, January 1, 1866, in Soria, *Elihu Vedder*, 46; Lucy H. Hooper, "The American Colony in Paris," *Appleton's Journal*, 11 (June 20, 1874), 779–81. Dexter Perkins, *Yield of the Years*, 33, has the map story.

[37] Eugene Benson, "Paris and the Parisians," *Galaxy*, 4 (September, 1867), 666–74.

[38] See Charles W. Elliott, "Life in Great Cities. V. Paris," *Putnam's Magazine*, 2 (July, 1868), 12–23; and Theodore Child, *The Praise of Paris*.

was architecturally new in the 1870's, the latest word in both appearance and public convenience. Baron Haussmann's renovations had created a city of great boulevards and imposing buildings, dotted with monuments and parks. The country's new rail system converged on Paris and could easily transport the interested visitor to the countryside or to adjacent nations. Like Germany, France combined old and new, but with a grace and controlled energy unknown across the Rhine. If Munich attracted artists with a sense of relaxed productivity, Paris attracted others desiring the same ideal with greater formality and elegance.[39]

Most Parisians doubtless thought as little about art as did the inhabitants of any other large city. Yet teaching institutions, government-sponsored exhibitions, and a lively critical establishment, all raised cultural questions to the forefront of daily life. American art students had little if any interest in the enduring debates over religion, foreign policy, or republicanism that agitated most Frenchmen. They only knew that governments came and went, while much of French life seemed dedicated to fostering and enjoying the arts. This integration of various ambitions and drives into a concern for culture appealed to American students.[40]

The average Frenchman comprehended changes in art and debates over taste no more than counterparts elsewhere. But the long association of art with state and church allowed him "to accept the artist and his work with respect, if without comprehension," as Will Low said.[41] The French did not demand that a painter justify his work as a form of labor, nor did they expect him to feel guilty about enjoying art. Art was a normal aspect of life for those so inclined, fit for men as well as women, as significant as

[39] Note the interesting attractions and repulsions depicted in William Crary Brownell, "New York after Paris," *New Princeton Review*, ser. 5, Vol. 6 (July, 1888), 84.

[40] Russell Sturgis, "The Paris Exposition. XV. The United States Fine-Art Exhibit," *Nation*, 27 (November 28, 1878), 332.

[41] Low, *Painter's Progress*, 57.

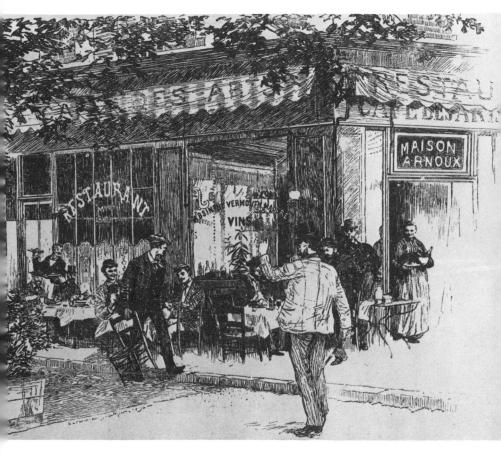

An art student cafe in Paris. *From* Frank Leslie's Popular Monthly,
*35 (September, 1892)*

building houses or running banks. "The French enjoy art as they do their chateaux and beautiful parks, their good dinners and the cool drinks on the boulevards, as they do their humble homes, and their *pot-au-feu*," the collector Louisine Havemeyer recalled. "It is in the race to love art. . . ."[42] American students wanted to take this sense of art's worth and normality back to the United States as the basis of art appreciation and production.

Many motives other than a love of beauty lay beneath the French interest in the arts. The system of art and craft education and production survived revolutions and changes of government because every regime needed to produce expensive export products. Glass, porcelain, and china; silver and goldware; furniture, rugs, and wallpaper; fabrics and clothing; and numerous other items of artwork, comprised a large part of the nation's export trade. These activities influenced other parts of the economy and attracted many tourists. Art and its ancillary trades affected hotels and apartment landlords, restaurateurs, art dealers and suppliers, and travel agents. The arts were big business as well as good influences. "Thousands of men and women live in France and Belgium by the direct practice of fine art, as only a few score live in America," Russell Sturgis reminded readers in 1866, "and the whole population, at least of the cities and towns, are brought face to face with the fine arts, and have them for a part of their daily life."[43] The governments of France, whether royal or republican, also used the arts to emphasize the country's vitality and wealth, which sustained her claims to great power status.

French governments since the seventeenth century had funded display facilities, educational institutions, and a system of honors to further this interest in the arts. The "Salon," an annual government-sponsored exhibition of

[42] Havemeyer, *Sixteen to Sixty*, 6–7.

[43] Russell Sturgis, "French and Belgian Schools of Art," *Nation*, 2 (January 25, 1866), 212. See also "A French Art School," *Harper's Weekly*, 22 (April 6, 1878), 278; Benjamin, *Contemporary Art in Europe*, 61–63.

works competing for prizes and recognition, was the focus of Parisian art life. It was usually staged in the lavish new Palais d'Industrie, which provided ample space and light. A system of juries composed of eminent academicians dispensed medals and honors which could affect an artist's entire career.[44]

On days for entering works at the Salon, art students gathered at the Palais in droves, competing for attention with each other, officials, and the well-dressed people who came to see the proceedings. The greasy smock and sticky paintbrush vied for authority with the Worth gown and lacquered walking stick. Little seemed sacred. Loud criticism of a neighbor's work often covered anxiety about one's own. Animal pictures provoked bleats and bellows. Religious paintings caused multitudes to fall on their knees in mock adoration. A well-painted nude might provoke a storm of whistles and bawdy remarks. Yet another canvas detailing daily life might cause groans and hisses.[45]

Once opened officially, the Salons were intensely criticized in the daily press and in the art reviews. Quarreling partisans of a picture or style often settled their differences in an early morning duel in the Bois de Boulogne. As a social event the Salon ranked easily with the races and the opera. The head of state and eminent personages from all walks of life attended. And the government purchased works for public buildings and provincial museums.

These reponses all reflected the importance of art to both artists and the educated public. Painting was significant enough to become scandalous or the subject of intense debate ordinarily reserved for political issues. In 1853, Napoleon III struck Courbet's *Bathers* with his riding crop, as a

[44] See Waters and Hutton, *Artists of the Nineteenth Century*, xviii–xx; Low, "A Century of Painting," *McClure's Magazine*, 7 (October, 1896), 425–27; Harrison C. White and Cynthia A. White, *Canvases and Careers*, 16–75; and Albert Boime, *The Academy and French Painting in the Nineteenth Century*, 1–21.

[45] "The Paris Salon," *Harper's Weekly*, 25 (May 7, 1881), 303–304.

sign of displeasure. A scandalized Empress Eugenie later hit Manet's *Olympia* with her fan.[46]

Responses were similar within the art world. The obvious tension among French art students, which could result in ugly scenes in the ateliers and cafes, symptomized the importance of success in an art career. The sharp competitiveness in European life, long based on a scarcity of both wealth and honors, carried into the art world. "The struggle for life is far more intense throughout the Old World than in our newer civilization," Will Low noted. "[The] ramifications of this primal necessity penetrate every function of life—and the whole social organization of Europe is permeated with a selfish but absolutely necessary intention to retain all real prizes of any career for the benefit of natives."[47] The limited chances for success caused tension between French students and foreigners. It also helped explain the bitter critical wars and internal politicking in the art world.

The Frenchman who won the race claimed a career as lavish and important as any in industry or politics. He lived in a superior home and worked in a modern studio. He had a ready market for pictures and could attract disciples. He entertained well and was the subject of press coverage. He claimed fortune and fame, which was often most important of all. "Fame may be acquired in other pursuits than that of art as well elsewhere as in France," S. G. W. Benjamin wrote in 1875. "But fame in art can only be acquired in Paris, and only then by exhibiting at the Salon. Without this one may perhaps sell pictures and acquire reputation, but fame never."[48] And the successful French painter had authority as an arbiter within the art world and as evidence of his country's vitality and greatness to the wider world. "In France, he whom art makes great occupies an important

---

[46] S. C. Burchell, *Imperial Masquerade: The Paris of Napoleon III*, 197.

[47] Low, *Chronicle of Friendships*, 116–117.

[48] S. G. W. Benjamin, "Practice and Patronage of French Art," *Atlantic Monthly*, 36 (September, 1875), 261.

relation to the state as well as society," a commentator reminded American readers unfamiliar with the prospect.[49]

Success on this scale seemed unlikely for the American artist, but the role of art in French life was a constant example. It fortified the sense of excitement that permeated an art world clearly embracing a broad new range of ideas and techniques. American students came to Paris in large numbers in the 1870's, as the classical and romantic traditions both weakened in favor of "modernism." Whatever the variety of its products and confusion of its directions, that modernism at heart emphasized a new kind of artistic self-expression. This made all the debates seem both personally and intellectually important to students.

The system of art education reflected these changes. The beaux-arts schools were reformed in the 1860's, and the curricula expanded to include art history and theory and the study of more national styles, in an effort to make the approach more cosmopolitan.

The student population contained a remarkable array of national types. German, Swedish, and Spanish words were heard in the ateliers. Left Bank restaurants offered American corn bread, Hungarian goulash, and Mexican tortillas to intrigued Frenchmen and resident foreigners. Special clubs combatted loneliness among Russian, Portuguese, and Japanese students.[50]

An increasing number of women added a special tone to the proceedings. By the mid-1880's some observers thought they accounted for nearly half the art student population. Living was more expensive for them than for men, and they encountered discrimination. The private instructors teaching students who could not enter the École des Beaux-Arts, to which women were not admitted, usually segregated the sexes. And women did not generally study the nude male

---

[49] "Glimpses of Parisian Art," *Scribner's Monthly,* 21 (December, 1880), 178.

[50] Low, *Chronicle of Friendships,* 33; Edwin H. Blashfield, *Mural Painting in America,* 214.

model.[51] The work of many of these fledgling painters appeared in the Salon, and in dealers' windows. They figured prominently in press coverage of the arts, fortifying Paris' claim to be the world's center of modern art.[52]

Americans adapted to this life. By the 1850's their numbers were large enough to support restaurants catering to tastes for griddle cakes, pumpkin pie, and baked beans. On Thanksgiving they usually congregated for a communal turkey dinner. The Fourth of July became a Latin Quarter holiday, much to the annoyance of English students. And in the best American tradition of joining, they organized special clubs and reading rooms for both study and relaxation. Just as people in New York and Chicago could read the foreign papers, so Americans in Paris could read papers, books, and magazines from home.[53]

These relaxations relieved the hard work that marked the art student's daily life. The government supported an extensive system of formal instruction in painting, sculpture, architecture, and the crafts. The painter's mecca was the École des Beaux-Arts on the Rue Bonaparte, which had a faculty of about 40 and a student body of some 1200 during the period. The methods of instruction emphasized figure drawing in large classes. The master in charge, usually a

[51] Copley Society, *The Art Student in Paris*, 23–24, discusses costs and facilities for women, as does Emily Meredyth Aylward, "The American Girls' Art Club in Paris," *Scribner's Magazine*, 16 (November, 1894), 598–605. John Rewald, *Post-Impressionism: From Van Gogh to Gauguin*, 272, notes the segregation. A note in *American Architect and Building News*, 20 (July 31, 1886), 56, quotes the New York *Evening Post* as saying that some 20,000 of about 42,000 people "who call themselves artists" of all kinds from all countries in Paris are women. This is obviously impressionistic, but impressive in terms of proportion. Nieriker, *Studying Art Abroad*, 48, makes the point about nude models.

[52] See the breakdown of Salon exhibitors by nationality and number in "Art and Artists," *Californian*, 4 (August, 1881), 179–80.

[53] Sanford Gifford to his father, November 25, 1855, and February 16, 1856, Gifford papers, AAA; Dorothy Weir Young, *Life and Letters of J. Alden Weir*, 23, 31, 59; Albert Parry, *Garrets and Pretenders: A History of Bohemianism in America*, 119; E. H. Wuerpel, "American Artists' Associations in Paris," *Cosmopolitan*, 20 (February, 1896), 402–409.

famous painter, criticized student work once or twice a week, with assistants in charge at other times.[54]

Instruction was free for students admitted to the program. As the number of applicants rose, a shrewd Fine Arts ministry devised stiff entrance examinations designed to eliminate marginal French students and all but the best foreigners. The overflow of students entered private studios and schools. This multifaceted system encouraged, often unwittingly, individualism and experimentation beyond the academic ideal. In time-honored fashion, students also criticized the instructors' work, and ridiculed the state's efforts to formalize their training and outlook. The art student was often a social radical in Europe, remaining as skeptical of firm rules in art as in politics. As the critic Earl Shinn noted in 1885: "The modern mind, at all events, is pulling away from the prescribed regimen with all the strength of its growth."[55] The attractions of academic ideals and success were strong but, as in the United States, did not prohibit innovation.

The informal art world was, if anything, more important than organized instruction. The student was entitled to a green oval *carte d'étude* which gained free or reduced admission to galleries and exhibitions. Students also pored over the work in the rapidly expanding system of private dealers' galleries. They could study anatomy at the municipal hospi-

---

[54] This explanation of the formal system is greatly condensed for present purposes. For contemporary assessments, see Earl Shinn, "Art-Study Abroad," *Nation*, 3 (September 6, 1866), 195–96; his "Art Study in France," *Nation*, 3 (November 8, 1866), 374–75; and his series, "Art-Study at the Imperial School in Paris," *Nation*, 8 (April 15, 1869), 292–95, 8 (May 6, 1869), 351–53, 8 (June 3, 1869), 433–34, 8 (June 24, 1869), 492–93, 9 (July 22, 1869), 67–69; and his "Art-Notes From Paris," *Nation*, 41 (November 11, 1885), 399–401. Henry Bacon, *A Parisian Year*, 52–94, is good, as is Henry O. Avery, "The Paris School of Fine Arts," *Scribner's Magazine*, 2 (October, 1887), 387–403. See also Samuel Isham, *The History of American Painting*, 397–403; Rewald, *Post-Impressionism*, 272; and Boime, *The Academy and French Painting, passim.*

[55] Earl Shinn, "Art Notes From Paris," *Nation*, 41 (November 12, 1885), 400.

tals and morgues. Commentators agreed that living amid historical associations, with ready access to the Louvre and other great collections, enhanced the fledgling painter's ability and inspiration.[56]

Students saw both the attractions and pressures of art life in the ateliers. Most classrooms were hot in summer and cold in winter, suffused with the small of stale tobacco, sweat, and paint. Dozens of students clustered around the stand, acidly judging the model's anatomy and each other's work. Newcomers were expected to run some gauntlet of initiation and be good sports later at a cafe. Each new student was supposed to epitomize the clichés attached to his nationality. The Germans were expected to march, the Swiss to yodel, Russians to dance, and Americans to do the war whoop. During intermissions while models rested, mock duels with loaded paint brushes, and boxing matches, raged. Negro spirituals, Spanish tarantellas, and varied folk songs might rise above the din.[57]

The tone was usually good-natured, but occasional brutal hazing gave a glimpse of the tensions that ran beneath the *joie de vivre*. Much of the atelier's confusion was an outlet for anxiety and frustration, revealing the fear of failure or a ruthless drive to succeed.[58] This constant tension had the merit of keeping up one's guard against both flying missiles and falling standards. "The intentness of their fellow work-men will keep them fully alive to their own shortcomings," Thomas Anschutz noted of the system.[59] And despite an occasional edge of violence on the bonhomie, shrewd ob-servers knew that a future sober academician likely as not

[56] Copley Society, *The Art Student in Paris*, 17; Lloyd Goodrich, *Thomas Eakins*, 17; Young, *Life and Letters of J. Alden Weir*, 31.

[57] Henry O. Tanner, "The Story of an Artist's Life," *World's Work*, 18 (June–July, 1909), 11770; George Biddle, *An American Artist's Story*, 125; Rewald, *Post-Impressionism*, 273–74.

[58] See Benjamin, *Contemporary Art in Europe*, 73, for some adverse comments on the behavior of French Art students.

[59] Thomas Anschutz to Edward H. Coates, May 15, 1893, copy in Anschutz papers, PAFA.

lurked beneath the bohemian exterior of the typical student.[60]

The American students in this mixture of nationalities quickly gained a reputation for sobriety and occasionally for prudishness. They tended to have some knowledge of fisticuffs, and the French students focused on other nationals. The first wave of Americans in the 1870's and 1880's came with an almost grim determination to learn better technique. Their successors in the 1890's seemed more genial, less defensive, and more sure of their roles.[61]

Parents often worried about the effects of the fabled French immorality on their offspring. Many American students thought Parisian life immoral and fortified each other's prudery. But much of what passed for looseness was mere surface gesture. Few societies were more conservative than the French in matters of sex and general propriety. Many old hands blamed the naughtiness, epitomized in the "Paris postcard," on tourists, who expected pornography to accompany the cancan and bistro.[62] Students doubtless composed some of the clientele of the bordellos that were a fixture of the scene. Relations between the sexes were often casual, and many couples lived together without benefit of clergy. But the debates that fed the art world's life centered on art not sex.

Students were inclined to take extended leisure elsewhere than in the Left Bank's dives. As in New York, artists sought a change of pace and view with each season. Contrasts and new sensations were as vital as formal instruction. Most American students returned home in summer, or lived in the countryside to sketch and soak up local color. Normandy and Brittany, where ancient customs and costumes sur-

[60] Kenyon Cox, *Artist and Public*, 46; White and White, *Canvases and Careers*, 22–23.

[61] See the analyses in New York *Times*, May 23, 1877, and March 11, 1888; and Cleveland Moffett, "Will H. Low and His Work," *McClure's Magazine*, 5 (September, 1895), 306.

[62] See Soria, *Elihu Vedder*, 44–45; Nancy Douglas Bowditch, *George deForest Brush*, 13; Low, *Chronicle of Friendships*, 308–309.

vived, were especially popular, as were the forested areas around Paris. Students understood the importance of studying nature and the human figure elsewhere than in the Salon or studio. They might also take a walking tour or visit other art centers. Many critics urged Americans to sample the best of several academies, if funds and energy permitted. "I should say, go to the French capital first," one counseled in 1894, "where the artistic atmosphere is stronger and more vital, and later when the eye has become strong and quick for drawing and proportion and something has been learned of color, [go] to Munich for a broadness and thoroughness of style and knowledge of detail."[63]

Parisian student life epitomized for Americans the effort to broaden the artist's social role, clarify his status as a seeker after special truths, and intensify his individual life.[64] The Parisian ideal was a vivid, working example of art as part of "normal" existence, offering both harmony of purpose and a strong sense of individual adventure and expression that seemed impossible in any other career.[65] Art study was also identified with youth. Bohemias seemed ways of institutionalizing the search for new expression, supposedly an attribute of youth and innocence, and of delaying the

[63] "Art-Student Life in Munich," *Art Amateur*, 31 (July, 1894), 30–31.

[64] For a cross-section of descriptions of Paris art life, see Margaret Bertha Wright, "Art Student Life in Paris," *Art Amateur*, 3 (September, 1880), 70–71; "Glimpses of Parisian Art. I," *Scribner's Monthly*, 21 (December, 1880), 169–81, 423–31, 734–43; Alice Fessenden Peterson, "The American Art Student in Paris," *New England Magazine*, 2 (August, 1890), 669–76; "The Art Student in Paris," *Art Amateur*, 27 (June, 1892), 10; J. Sutherland, "An Art Student's Year in Paris," *Art Amateur*, 32 (January, 1895), 52, and 32 (February, 1895), 86, and 32 (March, 1895), 108; Corwin K. Linson, "With the Paris Art-Student," *Frank Leslie's Popular Monthly*, 34 (September, 1892), 289–302; "Letters From a French Atelier," *Living Age*, 204 (February 9, 1895), 369–80; Lorado Taft, "Paris From a Mansard," *Brush and Pencil*, 1 (December, 1897), 49–52; Will H. Low, "The American Art Student in Paris," *Scribner's Magazine*, 34 (October, 1903), 509–12.

[65] Herbert F. Sherwood (ed.), *H. Siddons Mowbray, Mural Painter 1858–1928*, 21; Low, *Chronicle of Friendships*, 117.

routine life-style identified with adulthood. In its sense of exploration and self-expression, art-life thus seemed to offer a way of remaining young but not immature.[66]

Americans needed better knowledge of technique, but their intensive study had intellectual ramifications. As the German critic Richard Muther noted: "Straightened by no old artistic traditions, the Americans had no occasion to do homage to conservative opinions in their painting. The words Classicism and Naturalism had no meaning for them. They merely repaired to the studios where they believed themselves best able to learn."[67]

Their desire to sample a wide variety of both technique and cultural purpose made the Americans curious about both "modernism" and academic formulas. An eclectic approach dominated their experiences beyond the ateliers. They traveled widely in Europe, seeing a cross section of past and present art. And the tension in an alternating desire for cosmopolitan experience and concern to protect native qualities in the American scene to which they would return kept them both curious and skeptical. American students as a whole wished to infuse their society with culture. They also wanted it to reward their work. But they hoped to integrate art into a more open, democratic and fluid society than they found in Europe.[68]

By 1900 training in Paris or some other European art center seemed a normal complement to the art life of New York, Chicago, or San Francisco. And the knowledge of cultural developments available everywhere through the daily press and special publications lessened the emotional appeal of study abroad. The number of painters and their standards of ability increased dramatically from 1865 to about 1900. On the eve of World War I, the fabled Paris art world was alive with debates over "modernism," yet

[66] See John R. Gillis, *Youth and History: Tradition and Change in European Age Relations, 1770–Present*, 89–93.
[67] Richard Muther, *The History of Modern Painting*, IV, 299.
[68] Dana, *Young in New York*, 184; William Innes Homer, *Robert Henri*, 44.

seemed somehow less personal and exciting than in the 1870's.[69]

The impact of the Parisian experience naturally varied with individuals and lessened with time, but it remained especially important to the questing youths of the 1870's and 1880's, when art study was new. The city's chief effect came from a tone based on a great variety of old and settled emotions within a context that simultaneously emphasized adventure. And its variety and elegance fed a great need for the colorful and sumptuous in that early generation's life. Kenyon Cox, no exponent of idle emotion, caught that spirit well as a young student in 1879:

After the concert today I took a walk along the river, watching the sky and the moon and the yellowing poplar trees and the golden lights coming out in the fading daylight and the violet colored steam from the ferrys and the long yellow reflections in the shining water. Then I came back through the Tuileries with the sky getting darker and the dark twigs of leafless trees against it, the statues dark and gray and indistinguishable, the gravel walks and the grass plots and the flower beds rich with dusky mysterious color, the dark reflections of a couple of black swans in the glooming water of a fountain basin, and here and there the intense black note of a costume—it was charming.[70]

In time, this feeling became nostalgic yet retained a creative power. Whether in Greenwich Village, a provincial academy, or even outside the art world, old visions of a life colorful, broadly meaningful yet intensely personal, came back to the Paris art student.[71]

The contact of American art students with older civilizations affected American life in many indefinable ways. It enriched both art technique and content. Knowledge of the

---

[69] W. C. Brownell, "The Painting of George Butler," *Scribner's Magazine*, 26 (September, 1899), 302; Low, *Painter's Progress*, 149–50; New York *Times*, August 9, 1914, Part V, p. 11.

[70] Kenyon Cox to his parents, October 26, 1879, Cox papers, AALCU.

[71] R. H. Ives Gammell, *Dennis Miller Bunker*, 8.

culture of other peoples and debate over new ideas animated the art communities of every American city, thus extending their sense of scope and purpose. Foreign models illustrated how artistic expression could soften materialism and expand the experiences of both painter and patron. Art students acquired a new sense of the possibilites in the urban life, which they transmitted through teaching and the subject matter of their painting. Many took their aspirations into the expanding educational system. Above all, they gained a new level of confidence about their own country's prospects through comparisons with the wider world. Their search for culture, however individual in aim, had many lasting effects on a United States entering the arenas of world power.

# 4. Impressionism

In 1874 a group of French painters exhibited a collection of their recent works in Paris. The canvases radiated bright colors, often juxtaposed in small touches designed to break up familiar outlines. They forced the mind to see that reality was in the eye of the beholder, and their effect depended on the quality of light, which changed constantly.

Critics took a cue from Claude Monet's *Impression, Sunrise* (1872), and dubbed the painters "impressionists," and their style "impressionism." The canvases of the group's greatest precursor, Edouard Manet, were familiar to the art public, but those of Monet and other impressionists were less well known. The art community paid the new painting the homage of intense debate, both over its style and intellectual implications. What had seemed a marginal group and an eccentric way of painting gained importance from this and later exhibitions. Impressionism was clearly a new personal vision of reality as well as a manner of painting. Despite an initial hostile reception, it profoundly affected art everywhere in the decades that followed.

Its appearance at first seemed difficult to explain in the 1870's. Academic formulas had never repressed notoriously individualistic artists. But the impressionists' apparent insistence that reality itself varied from time to time in the same place had disturbing implications for the ideals of order and harmony in society at large as well as in painting. Many critics thought impressionism reflected a breakdown of discipline in the Paris art world. Others considered it a result of the painters' lust for recognition, even at the price

of scandal, and thought it would pass quickly. Still others believed it was a joke on academic taste, evidence of poor eyesight, or mere showmanship.

But impressionism had antecedents, however suddenly it seemed to appear on the art scene. And while granting the genius of its individual exponents, it symptomized many of the era's qualities. It reflected the urge for personal expression that permeated the art world. In depicting scenes from daily life, it was part of the era's democratic ideal. It satisfied the generation's desire for a new departure in painting still realistic enough for most people to understand. It filled a need for color sensation, especially among the new middle-class collectors. And its emphasis on motion and variety paralleled similar feelings of rapid change throughout industrial life.

Paris was the early center of impressionism, and for a time it seemed a peculiarly French phenomenon, explicable as part of the turbulent art scene along the Seine. But it quickly affected both the techniques and aims of painting in every western country. Nations as diverse as Norway, Italy, Germany, and the United States all soon boasted impressionist movements, however much the style varied to suit local conditions. This broad appeal seemed to validate the impressionists' claims to be truly innovative and especially suitable to modern life.

Americans first found impressionism as puzzling and challenging as did any other people. But several tendencies in the art scene had hinted at a change in style like the one impressionism offered. A turn from literal realism was clear. The art audience began to accept the "unfinished" picture, deliberately left vague to suggest change and complexity. A general desire for artistic self-expression inevitably meant that no single view of reality would reign, and that appearance was not fixed. The art public's growing education in sense perception emphasized new levels of color, motion, and individual interpretation that were basic to impressionism.

By the 1870's some critics began to see in these loose

tendencies a new "modern" approach with profound impli-
cations about the role of art in interpreting the world and
enriching individual experience. They began to praise
William Morris Hunt's preachments about the importance
of feeling in responding to art and approved his allowing
*"ideal suggestions* rather than pictures to pass from his
studio. . . ." [1] John La Farge won approval for subtle com-
positions designed to evoke rather than depict emotion.
"Somehow one learns in time that even in his sketches there
is no lack of completeness of motive," a New York *World*
critic noted in a review of 1878, "and that if it does not seem
completely expressed, that may not be so much the fault of
the painter as of the observor, if the latter has been accus-
tomed to the stock notion that completeness of expression
means a hunting of the motive to its fastness." [2] A broad
desire for pleasure, and for allowing the viewer to order his
own picture, helped pave the way for impressionism. [3]

Numerous changes in technique also laid the ground for
some major departure. Studying the live model, painting
with a loaded brush, and using richer colors all promoted
spontaneity and diverse interpretations of a changing re-
ality. [4] Some painters went out of the studio to catch nature
in more dynamic and colorful poses, though usually for a
greater fidelity to nature's meanings. "I prefer every time a
picture composed and painted out-doors," Winslow Homer
said in 1882, while granting the basic need for studio work.
"The thing is done without your knowing it. . . . This mak-
ing studies and then taking them home to use them is only
half right. You get composition but you lose freshness; you
miss the subtle, and to the artist, the finer characteristics of

---

[1] "Painting and a Painter," *Lippincott's Magazine*, 11 (January, 1873),
112; and "Art," *Atlantic Monthly*, 37 (May, 1876), 629–31.

[2] New York *World*, November 3, 1878.

[3] See "The Hunt Memorial Exhibition," *Atlantic Monthly*, 45 (January,
1880), 120.

[4] See the recollections in Will H. Low, "Carolus-Duran: An Apprecia-
tion," *Scribner's Magazine*, 61 (June, 1917), 771–74.

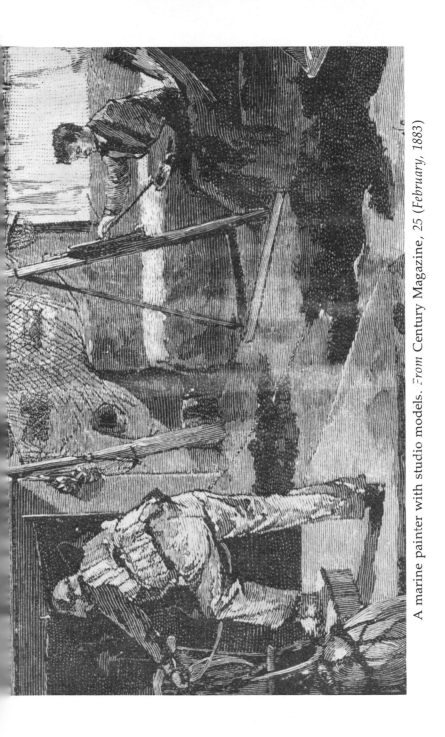

A marine painter with studio models. *From* Century Magazine, 25 *(February, 1883)*

the scene itself."[5] Hunt also counseled students to look at the world in changing attitudes. "Go out into the sunshine, and try to get some of its color and light. Then come back here and see how black we are all painting."[6] He even built a horse-drawn studio on skis, from which he painted winter scenery.

By the 1870's the term "impressionist" was often applied to any painter who avoided details in an effort to suggest broad emotion or changing character in a subject. Frank Duveneck and many other Munich-trained painters, thus seemed "impressionistic" in attempting to blur the forms of literal reality.[7] And by the 1890's it was an article of faith among painters and critics that "local color is always affected by atmospheric conditions."[8]

But these tendencies did not guarantee immediate understanding or acceptance of impressionism. Most critics remained uncomfortable with paintings that obviously ignored reality in favor of an entirely personal statement, as seemed the case with J. M. W. Turner. His canvases were colorful enough, interesting even while puzzling, and won praise for suggestiveness and a sense of motion. Yet they did not seem "real." Painting must follow "the self-evident limitation and guiding law of resemblance," as a critic noted in 1872. In this view, painting was "*not* free to neglect the most palpable features of the object imitated or to substitute a fanciful congeries of detail or indication drawn from some

[5] George W. Sheldon, *Hours with Art and Artist*, 138. Sheldon went on, after quoting Homer, to disparage the "imported" ideas that were not true to nature, and favored going outdoors to enhance the realism of nature, rather than to express the painter's individuality.

[6] Martha A. S. Shannon, *Boston Days of William Morris Hunt*, 129; D. Maitland Armstrong, *Day Before Yesterday*, 292–93.

[7] "The Art Season of 1879–1880," *Scribner's Monthly*, 18 (June, 1879), 312; "Pictures at the Academy," *Harper's Weekly*, 25 (April 9, 1881), 235–37.

[8] W. Lewis Fraser, "Winslow Homer," *Century Magazine*, 46 (August, 1893), 636.

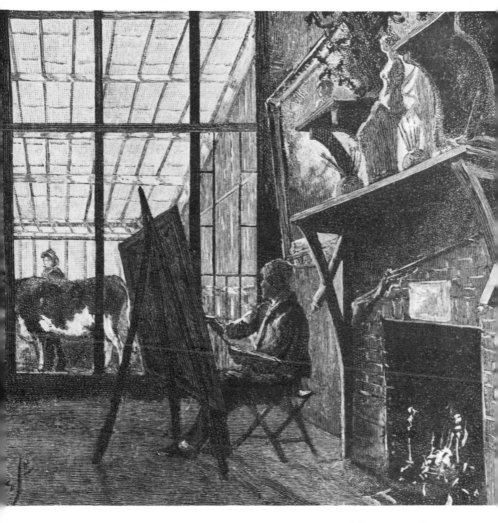

The studio of an animal painter. *From* Century Magazine, *25*
*(February, 1883)*

purely *a priori* and extraneous principle."[9] Painting must thus record a reasonably realistic subject before it could evoke a genuine emotional response through interpretation.

Landscape painting revealed many impressionistic attributes. Yet the softened outlines of forms and blurred colors in the work of George Inness, for instance, were meant to evoke a mood and enhance higher emotional meanings in subject matter rather than depict changing reality under the effects of light.[10] And painting outdoors did not necessarily make impressionists. It usually resulted in a higher palette and vivid subject matter without a true impressionist emphasis on light and the immediate moment.

Knowledge of impressionism came to the American art world in the 1870's and 1880's from several sources. Students and tourists in Paris mentioned it in reports home. Critics visiting the Salon and other exhibitions naturally encountered it. The general press and special art publications began to discuss it as part of the turbulent Paris art scene. A few collectors brought examples home. And by the mid-1880's, French dealers staged exhibitions and furnished American galleries with impressionist works for sale. The new art world was ready to analyze the style in both artistic and cultural terms.

Shock and bewilderment were among the first responses of American students and critics abroad. The young J. Alden Weir was unprepared for the "impressionalist" exhibition he saw in 1877. "I never in my life saw more horrible things," he wrote his parents. "They do not observe drawing nor form but give you an impression of what they call nature. It was worse than a Chamber of Horrors." He left

---

[9] "Turner's 'Slave Ship,' " *Scribner's Monthly*, 4 (June, 1872), 250. I do not mean to imply that Turner was an impressionist, but that his was probably the most familiar foreign work representing the tendency to break up literal reality.

[10] See "Art Notes," *Appleton's Journal*, 9 (January 25, 1873), 157–58. The New York *Times*, June 13, 1876, review of an art show referred to "a certain poetic indecision" in a landscape background. See the same paper's review of "unfinished" canvases on March 7, 1878, p. 4.

after a quarter of an hour with a headache, but not before "I told the man exactly what I thought. One franc entrée. I was mad for two or three days, not only at having paid the money, but for the demoralizing effect it must have on many. . . ." [11] Weir later became a major American impressionist, but was simply unprepared for the dissolved content and apparently garish colors he first saw. Like most other students, he came to France to develop technical skill, implying a reliance on form and discipline which the impressionists seemed to reject wilfully.

The author of a book on the Paris scene intended for prospective students was equally harsh in 1881, outlining a body of familiar objections to impressionism:

There are a number of painters in Paris whose works always figured in these exhibitions [of the refused], and they have at last formed themselves into a society under the title of "Impressionistes," which, as well as we can learn, intends to explain that they wish to present to the public their impression of nature. We have no reason to consider them dishonest, so we must conclude that they are afflicted with some hitherto unknown disease of the eye; for they neither see form nor color as other painters have given them to us, or as nature appears to all who do not belong to this association. Their models must be a regiment of monstrosities with green or violet flesh, the skies of their landscapes green, the trees purple and the ground blue. [12]

Like many early observers, he thought the impressionists were publicity seekers in revolt against academic taste.

Closer to home the art public encountered impressionism sporadically in the 1870's and 1880's. Mary Cassatt showed works at the Pennsylvania Academy between 1876 and 1879 and at the National Academy of Design in 1878. She exhibited with the Society of American Artists in 1878–80, largely because of Weir's encouragement, and was a

[11] Weir to his parents, April 15, 1877, in Dorothy Weir Young, *The Life and Letters of J. Alden Weir*, 123.
[12] Henry Bacon, *A Parisian Year*, 80–81.

member from 1880 to 1894. She sent a piece to the American
Watercolor Society show of 1880 and had 3 canvases at the
fine arts section of the Massachusetts Charitable Mechanics
Association exposition in Boston in 1878. Cassatt's Ameri-
can origins gave her a certain familiarity, and her work
seemed less radical than that of other impressionists.[13]

There were other glimpses of the coming controversy. In
November, 1879 a Frenchwoman named Madame Ambré
sang in Boston in company with Manet's famous painting
*The Execution of the Emperor Maximilian*. The Paris police
had banned the work for political reasons, which the singer
emphasized in her publicity. It was shown in the Boston
Studio Building and at a New York hotel but won little
understanding from the press.[14]

Information about the impressionists and the controver-
sies surrounding their work in Paris filtered back steadily,
and the 1880's saw the first significant exhibitions of their
works in the United States. In September, 1883 the "Foreign
Exhibition" in Boston offered two Manets, three Monets,
three Renoirs, and six Pissarros, which the French dealer
Paul Durand-Ruel sent as a probe of American taste.
William Morris Hunt died in 1879. And though the Boston
art world remained receptive to more familiar French mod-
ernism, it was skeptical about the impressionists. A news-
paper critic analyzed the works in terms that were already
clichéd: the drawing was bad, color garish, subject matter
vulgar, and effect unfinished. He tolerated Manet because
his work echoed Velásquez. He noted "a queer genius called
Pissarro; and a marvellous realist-impressionist called Re-
noir, who is the boldest bad man of the lot." But the show's
tone came from "the eccentric products of the *Salon des
Refusés*," and seemed disturbing. "Altogether, Paris would
laugh to see this assortment of perverse and burlesque can-
vases; and we, on the other hand, cannot but regret their

[13] See Breeskin, *Mary Cassatt, 1844–1926*, 11–12; Frederick A. Sweet,
*Miss Mary Cassatt, Impressionist from Pennsylvania*, 47–50, 105–107.
[14] Richard J. Boyle, *American Impressionism*, 53.

predominance in a collection shown here as purporting to represent the contemporary art of France."[15] That "predominance" was just the point that alternately disturbed and fascinated critics and viewers, for impressionist works clearly became the center of interest in any exhibition.

The French government gave the Statue of Liberty to the American people in 1883. Efforts to raise money for a suitable pedestal included a "Pedestal Exhibition," the object of intense debate after it opened in December at the National Academy. William Merritt Chase and Carroll Beckwith chose works with a shrewd eye for fruitful controversy. They showed paintings by Géricault, Courbet, Corot, and the Barbizon school, but focused attention on four Manets, including *Boy With a Sword* and *Woman With a Parrot*, and Degas' *Little Ballet Girls in Pink*.[16]

A growing awareness of impressionism sparked interest in Durand-Ruel's major show of 1886 in New York. He later furnished works to New York dealers, and staged a show at a Chicago dealer's gallery in 1888. Visitors saw numerous impressionist works at the Inter-State Industrial Exposition of 1890 in the Windy City. Impressionism became a major topic of art debate, capped with a large exhibit at the World's Columbian Exposition of 1893.

Hard times in France and curiosity about the American art scene both prompted Durand-Ruel to stage the show of 1886. He saw a market in the United States and believed Americans more receptive to impressionism than Europeans were. Braving a thicket of bureaucratic rules, dealers' jealousies, and tariff duties, he brought some three hundred canvases to New York. The exhibition of "Works in Oil and Pastel by the Impressionists of Paris," staged at the American Galleries in April–May, 1886, presented a cross section of impressionism and created a furor. Public response was

[15] Boston *Advertiser*, September 3, 1883.
[16] See Sweet, *Miss Mary Cassatt*, 105–106; Boyle, *American Impressionism*, 54; and Hans Huth, "Impressionism Comes to America," *Gazette des Beaux-Arts*, 29 (April, 1946), 225–52.

so great that the show moved to the National Academy for another month. Though the net proceeds of the $18,000 worth of pictures sold was not great after fees and duties, the money was crucial to the painters. And Durand-Ruel remained convinced that with further encouragement, Americans would embrace the style.[17]

The show helped crystallize a lively debate that made impressionism the most important subject in the art world for at least a decade. The reponse ran the gamut of emotions from outrage to cautious skepticism to approval. In due course, critics and painters saw impressionism not merely as a way of painting, but also as an expression of modern life. The intense discussion revealed a feeling that, like it or not, impressionism was a major change in art history.

Early viewers of this impressionism had few standards of judgment for such an apparent departure of manner and purpose in painting. The "impressionistic" tendency in American art remained wedded to a realism based on studio conventions. It still focused on the objects depicted and their "higher" emotional meanings and was the product of reflection rather than immediacy. Painters used lighter palettes but still stressed inherited ideas of contrast and tone. And they generally saw light as a means of intensifying total effect or highlighting subject matter, not as a subject itself.

The average viewer required recognizable outlines, shaded tones, and a unifying finish. He did not in fact at first "see" a picture in impressionist works. "There are some effects that look as though they were produced by gluing segments of the whites of hard boiled eggs over two thirds of the canvas," a New York *Times* reporter noted in 1886, "views of green fields with patches of sunlight and vegeta-

---

[17] See Lionello Venturi (ed.), *Les Archives de l'impressionnisme*, II, 77–81, 218; Camille Pissarro, *Letters to His Son Lucien*, 65, 72, 77, 89; John Rewald, *History of Impressionism*, 523–24, 531–32. The canvases included 50 Monets, 42 Pissarros, 38 Renoirs, 23 Degas, 17 Manets, 15 Sisleys, 9 Morisots, and 3 Seurats.

tion that remind one of a well mixed mayonnaise of to-
matoes, and country scenes in which the trees, the grass,
and the rustic abodes recall the leaden farm houses and
surroundings sold in the toy shops." [18]

The colors were equally shocking in intensity, strange-
ness of relation, and thickness of application. "Some of the
colors here do not cry," a reporter for the *Times* noted again,
"they yelp: as if but one idea had possessed the men who
gave them being, and that was, to call attention to them-
selves at any cost." [19]

The whole texture seemed evidence of haste or super-
ficiality:

The first feeling about such works as these is, what extraordinary
impertinence on the part of the artists! It is like turning the wrong
side of the stage flies to the audience, it is offering the public work
which has been prepared up to a certain point only. No wonder
that artists who are not in sympathy with the undaunted band of
Impressionists affirm, sometimes not without a round expletive,
that they can turn out several such canvases every day in the
week! [20]

Impressionism was obviously a kind of realism, the work of
trained artists, with a powerful intention, but baffled critics
could not see its antecedents. Sensing this importance,
some commentators opted for a bland view while awaiting
developments. [21]

A sense of seriousness ironically united both those who
saw impressionism as a threat to stability and tradition, and
those who saw it as a liberation of the senses. The newspa-
per space devoted to describing and analyzing the paintings
revealed an earnest desire to plumb their meaning. The
thousands of visitors, however puzzled, radiated the same
sense. And many commentators warned above the hubbub

---

[18] New York *Times*, May 28, 1886.
[19] *Ibid.*, April 10, 1886.
[20] *Ibid.*
[21] Boston *Sunday Globe*, April 18, 1886.

that Americans had better take impressionism seriously, even if they did not like it. As *Art Amateur* had said in reviewing the Pedestal Exhibition of 1883, "the Impressionist movement means change, if not progress. There is little doubt that all the good painting of the men who will come into notice during the next ten years, will be tinged with Impressionism, not perhaps as it has been put into words by the critics, but as it has been put into paint by Manet and a few others."[22]

And a few critics welcomed impressionism from the first. Luther Hamilton saw the exhibition of 1886 as "one of the most important artistic events that ever took place in this country. . . ." Impressionism was "a glorious protest against the everlasting commonplace, which is another way of saying that its pictures were that rarest thing, a record of the artists' own impressions, not, as usual, their reminiscences of other pictures."[23] Conventional taste did not crumble, but was shaken. Change had come, and its effects could only grow.[24]

Neither the furor nor the gathering sense of approval for impressionism surprised Durand-Ruel. The very fact that fellow dealers obstructed him, and spread stories that the impressionists were madmen, revealed their fear of the style's inherent appeals. And American curiosity and openmindedness worked in his favor. "Don't think that the Americans are savages," he warned the painter Henri Fantin-Latour. "On the contrary, they are less ignorant, less bound by routine than our French collectors."[25] He was

[22] Quoted in Huth, "Impressionism Comes to America," *Gazette des Beaux-Arts*, 29 (April, 1946), 233–34. See also New York *Tribune*, April 10, 1886, and New York *Sun*, April 11, 1886. For more analysis of the debate's development, see John D. Kysela, "The Critical and Literary Background for a Study of the Development of Taste for 'Modern Art' in America, from 1880 to 1900' Master's thesis, Loyola University, 1964.

[23] Luther Hamilton, "The Work of the Paris Impressionists in New York," *Cosmopolitan*, 1 (June, 1886), 240. See also "The Impressionists," *Art Age*, 3 (April, 1886), 165.

[24] Clarence Cook, "The Durand-Ruel Collection of Paintings at the National Academy of Design," *Studio*, 3 (July, 1887), 2.

[25] Cited in Rewald, *History of Impressionism*, 531.

satisfied with this beginning and was sure that patrons would see impressionism as a logical extension of the Barbizon painters whose works he had helped make familiar. "The general public, as well as every amateur, came not to laugh, but to learn about these notorious paintings which had caused such a stir in Paris."[26]

In more concrete terms, impressionism appealed to some collectors. Durand-Ruel considered the sales of 1886 as a seeding of the market. By 1891 he regularly stocked American dealers with impressionist prints, drawings, and oils and finally opened his own outlet. This market was centered in New York, but Mrs. Potter Palmer of Chicago became a major collector, and there were several important impressionist works in Boston collections. The style soon had an audience in most cities, especially among the new educated middle class.[27] The American market was so important by 1893, that Pissarro thought his friends faced ruin when the panic of that year affected art sales.[28] And by the turn of the century many Frenchmen feared that Americans would buy up all the major impressionist works.[29]

Pleasure in their appearance doubtless explained why many collectors bought impressionist paintings. But the critical debate on the style's implications ran deeper than surface phenomena. The American art world treated the early impressionists as part of a larger wave of "modernism"

[26] Quoted in Boyle, *American Impressionism*, 52. The critic for the New York *Tribune*, April 11, 1886, noted in passing that "We are disposed to blame the gentlemen who purvey pictures for the New York market for leaving the public in ignorance of the artists represented at the exhibition in the American Art Galleries."

[27] See Huth, "Impressionism Comes to America," 238–39; Royal Cortissoz, *Personalities in Art*, 269–70; Pissarro, *Letters*, 176–77; John D. Kysela, S. J., "Sara Hollowell Brings 'Modern Art' to the Midwest," *Art Quarterly*, 27 (Nov. 2, 1964), 150–68; Leslie S. Goldstein, "Art in Chicago and the World's Columbian Exposition of 1893" Master's thesis, University of Iowa, 1970, 21; Marian Lawrence Peabody, *To Be Young Was Very Heaven*, 34.

[28] Pissarro, *Letters*, 221–22.

[29] Harrison C. White and Cynthia A. White, *Canvases and Careers*, 128–29.

which had fascinated them since the 1860's. Like all other innovative styles, impressionism doubtless would become formulistic. But perceptive critics understood that whatever the nature of that change, impressionism would affect both the techniques and aims of painting for much time to come, and it merited close analysis. It was chiefly important for the world view it implied.

That world view had numerous facets. Impressionism was first and foremost a new technique of painting, bound to appeal to younger painters seeking self-expression through texture and color. It was a new way of perceiving old things, offering fresh insights into familiar landscapes, city views, and personalities. It was an equally important way of seeing new things, typified in the transitory aspects of nature and people. It also captured the sense of change that permeated modern life. And it could make that change orderly and secure in an essentially cheerful art comprehensible to everyone.

Many technical aspects of impressionism provoked critical debate. Some Americans were ambivalent about the impressionists' lavish and often unusual use of color. Impressionism supposedly rested on a theory of color effects, which held that small strokes of carefully juxtaposed tints blended in the eye at a modest distance from the canvas. These colors varied under light, which now became a major subject-matter. This technique allegedly guaranteed a more realistic effect than studio formulas based on reflection. It implied that reality shifted constantly under light and was in the beholder's eye. Technology also seemed to explain some of impressionism's departures. Collapsible tubes kept paints fresh and uniform, while modern chemistry offered several bright new colors.[30] Always fascinated with gadgetry and technology, Americans used these points to explain impressionism in early stages of the debate.

Formalist critcs and painters remained unimpressed with these color innovations. "We are inclined to think that there

[30] See Boyle, *American Impressionism*, 26–27.

were heroes before Agamemnon, and that the art of the past will not necessarily tumble into oblivion because of the discovery that three primary colors, placed side by side, give more of the physical sensation of light than does a bit of white paint," a *Nation* critic noted sardonically in 1890.[31] Critics soon turned from analyzing these mechanical color effects to impressionism's content and intentions. In fact, the impressionists' interest in color theory was secondary. Art was always more important than science in their minds.[32]

Impressionism also encountered a long-standing American fear that color was sensuous and overrode the higher emotional qualities of art.[33] Early critics complained about the apparent disorder in the impressionists' coloration, and the thickness of application, which lent credence to the charge that they sought mere sensual effects drawn from "a paintbox struck by lightning."[34] Others saw no great benefit in changing painting from a pervasive use of dark tones to a pervasive use of light ones in efforts to depict light effects.

The new trend also seemed opposed to the demands for discipline and skill that animated the generation's search for technical competence and coherent expression. It looked hasty, riddled with shortcuts." . . 'impressionism' implies, first of all, impatience of details," William C. Brownell noted in 1879.[35] An art journal warned painters to remember their

[31] "Fine Arts: The Society of American Artists," *Nation*, 50 (May 8, 1890), 382. This review was apparently written by Kenyon Cox and William A. Coffin. See also Will H. Low, "A Century of Painting," *McClure's Magazine*, 7 (June, 1896), 68.

[32] See Royal Cortissoz, "Claude Monet," *Scribner's Magazine*, 81 (April, 1927), 329–36; and John A. Richardson, *Modern Art and Scientific Thought*, 22–23.

[33] See Barbara Novak, *American Painting of the Nineteenth Century*, 59, 91, 121, 129–31, 147–48, 243–44.

[34] William C. Brownell, "Whistler in Painting and Etching," *Scribner's Magazine*, 18 (August, 1879), 482.

[35] *Ibid.*

motto, *Ars longa, vita brevis.* "The error of the young 'impressionists' is apt to be that they are too easily satisfied with work in the expressive or preparatory stage." In this view, art must pass through stages of finish toward elevating complexity. "There are no libraries open to the public composed of works exclusively in short-hand."[36] And more traditional artists frankly thought the style superficial, bearing few hints of the hard work they thought necessary to create a meaningful statement. "All this 'impressionist' business is well enough in its own way, as far as it goes," the young Edwin Austin Abbey noted in 1880, "[but] *I* like to feel in a man's work that it has hurt him a little, given him a wakeful night or two, and a little headache."[37]

But the most persistent criticism of impressionism focused on its treatment of light. Oriented toward the substance and symbolism of subject matter, however freely rendered, many Americans resisted the idea that light provided either consistent interest or meaning to painting. They saw it generally as a means of emphasizing more important things. Even an able impressionist like Theodore Robinson counseled compatriots to study drawing and design while loving light.[38] By the mid-1890's many sympathetic observers began to regret the loss of form and overt content in the rage for depicting light. A New York *Times* review of Monet's work in 1895 summed up this growing criticism:

If, under the new conditions, we get color, it is at the expense of composition; if we are blinded with brilliant sunlight, we look in vain for qualities of careful draughtmanship; if there is suggested the sparkle and the vibrancy of nature, then we are bothered by spots of crude color, awkward brushwork, and unpleasant promi-

---

[36] "Art for Artists," *Art Amateur*, 2 (April, 1880), 90. See also, "Art in Boston," *Art Amateur*, 24 (May, 1891), 141; and Theodore Child, "A Note on Impressionist Painting," *Harper's Monthly*, 74 (January, 1887), 313–15.

[37] Abbey to Charles Parson, January 17, 1880, in E.V. Lucas, *Edwin Austin Abbey*, I, 97.

[38] Theodore Robinson Diary, November 21, 1894, FARL.

nence of pigment. In short, the fin-de-siècle men present their one new true note at the expense of many other inharmonious ones.[39]

Impressionism implied that the individual's view of the moment was reality, and that spontaneous enjoyment was superior to reflection and analysis. This idea that "every time is the first time," as William M. Chase remarked critically late in life, excited many people.[40] But it seemed shallow to others, who thought that emphasis on transitory effects would undermine hard-won progress toward synthesis and order in culture. They also feared that painting would become scientific and utilitarian if it eliminated lasting emotion in favor of momentary pleasures of the eye.[41] Henry James, among others, deplored the early emphasis on surface realism. "To embrace them [the impressionists] you must be provided with a plentiful absence of imagination," he wrote in 1876.[42] George Inness also spoke for many who desired higher emotion in art, complaining that impressionism believed "the material is the real."[43]

Even after impressionism triumphed the world over, many observers disliked its lack of emotional complexity. "And a picture should be something more than even pictorial," William C. Brownell wrote in 1912. "To be permanently attaching it should give at least a hint of the painter's philosophy—his point of view, his attitude toward his material. In the great pictures you can not only discover this attitude, but the attitude of the painter toward life and the world in general." Despite all the good things it emphasized in painting, color, motion, and variety, impressionism was unsatisfying in this view. High art required the "presentation of an idea by means of the convergence and interdependence of objects focussed to a common and central

[39] New York *Times*, January 14, 1895; and also March 11, 1896; Arthur Hoeber, "The Art of the Month," *Bookman*, 9 (April, 1899), 137–45.
[40] "W. M. Chase," *Nation*, 103 (November 2, 1916), 428–29.
[41] Theodore Child, *The Desire for Beauty*, 172–73.
[42] New York *Tribune*, May 13, 1876.
[43] Quoted in Nicolai Cikovsky, Jr., *George Inness*, 44–45.

effect. To this impressionism is absolutely insensitive. It is the acme of detachment, of indifference."[44] In short, it lacked passion, a major aspect of the American view of the artist as a discoverer of special reality. Impressionism thus might have some ironic effects on the artist's hard-won status. It could make his image more glamorous because more colorful, yet lessen his authority as a cultural leader revealing lasting truths.

And many critics consistently denied the merit or even possibility of impressionism's vaunted spontaneity. "To assert that a fine impressionist picture looks like a natural scene, or is intended to look like a natural scene, is to state a paradox," Russell Sturgis held in 1903:

Here is a still meadow with spindling poplars and a slow-moving almost unruffled stream, and there is evidently deep soft grass on either side, and the limited range of vision is bounded by a wall of low hills. A very few cattle are knee-deep in the herbage. Those are the ponderable facts. But the artistic fact is that all this is invested with a colored light which does not exist for the ordinary looker at fields and hills and cows. What that light is depends entirely upon the mood of mind of the painter, which mood may have been superinduced by the temporary aspect of the place under a given sunset light, or by the recollection of a light seen upon another field far away, or upon all these influences taken together.[45]

Opinion varied among artists as among critics. Many men who were "modern" in 1870 after studying in Paris or Munich now feared becoming old-fashioned in their own lifetime and resisted accordingly. Older artists disposed to emphasize subject matter and symbolic emotions were often bitterly hostile to impressionism. The notion that the

---

[44] William C. Brownell, "French Art. III. Realistic Painting," *Scribner's Magazine*, 12 (November, 1912), 604–27. See Also New York *Tribune*, April 10, 1886; Clara Stranahan, *A History of French Painting*, 459; "Brownell's French Art," *Nation*, 73 (November 21, 1901), 400–401.

[45] Russell Sturgis, "Painting," *Forum*, 34 (January, 1903), 421; and also Frank J. Mather, Jr., "Art," *Nation*, 90 (January 6, 1910), 21.

painter recorded what he saw rather than what was "really" there seemed an extension of the hotly debated "art for art's sake" idea. Some painters thought the style too impersonal, while others thought it too individualistic. "Every aesthetic activity will become more sensuous and less intellectual," a *Scribner's* critic warned in 1891. "And the work of every artist will become less coherent and more chaotic." [46]

But other spokesmen did not regret the abandonment of academic formulas. "It is distinctly felt that the painters have worked with decided intention," the *Critic* noted of the Durand-Ruel show, "[and] that if they have neglected established rules it is because they have outgrown them, and that if they have ignored lesser truths, it has been in order to dwell more strongly on larger [ones]." [47]

Those who approved of impressionism saw it as a new level of expression and status for the painter. "In fact it is the presence of vivacity and vitality which induces us to think less of faulty drawing and discordant colors," the New York *Tribune* noted in 1886. "These men paint as if they liked it, with an abandon in which there is a certain sensuous charm." [48] And Clarence Cook caught this attractive spirit with his usual candor. "Allow for all exaggerations, deduct for all the crudeness, and vain shooting at the sun," he too noted of the Durand-Ruel show, "[and] what everyone must feel here is the work of men delighting in the exercise of their art, not working at a task for the sake of boiling the pot, not weaving rhymes at a penny a line, but singing as they paint, and facing the new world with the leaping wine of discovery in their veins." [49]

[46] "Point of View," *Scribner's Magazine*, 9 (May, 1891), 657–58. See also Jervis McEntee Diary, April 10, 1866, AAA; New York *Times*, April 10, 1886; T. C. Steele, "Impressionalism," *Modern Art*, 1 (Winter, 1893); Nancy Hale, *The Life in the Studio*, 198.

[47] *The Critic*, April 17, 1886, cited in Rewald, *History of Impressionism*, 531.

[48] New York *Tribune*, April 10, 1886.

[49] Clarence Cook, "The Impressionist Pictures," *Studio*, 21 (April 17, 1886), 245.

A growing stream of approval complemented criticism of impressionism into the 1890's, for Americans found many of its qualities attractive. On both sides of the Atlantic impressionism appealed to the era's desire for a colorful and interesting life style. It depicted many informal activities such as dancing, picnicking, boating, and outings in the park, yet remained stylish. Treatments of smoke, of steam and fog, of water reflections, and of changing light and foliage were equally exciting. Impressionism's general concern with motion and change in optimistic settings made it attractive to the industrial age. And it promised refinement and enjoyment through art to a widening range of people who had hitherto found art forbidding or threatening.[50]

The impressionists' use of contemporary subjects, which Europeans often criticized, appealed to more egalitarian, present-minded Americans. "That has in all ages been the truest art which has best expressed the ideas, the life, manners, and beliefs of the time, as felt by the artist whom they inspired . . . ," S. G. W. Benjamin noted in 1875.[51] Scenes drawn from the streets, labor, amusement, and domestic life seemed only logical to many younger painters. "I believe the man who will go down to posterity is the man who paints his own time and the scenes of everyday life around him," Childe Hassam said in 1892. "A true historical painter, it seems to me, is one who paints the life he sees about him, and so makes a record of his own epoch."[52]

Impressionism was also attractive in offering a new kind

[50] Albert Rhodes, "A Day with the French Painters," *Galaxy*, 16 (July, 1873), 5–15. See also the general discussion in Richardson, *Modern Art and Scientific Thought*, 22.

[51] S. G. W. Benjamin, "The Practice and Patronage of French Art," *Atlantic Monthly*, 36 (September, 1875), 257; and Bacon, *A Parisian Year*, 78.

[52] A. E. Ives, "Mr. Childe Hassam on Painting Street Scenes," *Art Amateur*, 27 (October, 1892), 116–17. Camille Mauclair, *The French Impressionists*, 40, is an interesting French view. See the letter of Eugene Boudin in Rewald, *History of Impressionism*, 44, for a good statement of this belief in the need to portray the new middle class.

of interplay between artist and audience. Previous painters of both realism and allegory had treated the canvas as an object to be studied rather than as an event in life. The sense of motion and inexactness in impressionist works demanded participation of the viewer, who gained added significance as a part of the scene.[53]

And while many in the older generation suspected the sensuousness of impressionism's color and light, the new art world was ready for this richness. Critics who matured in the 1850's and 1860's generally criticized light and color effects more than did painters and patrons who came of age after 1865. Impressionism had a waiting audience desiring eye appeal and immediacy, no matter what older critics said about the need for uplifting art. Theodore Robinson even held that a new level of artistic perception accompanied other complexities in modern life. "It is a plausible theory that our forefathers saw fewer tones and colors than we," he wrote in 1892, "that they had, in fact, a simpler and more naive vision; that the modern eye is being educated to distinguish a complexity of shades and varieties of color before unknown."[54]

Critics who began by opposing impressionism's "garishness" often came to accept the light it let into the art world, once a sense of form and design tamed it. "We needed a revolution of a violent kind to restore to the eye its simple

[53] See the Renoir statement of about 1908 in Rewald, *History of Impressionism*, 582; and also Richardson, *Modern Art and Scientific Thought*, 20. Frank J. Mather called this sense of participation "a vividly quick transaction between the individual soul and nature." See his "The Present State of Art," *Nation*, 93 (December 14, 1911), 587.

[54] Theodore Robinson, "Claude Monet," *Century Magazine*, 44 (September, 1892), 699. He earlier thought this was the result of habit and certified taste, which the new painters would simply have to educate the art public against. "We have quite a fight on our hands in America to get people away from their liking for the dam'd [?] low-toned [?] greasy bituminous sort of thing, niggled over no end, which came in with the Düsseldorf men, and has been faithfully kept up since." Robinson to Kenyon Cox, May 22, 1883, Cox papers, AALCU.

rights as first counsellor for the graphic and plastic arts," Frank J. Mather noted in the retrospect of 1910.[55]

Impressionism always had critics, and no single kind of painting ever dominated American art. Allegorical murals, literal realism, sentimental anecdotage, and Munich-derived landscapes and portraiture all accompanied its march to acceptance. But by the turn of the century impressionism was a major influence in the art world. In retrospect, its appeals were obvious. Subject matter drawn from daily life seemed egalitarian and personal. Motion and change were consistent aspects of American taste. Impressionism was rapidly identified with progress and modernization. The style was suitable to any section or class in the United States. And it appealed strongly to a generation weary of studied complexity and the search for higher emotion in art, and ready for sense appeal. "Going from this world of frank color to the timid apologies and harmonies of the old-school painters is depressing," Hamlin Garland noted for many of his generation in 1894. "Never again can I find them more than mere third-hand removes of nature."[56]

Impressionism became a world style, suitable to many landscapes and cultures in the new industrial era. But its practitioners in every country adapted to local conditions and traditions. The "American solution" centered on depicting a new level of color and light without dissolving form and design. All the major American impressionists, such as John H. Twachtman, Childe Hassam, J. Alden Weir, and Theodore Robinson were trained in European schools. While generally embracing impressionism's main thrust toward higher tones and light effects, they avoided extremes of raw color and broken composition.

Robinson was one of many American impressionists who used photographs in designing oils. This was partly a mat-

---

[55] Frank J. Mather, Jr., "The Painting of [Joaquin] Sorolla," *Nation*, 90 (March 3, 1910), 221; and "The Field of Art: Impressionism," *Scribner's Magazine*, 21 (March, 1897), 391.

[56] Hamlin Garland, *Crumbling Idols*, 121–41.

ter of economy, since he generally lacked money to hire models, but also revealed a determination to keep a sense of place and structure in his works.[57] Critics usually praised the solid appearance of his canvases, calling him "an intelligent artist" for wedding substance to an impressionist technique.[58]

And Robinson often finished works in the studio, disregarding the impressionist conventions about *plein air* painting as vital to realism and spontaneity. Many of his most popular works hid painstaking labor and retouching beneath a colorful and interesting treatment.[59] Throughout his short life (1852–96), Robinson was concerned to retain the essence of form under impressionist color and motion. A friend of Monet's, he reported in 1892 that the master was developing a fresh concern for form now that impressionism's initial liberating impulses were hardening into conventions.[60]

Though attracted to impressionism's new sense of light, Americans continued to analyze subject matter and emotional appeals. In a typical discussion of Monet's work in 1896, a critic dwelled on how poplars seemed to sway, the appearance of boats and water, and what costumes looked like, without emphasizing actual changing light in the pictures.[61]

The main American impressionists did not wish merely to record, but to interpret both light and the objects it illuminated. Philip Hale, who lived near Monet while studying in France, and who became a significant Boston painter after returning in 1895, typified this approach. "My mother and father had the utmost contempt for painters who painted things out of their heads," his daughter recalled:

---

[57] John I. H. Bauer, *Theodore Robinson, 1852–1896*, 35–37.

[58] "Fine Arts: The Society of American Artists," *Nation*, 50 (May 8, 1890), 382.

[59] "The Field of Art," *Scribner's Magazine*, 19 (June, 1896), 784–85.

[60] Diary of Theodore Robinson, October, 3, 1892, FARL.

[61] "Claude Monet," *Scribner's Magazine*, 19 (January, 1896), 125.

Not that they wanted to paint what is sometimes called photographically; far from it. They wanted to "render the object"—an immensely subtle process involving the interplay of the painter's subjective view with the way light actually fell upon the object. The conflict—rather, the marriage—of objectivity and subjectivity was what made art such a wildly exciting and magical thing to my parents that they cared about literally nothing else, except maybe me.[62]

Similar concerns for unified design and a harmonious effect dictated a subdued coloration in American impressionism. Americans did not want either light or color to overwhelm a painting's total effect. "Garishness" militated against the new sense of realism that supposedly was impressionism's purpose. Americans tended to use soft colors and careful blendings to create an emotional mood as well as visual splendor. A critic reviewing an impressionist show in 1893 remarked that the American canvases lacked "the splendid barbaric color that distinguishes the work of the Frenchmen. They tend to silvery greys modified by greens and blues quite as silvery."[63] And in 1896 a Boston newspaper praised Weir's work as "Impressionism minus the violence. . . ."[64] Many critics remained skeptical of the sensuous color in classic impressionism, however much it appealed to the public, preferring the "cool, grey ghosts of passionate feeling . . ." in Weir's best work.[65]

[62] Hale, *Life in the Studio*, 20. Cecilia Beaux had similar reactions to impressionism, liking many of its aspects while preferring "Nature's Trinity: The Sun or Light, the Object, and its Shadow. Out of the union of these three emerged Form. Form made flesh and dwelling among us, [was] intimate and divine at the same time." See Cecilia Beaux, *Background With Figures*, 127–28. See also Allen Tucker, *John H. Twachtman*, 9; and Homer St. Gaudens, "Thomas W. Dewing," *Critic*, 48 (May, 1906), 419.

[63] Quoted in *Life and Letters of J. Alden Weir*, 178.

[64] Quoted in *Ibid.*, 188.

[65] New York *Times*, April 11, 1915, Part V. pp. 22–23. See also Charles H. Caffin, *American Masters of Painting*, 14–15; and Christian Brinton, "The Conquest of Color," *Scribner's Magazine*, 62 (October, 1917), 513, noting in passing "the typical American looks askance upon any degree of chromatic license."

This sense of resolved conflicts within an impressionist technique was clear in the work of John H. Twachtman. He infused canvases with a reassuring harmony in a coloration that created a moody, romanticized effect. Twachtman and other American impressionists of like approach won approval for seeking "to paint the *feeling*, not the thing; and in the measure that the feeling of the painter is of distinguished quality his work reveals it."[66] His canvases were calm yet moving. He was "among the few artists who, having taken up the impressionist principle, found a way to express his personal ideas with a true degree of personal force," according to the painter Marsden Hartley.[67] Many critics praised the mystery and harmony in his works, as well as Twachtman's sense of abstract design.[68]

This modified impressionism was applicable to both city and country life. It helped balance the old American conflict between liking and fearing nature, making landscape both intense to the eye and reassuring to the mind. Painters like Hassam who focused on urban life did so through a curtain of life. Their work transformed urban impersonality into stylish design, haste into vitality, confusion into an interesting variety. Impressionist portraiture dwelled on personality rather than character, often treating the figure as a form of action rather than as an object. In many ways, American impressionism was both modern and traditional.

These tastes affected attitudes toward the major French impressionists. The work of Edouard Manet was the first contact for many Americans seeking to understand impressionism, and it retained a special place in criticism and appreciation. Manet's painting was labeled impressionistic

[66] Frank Fowler, "Paintings at the Carnegie Art Institute, Pittsburgh, Pa.," *Scribner's Magazine*, 41 (March, 1907), 381–84. See also New York *Times*, March 7, 1901; *Life and Letters of J. Alden Weir*, 189–90; and "Third Annual Exhibition of Ten American Painters," *Artist*, 27 (April, 1900), xxvii–xxviii.

[67] Marsden Hartley, *Adventures in the Arts*, 76–77.

[68] See the comments of J. Nilsen Laurvik in John E. D. Trask and J. Nilsen Laurvik (eds.), *Catalogue de luxe of the Department of Fine Arts, Panama-Pacific International Exposition . . .* , I, 24.

and was clearly innovative. Yet it retained old masterish qualities that made him seem more serious than many early compatriots intent on dissolving form in a shower of color and light.

Manet had an unusual sense of proportion and figure placement. His colors were strong and familiar. This helped make his paintings seem both disturbing and interesting to early observers. His work also radiated a positive sense of trying to escape formal conventions. This and an obvious ability to paint, with a new but subdued sense of light, appealed to many critics and painters dissatisfied with formulas, yet not willing to abandon inherited standards of form.

A few Americans immediately approved of Manet, even while remaining skeptical of impressionism. "The most interesting thing in Paris now is Manet's exhibition," Sargent wrote a friend of the retrospective show in 1884. "It is altogether delightful."[69] In the first debates over impressionism, many critics gave Manet the benefit of the doubt, praising his intentions if not his work. A critic noted of the Salon of 1880, that Manet was "less mad than the other maniacs of impressionism. . . ." He was "not to be judged by the same standards as are those who have joined the ranks of the Impressionists merely because it is easier to dash off an unnatural daub, defying all the rules of perspective and colouring, than it is to paint an accurate and carefully finished picture."[70]

There was a similar tendency to see Edgar Degas as something more than an impressionist. His unusual subject matter, such as ballerinas and jockeys, was appealing. His use of the snapshot effect, cropping the edges of a scene, drew in the spectator and emphasized motion. But Americans most

[69] Quoted in Charles Merrill Mount, *John Singer Sargent*, 74–75.

[70] Lucy H. Hooper, "Art-Notes From Paris," *Art Journal*, 6 (1880), 188. See also Frank Fowler, "Modern Foreign Paintings at the Metropolitan Museum: Some Examples of the French School," *Scribner's Magazine*, 44 (September, 1908), 381; Brownell, "French Art. III. Realistic Painters," 622; New York *Times*, March 12, March 17, 1895; Christian Brinton, *Impressions of Art at the Pacific Exposition*, 14.

often praised his sense of proportion, drawing, and firm coloration. Like Manet, he echoed old masters while employing impressionism's spontaneity and excitement. A critic summarized this view in 1917: "Degas remains at heart a classic. A certain antique purity of poise and rhythm always characterizes his slender steeplechasers and none too seductive exponents of the *pas seul*."[71]

Of the first impressionists, Claude Monet had the strongest impact on Americans. His emphasis on light and high colors seemed the best statement of the new style to those disposed to like impressionism. Opponents used his canvases to illustrate its excesses, proponents to show its appeals. A mere five years after the Durand-Ruel show of 1886, Pissarro complained that Monet had dominated the American market.[72]

Monet's work passed through several stages during a long lifetime, and he was never as concerned with surface appearance as some critics contended. He always sought to depict context as well as light and color.[73] Like other impressionists, Monet doubtless first exaggerated the need for *plein air* painting, immediacy and light. He admitted to Robinson that every scene required some study.[74] And he declined to visit America because he could not paint in a country he did not know from long experience. He also chided Americans for trying to depict foreign scenes they did not understand.[75]

By the 1890's, Monet's work had gained a new subtlety. In time, critics treated him as more than a splendid eye.

[71] Brinton, "The Conquest of Color," *Scribner's Magazine*, 62 (October, 1917), 516. See also Stoddard Dewey, "Degas' Art and Its Value," *Nation*, 96 (January 23, 1913), 90.

[72] Pissarro to his son Lucien, April 3, 1891, *Letters*, 159.

[73] Lilla Cabot Perry, "Reminiscences of Claude Monet from 1889 to 1901," *American Magazine of Art*, 18 (March, 1927), 120. See also *Paintings by Monet*, Art Institute of Chicago, 1974, 20–21.

[74] Theodore Robinson Diary, June 21, 1892, FARL.

[75] Walter Pach, "At the Studio of Claude Monet," *Scribner's Magazine*, 43 (June, 1908), 765–66.

Charles Caffin said in 1911: "We have discovered our mistake and realize now the subjective character of his vision; that it was not satisfied with the external aspects of the scene; that, in fact, it penetrated to its very core and brought to the surface its spiritual inwardness." [76]

And after the first shock or infatuation with color and sense reaction passed, the structure of Monet's paintings seemed to emerge from the captivating light. As the New York *Times* said in 1915:

. . . Monet gains in solidness with time. One comes to see under the robe of light which he worked over continually a structure of true form. The Bordighera houses sit firmly on their foundations. The haycock in the winter fog is a thing of substance, loosely packed together though it be; the houseboat lounging along the Seine for a morning's voyage is fit to shelter and convey its human freight. [77]

Of course, these perceptions also fitted the American need to see with more than the eye, and to find in nature more than light and color. [78]

Impressionism's larger aesthetic and cultural meanings fascinated the critics who charted its progress toward acceptance. The shrewdest of them realized that it was not the

---

[76] Charles H. Caffin, *The Story of French Painting*, 178–179. Caffin noted elsewhere that Monet's lack of analysis was in fact an effort to let nature speak for itself, thus intensifying its effect and meaning. See his *American Masters of Painting*, 116–17.

[77] New York *Times*, December 12, 1915, Sec. III, p. 2.

[78] A standard encyclopedia entry in the early part of the debate over impressionism reflects the desire for "deeper meanings" that Americans ascribed to the new paintings: "IMPRESSIONISTS, Class of painters who strive to reproduce on canvas the impression that nature makes on them. Impressionism differs from realism in that it attempts to go deeper; and besides showing a glimpse of nature as it really appears to the eye seeks to convey an idea of the effect that particular piece of landscape or marine view exerts on the mind. The new school originated in London [sic]. It has drawn the severest criticism of veteran painters; but has gained a degree of popularity, and seems likely to exert at least some modifying force in art." *Alden's Manifold Cyclopedia*. New York, John B. Alden, 1889, XIX, 478.

radical departure it seemed in the 1870's and 1880's. The Barbizon painters, English artists like Turner and Constable, among others, all symptomized a growing tendency to emphasize the transitory and personal aspects of nature. Like many innovators, proponents of impressionism first insisted on its newness, then as approval came, looked for certifying antecedents. Most of the French impressionists had academic training, and many persistently longed for the acceptance symbolized in Salon honors and government purchases. "While renouncing the academic traditions, the Impressionists have taken great care to provide themselves with a very respectable pedigree," an American critic noted in 1892.[79]

The art community retained the twin desires to make art part of life in general, and to enhance and protect the artist's status in a fluid and democratic society. This underlay much of the critical effort to explain and incorporate impressionism into a general art tradition. The public appreciated its surface appeals. But after the initial fascination with technique, critics tended to see impressionism as another manifestation of special qualities in modern life.

Much of modern life, especially in cities, compressed and intensified experience. This tended to make the sense of living episodic rather than continuous and created demands for a heightened sense of meaning registered in intense moments. Observation replaced reflection and analysis. A critic in 1895 caught the essence of this drift in a striking analogy: "In this day, when even steam is growing old-fashioned, and electricity is taking its place, it is not surprising that much of the work of our younger artists should resemble the telegram. To the past belongs the well turned phrases, the courtly elegance of the leisurely letter-writer; to transmit the essential thought is the object of to-day. Hence the 'advanced' picture."[80]

---

[79] R. R., "From Another Point of View," *Art Amateur*, 28 (December, 1892), 5.

[80] W. Lewis Fraser, "Sergeant Kendall," *Century Magazine*, 50 (July, 1895), 478.

Emphasis on compression revealed both a new belief in individual perception and the desire for a total effect characteristic of a broadened art public. The idea that both artist and viewer were part of a creative process appealed to this audience. This made both art and nature susceptible to experience rather than analysis. Capturing the moment that signified a larger complex process became a major concern of art in general.[81] Skyscraper architecture revealed this effort to arrest but emphasize upward motion. And modern sculpture tried to intensify the symbolic act. As Frank J. Mather said in 1911: "In fact, the essence of impressionism lies, not in technical recipes of any sort, nor yet in subject matter, but in this endeavor to isolate and enhance the creative moment, preserving at all costs the innocence of the eye and reducing the life artistic to a series of keen but disconnected emergencies."[82]

Impressionism was also part of the era's general intellectual emphasis on endless experience. The excitement of discovery displaced contemplation. Impressionism radiated a sense of infinity, of "a focus with indefinite edges" that invited exploration.[83] This sense remained optimistic and progressive until a bittersweet fatalistic tone invaded *fin de siècle* art.

The arts generally reflected by the 1890's, a decline of social stability and predictability, which some found exciting and others threatening. A growing number of people saw life and nature not as stable entities, but as means to register experience and feeling. Impressionism on some level allowed the artist to express that sense of fragmentation in an orderly way. And it equally permitted the viewer

---

[81] See Louis Weinberg, "Current Impressionism," *New Republic*, 2 (March 6, 1915), 124.

[82] Frank J. Mather, Jr., "The Present State of Art," *Nation*, 93 (December 14, 1911), 585. See also Eliot Clark, "Theodore Robinson: A Pioneer American Impressionist," *Scribner's Magazine*, 70 (December, 1921), 763–68.

[83] See Harper Pennington, "Whistler," *Scribner's Magazine*, 35 (May, 1904), 640, for some good general remarks on this trend.

to control that sense of impending chaos in meaningful participation. Despite its identification with surface appearance and unsophisticated reactions, impressionism was in some measure part of a general effort to depict unconscious motivations and desires.[84]

On more personal levels, critics continued to dissect impressionism even as newer styles invaded the American art world. Some always held that impressionism was a passing fad; others thought its popularity rested on dealers' propaganda. And some critics accused brethren of riding bandwagons, praising everything new in case it was the wave of the future.[85]

But by the 1890's discussion of impressionism took on the past tense. The style had clearly triumphed with a large section of the art world. In 1900, Charles Caffin chided the French for not accepting impressionism fully.[86] Closer to home, others criticized museums, especially pacesetters like the Metropolitan, for not buying more impressionist works, now that the public and painters approved.[87]

But the unthinkable happened in the new century. Impressionism became "academic," "old-fashioned," and "conventional," all the words its adherents had thrown at

[84] Russell Sturgis, "The Recent Comparative Exhibition of Native and Foreign Art," *Scribner's Magazine*, 37 (February, 1905), 256, touches this idea. See also Linda Nochlin, *Impressionism and Post-Impressionism . . .* , 17.

[85] See William Howe Downes, "Impressionism in Painting," *New England Magazine*, 6 (July, 1892), 600–603; Charles De Kay, "French and American Impressionists," special feature article in New York *Times*, January 31, 1904, p. 23; Mather, "Art," *Nation*, 90 (April 28, 1910), 443–44; and Leo D. Stein, "An Inadequate Theory," *New Republic*, 5 (January 29, 1916), 340.

[86] "The Art and Influence of Paris Today," *Artist*, 29 (October, 1900), iii. In retrospect, the famous French dealer Ambroise Vollard agreed that the French public had not really accepted impressionism by the 1890's; see his *Recollections of a Picture Dealer*, 32–43.

[87] Frank Fowler, "Modern Foreign Paintings at the Metropolitan Museum, Some Examples of the French School," *Scribner's Magazine*, 45 (September, 1908), 384.

foes a generation earlier. Yet impressionism's decline in the hands of all but a few artists was clear. It was dexterous and elegant painting but became thin and decorative. As Mather noted in 1910: "The danger is lest blondness degenerate into the generalized pink bloom of Boucher, or attenuate itself more acceptably in the nacreous greys of Fragonard."[88] The style also developed a set of conventions equal to those of any school that triumphed in the past. ". . . the purple cow eating blue grass against a green sky was not wholly a myth," the art historian Samuel Isham noted.[89] And some critics always attacked the lack of form and overuse of light.[90]

New critics, oriented toward an emerging abstractionism, dismissed impressionism as the final form of a realism too limited for the modern age. That age, in their view, would live by symbols rather than objects.[91] And however much impressionism had helped that trend toward abstraction with debate and technique, its time had come and passed away. The new art would come from the mind, not the eye.

[88] Frank J. Mather, Jr., "The Pennsylvania Academy," *Nation*, 90 (February 3, 1910), 122.

[89] Samuel G. Isham, "French Painting at the Beginning of the Twentieth Century," *Scribner's Magazine*, 38 (September, 1905), 384; Henry G. Stephens, "Impressionism: The Nineteenth Century's Distinctive Contribution to Art," *Brush and Pencil*, 11 (January, 1903), 279–97; and *Collector and Art Critic*, 2 (February 15, 1900), 135.

[90] See Caffin, *Story of American Painting*, 269.

[91] See Willard Huntington Wright, *Modern Painting*, 83, 233; Frank J. Mather, Jr., *Modern Painting*, 218; Walter Pach, "Some Reflections on Modern Art Suggested by the Career of Arthur Burdett Frost, Jr.," *Scribner's Magazine*, 63 (May, 1918), 637. See the interesting analysis in Meyer Schapiro, "Nature of Abstract Art," *Marxist Quarterly*, 1 (January–March, 1937), 82.

# 5. Modernism
# and a New Century

The progress of impressionism epitomized many funda-
mental changes of taste and purpose in the post–Civil War
art world. The period's basic art tendency was toward inno-
vation rather than elaboration of inherited methods and
aims. This inevitably emphasized the artist's importance as
an experimenter in search of nature's true meanings. It also
gave a fresh sense of importance to the whole art world as
part of ongoing progressive thought. And it meant that
painting was more and more free to explore nonmaterial and
invisible life. This process underlay the "modernism" that
agitated the new century.

The pervasive interest in gesture and experiment, trans-
lated in painting as color, new subject matter, and motion,
dominated the era's intellectual life. "It is characteristic of
the progress of science that we are constantly compelled to
reconsider the hypotheses of our predecessors," an art
magazine noted in 1880, "and to regard almost any funda-
mental hypothesis as merely tentative and temporary." [1] By
1911, Charles Caffin alternately praised and worried over
demands for innovation that flooded the art world. [2]

These tendencies became visible in various emphases
within the art world. Foremost was a consistent desire
among "moderns" of whatever persuasion for a fresh sense
of sight. The eye must widen the mind's scope of experience

[1] "Sketches and Studies," *Art Journal*, 6 (1880), 174.
[2] Charles H. Caffin, *The Story of French Painting*, 173.

and intensify effects. Russell Sturgis warned in 1866 that "the duty of the art critic for many a year to come must be to teach the principles of art which appeal to the eye."[3] This would enrich life and create a general artistic renaissance. It would also have unforeseen results, in steadily increasing demands for intensified sensation through the condensation of forms as the eye wearied of familiar reality.

The desire for variety and intensity of response rapidly turned new painters from imitating nature to evoking feeling of some kind. William C. Brownell noted this in 1880: "Almost without exception, nature is to them a material rather than a model; they lean toward feeling rather than toward logic; toward beauty, or at least artistic impressiveness, rather than literalness; toward illusion rather than toward representation."[4] Each aspect of this process would add to the momentum toward abstraction that triumphed after 1900.

It was but a short step to let the artist define painting's appearance as well as purpose. "Is not true art work, on the contrary (to art that exists for its own sake), instantly recognized as its own excuse for being?" the critic Mariana G. van Rensselaer asked in 1880 amid the "art for art's sake" debate. "Does it not express the fact that at the time of its production its author existed for its sake alone, that he and none other could have done thus and so, and that he could have done no other thing—and this thing in no other way—at just that time and in just that mood?"[5] One logical, if sometimes undesired conclusion from this tendency was that art came from what artists believed and saw, not from nature or recognizable reality.

[3] Russell Sturgis, "Fine Arts: What is Art Criticism?", *Nation*, 2 (April 19, 1866), 505. See also Frank Fowler, "The New Heritage of Painting in the Nineteenth Century," *Scribner's Monthly*, 30 (August, 1901), 354; and "The Value of Art Effort," *Scribner's Monthly*, 44 (September, 1908), 253—54.

[4] William C. Brownell, "The Younger Painters of America," *Scribner's Monthly*, 20 (May, 1880), 7–8.

[5] Mariana G. van Rensselaer, "Artist and Amateur," *American Art Review*, 1 (1880), 339–40.

To traditionalist critics this drift represented artistic egotism and instability.[6] But more sympathetic critics saw it as a way of enhancing the artist's role and of increasing art's importance generally. In any event, the idea that the artist defined art's nature was a key inheritance from the old century to the new. In retrospect Americans saw Manet as the transitional figure. His work was not really about impressionism or realism but the artist's role as creator of art. As Christian Brinton insisted in 1915: "Manet won two imperishable triumphs. He demolished the sterile prestige of academic tradition, and he taught us the possibilities of painting as a thing existing of, and for, itself alone—as something independent of history, allegory, or anecdote."[7]

The appearance of painting changed as much as its apparent meanings throughout the period. The early turn away from realism first emphasized a new sense of color, then of perceiving objects. "The true interest of the subject is quite independent of the objects that are depicted," a writer noted in 1889 of Duveneck's *Turkish Page*, "and resides for the most part in the delightful harmony of a complicated scheme of color."[8] Impressionism carried this trend to a logical conclusion, dissolving apparent form in color perceptions, with an emotional response.

A desire for abstract forms and designs accompanied the interest in color. Winslow Homer was one of many painters to win critical praise for depicting forceful emotions in simplified forms. "Before Cézanne, he loved to see nature as raw planes thrusting and grinding against each other," Frank J. Mather noted in retrospect, "and he settled at Prout's Neck where nature gave the daily spectacle of the gnawing and gnashing of the sea against the frayed edges of the land."[9]

---

[6] See *Nation*, 63 (November 12, 1896), 368.

[7] Christian Brinton, *Impressions of Art at the Panama-Pacific Exposition*, 14.

[8] Walter Montgomery (ed.), *American Art and American Art Collections*, II, 984.

[9] Frank J. Mather, Jr., *Modern Painting*, 178.

Edmund C. Tarbell (1862–1938) in his studio. *Courtesy Library of Congress*

Other painters followed the same general aims with different gestures. To the fashionable portraitist Thomas W. Dewing, female figures were symbols, regardless of their dress or occupation. Like many other artists, Dewing worked toward an abstraction whose full implications he did not understand or, perhaps, desire. But his rather abstract design and tone helped prepare the art public for a new kind of seeing and response. By the mid-1890's he and others represented "the growing indifference of the school to subject considered purely as subject." [10]

The same desire to see forms and painterly design was pronounced in the work of John W. Alexander. Noted for his elegance of line and arrangement, Alexander emphasized planes, outlined forms and stripes, and mere areas of paint. His figures remained recognizable but were basically means of rearranging reality into an artistic statement that transcended visible nature. [11]

*Fin de siècle* painting also bore overtones of complex emotions that both disturbed and fascinated the art world. A mystical strain in American art had long dealt with nonrealistic themes. A few painters like Elihu Vedder and Albert Pinkham Ryder employed a romantic symbolism to suggest depths to reality and "to give to the unreal and impossible an air of plausibility and real existence." [12] But

[10] Royal Cortissoz, "Some Imaginative Types in American Art," *Harper's Monthly*, 91 (July, 1895), 166. See also Charles H. Caffin, "The Art of Edmund C. Tarbell," *Harper's Monthly*, 177 (June, 1908), 66.

[11] Alexander is an interesting bridge between inherited realism and abstraction. See "The Field of Art," *Scribner's Magazine*, 19 (March, 1896), 391; Harrison S. Morris, "The Portraits of John W. Alexander," *Scribner's Magazine*, 25 (March, 1899), 340–48; Christian Brinton, "The Art of John W. Alexander," *Munsey's Magazine*, 39 (September, 1908), 744–55; Charles H. Caffin, "John W. Alexander," *Arts and Decoration*, 1 (February, 1911), 147–48; Margaret Steele Anderson, *The Study of Modern Painting*, 231; Howard Russell Butler, "John White Alexander," *Scribner's Magazine*, 58 (September, 1915), 387–88. Kenyon Cox, "John White Alexander," *Scribner's Magazine*, 58 (September, 1915), 386; and Arthur Jerome Eddy, *Cubists and Post-Impressionists*, 198.

[12] See Montgomery, *American Art and American Art Collections*, I, 163.

this romantic tendency remained generally optimistic or, at least, nonthreatening.

Impressionism seemed to exhaust the possibilities of realistic representation. And while delighting the eye, it also hinted at unseen elements of nature beneath the vibrant light and color. Willard Huntington Wright saw impressionism as an unwitting agent of the abstract modernism he praised. It had sought first principles and "turned the thoughts of artists from mere results to motivating forces, from the ripples on the surface to the power which causes the tides." [13]

The challenges these diffuse tendencies represented both for the form and emotional content of painting were clear to some critics. Of changes in appearance, Kenyon Cox noted in 1905: "It would seem that painting can go no further in the direction of Whistler's later work without ceasing altogether to be the art we have known by that name." [14] Of changes in emotional effect, Christian Brinton said in 1915: "With the ancients, painting remained a submissive servant. With Whistler it became an aesthetic adventure. With us it is more and more assuming the aspect of a subjective experience." [15]

The post–Civil War generation of artists and patrons was turbulent and experimental, with many ambitions and means. But a movement away from literal reality and certified emotion toward complexity and ambivalence was dominant. A new conception developed that art was a form of expression relying less on familiar appearances than on an artist's singular vision. The painting and the gesture became objects and emotions, and the artist's view of essentials was a new form of reality. There was no inevitable, observable linear development toward abstraction as an alternative to realism. But on many psychic levels, the new

[13] Willard Huntington Wright, *Modern Painting: Its Tendency and Meaning*, 88.

[14] Kenyon Cox, *Old Masters and New*, 231.

[15] Brinton, *Impressions of Art at the Panama-Pacific Exposition*, 27.

generation of 1900 was ready for a fresh modernism, even if it seemed shocking and radical.

Knowledge of that modernism entered the art world in stages, then it became the subject of a major cultural debate, much as with impressionism a generation earlier. A few native painters, of course, always opposed prevailing conventions. The general press and special art publications both reported their criticism, and an occasional show after 1900 displayed their work to the public. The dual appeals of nationalism and cosmopolitanism continued, as did varied styles of painting. But the most controversial art news came from abroad, where the art world, especially in France, was in turmoil again by the early years of the century.

New York was the country's cultural center, and various institutions there hosted examples of the controversial new European art. The focus of these displays was Alfred Stieglitz's Photo-Secession Gallery at 291 Fifth Avenue, dedicated to the avant-garde. Between 1908 and 1913 the Gallery showed many works of the "postimpressionists" as well as early abstractionists. From November, 1905, to April, 1912, some 167,000 people visited the Gallery's shows.[16] Many painters and students also saw new work in France and brought back reports and reproductions. Their impressions were fragmentary but affected the New York art scene. The Armory Show of 1913 was a major catalyst of cultural opinion but did not burst on an unprepared or unsympathetic art world.[17]

The public tended to see "modernism" as a single trend, but knowledgeable critics analyzed its component parts. Postimpressionism, cubism, futurism, vorticism, orphism,

[16] New York *Evening Sun*, April 27, 1912.

[17] "The Exhibitions at '291,'" *Camera Work*, 36 (October, 1911), 29; William Innes Homer, *Robert Henri and His Circle*, 174–75; and Charles Eldridge, "The Arrival of European Modernism," *Art in America*, 61 (July–August, 1973), 35–41. The details of the famous Armory Show (not repeated here) are in Milton W. Brown, *The Story of the Armory Show*; and Meyer Schapiro, "Rebellion in Art," in Daniel Aaron (ed.), *America in Crisis*, 203–42.

and other "isms" became familiar, if confused, subjects in
the art press. But whatever their varieties and differences,
these styles did form a larger "modernism." Critics judged it
with three general canons: departure from realistic por-
trayal, insistence on the merit of the artist's individual ex-
pression, and the new painters' apparent lack of concern for
public taste or expectations.

This modernism provoked fresh debate among the critics
armed with cultural authority won during the preceding
generation's art wars. The new painting's difficult forms and
obvious intellectual implications increased the critics' role
as educators of the public, reflectors of reigning art ideals,
and harbingers of change.

Their divided responses paralleled those of painters and
patrons. Most older critics remained oriented toward cos-
mopolitan art derived from historic models. Though labeled
"conservative," they were really traditionalists. They saw
modernism as threatening to social order, and dangerous to
the artist's hard-won social respectability. Their best known
spokesmen were probably the muralist Kenyon Cox and the
critic Royal Cortissoz, both of whose credentials were im-
peccable within narrow confines. Deeply versed in the tra-
dition they supported, neither led an ivory tower existence
divorced from competition. Both were genuinely concerned
about the need for a stable culture in the United States.
Cortissoz probably spoke best for this view late in life:

As an art critic, I have been a "square shooter," knowing neither
friend nor enemy. My belief, as an art critic, has been, briefly
stated, this: That a work of art should embody an idea, that it
should be beautiful, and that it should show sound craftsman-
ship. I have been a traditionalist, steadfastly opposed to the in-
adequacies and bizarre eccentricities of modernism.[18]

Willard Huntington Wright defended the opposite posi-
tion. His sharp pen eviscerated many a foe, and his dog-

---

[18] Quoted in his obituary, New York *Times*, October 18, 1948.

Royal Cortissoz (1869–1948), art critic. *Courtesy Archives of American Art, Smithsonian Institution*

matic voice and manner dominated numerous exhibitions and cocktail parties. He understood the European scene and admired much contemporary art. But he especially insisted on the need for Americans to perceive artists as creators of reality. He had few illusions about art politics and fads. Any innovation risked being overpraised in an era of fast communications and advertising. Just as the new art was complex in depicting new levels of consciousness, so its critical friends must be hard-minded in judgments. "The critic who does the greatest harm to modern painting is the one who defends it as a whole, who pampers and coddles it, who declares that all of it is superior to the old," he wrote in 1916. "The insincere modern men must be pointed out, lest the conscientious ones suffer." [19]

The debate's middle ground fell to a few men like Frank J. Mather, Jr., art critic for the *Nation*, professor at Princeton, and author of textbooks. Mather remained skeptical of departures in the arts, but urged an open mind and accepted those innovations derived from past tradition. He generally approved of ideational content in art and sound craftsmanship but accepted the individual artist's need to experiment. He was reasonably detached, asking that new art cite its precedents and explain its avowed purpose in intelligible terms. He was especially concerned to retain general cultural cohesion and values, while admitting art's right to change.

A host of other voices offered the public a broad range of criticism and comment. Critics for the two-cent press and ten-cent magazines relied on humor or ridicule. But impressionism had taught many commentators not to scoff at the new, and they often opted for a sympathetic blandness. [20]

[19] Willard Huntington Wright, "The Aesthetic Struggle in America," *Forum*, 55 (February, 1916), 201–20. Wright was the brother of the synchromist, Stanton Macdonald-Wright. He later became famous as "S. S. Van Dine," pseudonymous author of detective stories.

[20] See the remarks of one Israel White in the Newark *Evening News*, cited in *Camera Work* 36 (October, 1911), 53.

Throughout the debate on modernism, hostile observers accused many critics of favoring the new because they had failed to praise earlier movements that triumphed. Cox justified his "prosecuting attorney role" as a necessary balance to the positive criticism the moderns received.[21]

Much of this commentary, which shaped a broader public opinion, seemed confused or mistaken in retrospect. But the best critics were neither ignorant nor insincere, and their intense reactions, whether pro or con, revealed the importance they assigned to art. Whatever their approach, they analyzed the new modernism seriously in both aesthetic and cultural terms. They granted its claims to represent more than isolated artistic acts.

The debate attested to the preceding generation's achievement in making art important in American life. Most commentators were proud of the country's cultural growth and saw American painting as equal to any in the world. They did not wish this cultural momentum to weaken.[22] They especially feared reviving the old image of the artist as an eccentric or marginal man, pursuing a vision irrelevant to society at large or to a broader cultural tradition.[23]

The new art aroused sharp emotions after 1900 precisely because it represented basic changes both in aesthetic perception and social attitudes. In the 1880's impressionism seemed the last word in painting yet was old-fashioned a mere decade later. The once exciting Munich style was as dated as whatever it had replaced. A sense of speeded-up change permeated industrial societies. The optimism that prevailed throughout the nineteenth century faltered to-

[21] See Christian Brinton, "Evolution Not Revolution in Art," *International Studio*, 69 (April, 1913), xxvii–xxviii; "Cube Root of Art," *Independent*, 74 (March 6, 1913), 492–94; Kenyon Cox to Frank J. Mather, Jr., January 29, 1915, Mather papers, PUL.

[22] Christian Brinton, "The New Spirit in American Painting," *Bookman*, 27 (June, 1908), 351, reveals this sense of progress and ongoing motion in culture.

[23] Frank J. Mather, Jr., "Newest Tendencies in Art," *Independent*, 74 (March 6, 1913), 504–12.

ward its last decade, as the new introspective arts so clearly showed. Terms like "decadence" and "chaos" replaced "experiment" and "innovation." This sense of change was clear in demands for a constant procession of new art. "We live in a world which is growing quite delirious for something new, when any revolt is hailed as a new dispensation," the critic Frederic Harrison warned in 1893. "A man has only to shout out loud enough the new Gospel—say, 'Murder is a fine art,' 'The true beauty of dirt,' or 'Ugliness is a joy forever,'—and he straightway gathers around him a sympathetic group."[24]

Impressionism now seemed a stage in an infinite and unknowable process. "We seem to be artistically in a somewhat chaotic state," the New York *Times* noted in reviewing a Monet exhibition in 1895. "[The] old no longer suffices, nor does the new fully satisfy us. Our old gods are broken, but they have given us no new ones to whom we can bow down in submission."[25] Many American political and economic theorists remained optimistic about man's state. Artists and intellectuals in the avantgarde did not. Many would have agreed with Virginia Woolf's famous comment that "On or about December, 1910, human character changed."[26] With the clarity that comes with retrospection after passing through a complex process, the painter Jerome Myers recalled: "The American art world in the years immediately preceding 1913 was a landscape before an impending storm."[27]

The substance of that storm was more clearly defined in older European civilizations but had echoes in the United States. There was a growing sense among intellectuals and artists that the future could not be predicted from the past. The irrational or unconscious, as Freud's great works re-

---

[24] Frederic Harrison, "Decadence in Modern Art," *Forum*, 15 (June, 1893), 435.

[25] New York *Times*, January 14, 1895.

[26] Quoted in Ian Dunlop, *The Shock of the New*, 132.

[27] Jerome Myers, *An Artist in Manhattan*, 32.

vealed, often dominated the rational. Little in life thus seemed secure. The hidden and implied took on greater force than the overt or "real" in the arts. Shadows became more significant than what cast them, and the insights of a moment could equal the study of a lifetime. Condensation, symbolism, ambivalence marked the advent of a new kind of world for the creative mind.[28] As the painter-critic Walter Pach recalled: "All this distrust of fixity, of rules, came from a premonition, such as its frequently observable among artists, of something science discovers later on. In this instance it was an understanding that the role played by the unconscious in our lives had been vastly underestimated."[29]

The critic Benjamin de Casseres noted this process with mixed emotions. Earlier Americans had welcomed exploration and change, but their fortifying optimism about its results had faded. Could the art world sustain the anxiety which unresolved problems and open-ended processes created?[30] The new painters and their friends still saw the artist as a finder of special truth, now seeking the first principles, designs, and forces that underlay "reality." Could a generation that needed the comforts of that reality afford the quest? Seldom in American history was the answer so ambivalent.

These pervasive moods underlay the specific charges leveled against the new painting. Its frank abstraction and rearrangement of visible reality into private visions was disturbing. As with the first impressionist works, most viewers simply did not see "pictures" in the new art. Some found the condensed imagery exciting, but to most people

[28] These themes have been explored often but are well stated in H. Stuart Hughes, *Consciousness and Society*, esp. 16–17, 63–66; Carl E. Schorske, "Politics and the Psyche in *fin-de-siécle* Vienna: Schnitzler and Hofmannstahl," *American Historical Review*, 66 (July, 1961), 930–46; and Claudia C. Morrison, *Freud and the Critic*, 43–44.

[29] Walter Pach, *Queer Thing, Painting*, 45.

[30] Benjamin de Casseres, "The Unconscious in Art," *Camera Work*, 36 (October, 1911), 17.

the new works resembled mirrors fractured into incoherent pieces, which artists insisted still reflected reality. This often bewildered even those people inclined to accept innovation. The change seemed not a predictable phase, but a quantum jump into the unknown.[31]

Dislike of the "ugly" picture quickly became a standard critical response to modernism in general and to cubism in particular. Critics like Cortissoz insisted that the extreme modernists' desire for personal gesture simply overrode the depiction of beauty, which was art's main purpose. By "beauty" Cortissoz did not mean surface charm, but a sense of harmony, order, and interpreted form intelligible to others than the artist.[32] This beauty was a unifying cultural ideal especially important in the diffuse, materialistic American democracy. The new modernism thus seemed divisive, threatening to separate artist from public, and to overthrow the importance the mature generation had won for art in American life.

The response from promoderns was predictable: all new art looked ugly or strange because the eye and mind were not trained to see its design. Sympathetic critics readily agreed that the new abstraction was a formidable challenge to the inherited ideas of form and expression. But as Arthur Jerome Eddy said, "even the ugly, the grotesque, the hideous has its use. Any art may become so smug, so complacent, so conceited that it requires the shock of the ugly to stir it to new life. After Bouguereau, Matisse was inevitable."[33]

Almost all observers agreed that the new art, whatever its "ism," implied a changed view of reality, not merely another way of painting. Moving beyond this level of interpretation to creating a private reality, as moderns in-

[31] See the remarks of Arthur Dove in Eddy, *Cubists and Post-Impressionists*, 49.

[32] Royal Cortissoz, *American Artists*; 3, and also his *Personalities in Art*, 301; and "Incidents of the Winter Season in New York," *Scribner's Magazine*, 87 (March, 1930), 352.

[33] Eddy, *Cubists and Post-Impressionists*, ix, 157.

sisted, was challenging. As the daughter of Philip Hale the impressionist noted:

That attitude in modern painting was what profoundly distressed her [Mrs. Hale]. It was not at all that modern pictures were abstractions. "Every good painting is basically an abstraction," my father used to say. Or that they were not representational. Her dismay was different from the layman's dismay. What depressed her was the loss of that rapturous meeting between the artist's private vision and the shimmering world of objects. To her it amounted to a loss of soul.[34]

The "egotistical" painter soon joined the "ugly" picture in the stock caricatures of modernism. Cortissoz thought the moderns were "misguided experimentalists, wallowing in error."[35] Though less strident, Mather also saw the new art as unexpected fruit from the tree of democratic egalitarianism.[36] Cox saw this modernism as the final stage in the long abandonment of discipline and tradition in democratic-industrial societies. The movement from impressionism, which at least dealt with reality, to this new modernism "ended in the deification of whim." Claims of unusual insight in these artists did not move him. "We've been carefully educated to believe that genius is always misunderstood. The result is that some of us are ready to think that anything unintelligible must be full of genius."[37]

These sharp responses reflected deeper fears. Traditionalists like Cortissoz had long recognized the delicate balance in "the great aesthetic quarrel of the nineteenth century, that between tradition and temperament."[38]

---

[34] Nancy Hale, *The Life in the Studio*, 27.

[35] New York *Tribune*, February 17, 23, 1913.

[36] Mather, *Modern Painting*, 93.

[37] From a long interview with Cox in New York *Times*, March 16, 1913, Part VI, p. 1. See also Cox to Allyn Cox, April 16, 1912, Cox papers, AALCU; W. C. Brownell to Frank J. Mather, Jr., December 12, 1916, Mather papers, PUL; and Cox to Robert Underwood Johnson, August 22, 1918, Cox file, AAAL.

[38] Royal Cortissoz, *Art and Common Sense*, 182, speaking of Whistler.

Temperament, translated as egotism, now seemed triumphant. It would destroy the fragile bonds between artist and public. Cultural spokesmen had long sought a special role for art in, but not apart from, society. There was a strong fear now that the new art was frankly elitist, indifferent to the larger community's need for cultural order and expression.[39]

A few new spokesmen welcomed this change. Alfred Stieglitz cared nothing for mass opinion, and did not believe a democracy could create great art.[40] Willard Huntington Wright was blunt: "The antagonism of the masses to the artist sprang up simultaneously with the disgust of the artist for the masses. It was the inevitable result of the artist's mind developing beyond them."[41] Part of the artist's inherited role was to cultivate taste in society. In the view of people like Wright, he could now move on whether or not anyone followed. This view thus rejected both democratic and traditionalist ideals, and seemed to prove the moderns' contempt for public opinion.

Many other observers feared that emphasis on individualism would destroy the foundations of art. Both the artist's sense of importance within an ongoing tradition and his technical skill were threatened. "It is a serious matter when students are told that they must not know anything in art," William Merritt Chase insisted in a widely discussed speech given shortly before his death in 1916.[42] Young painters would now seek notoriety, shortcuts to fame and fortune. And if anyone could be an artist, what became of his status as a purveyor of special truths?[43]

---

[39] See Kenyon Cox, *Artist and Public*, 1ff.; Edward Godfrey Cox, "The Distemper of Modern Art and Its Remedy," *South Atlantic Quarterly*, 15 (October, 1916), 361–78; Edwin H. Blashfield, "The Painting of Today," *Century Magazine*, 87 (April, 1914), 838.

[40] Milton W. Brown, *American Painting from the Armory Show to the Great Depression*, 39–41.

[41] Wright, *Modern Painting*, 65.

[42] William M. Chase, "Painting," *American Magazine of Art*, 8 (December, 1916), 50–53.

The apparent turn inward to personal feelings seemed to shrink art's horizon for many observers. The artist who spoke to all the world in prior ages now seemed ready to speak only for himself and a few of like mind. The implications were ominous. The introspective search for individual expression might easily become morbid and self-defeating.[44] Mather warned in 1911 against reducing art to the "vivid isolated vision."[45] And Cox thought the modernists' symbols and views invalid precisely because they lacked connections to the larger world. What good was any special language if no one else comprehended it?[46]

And the frequently expressed view that whatever its merits, the new art was at least interesting especially exasperated opponents. This made art seem a mere diversion rather than a basic aspect of life. As Mather said of the Armory Show:

On all hands I hear in the show the statement, At any rate, this new art is very living and interesting. . . . True, but something like that might be one's feeling on first visiting a lunatic asylum. The inmates might well seem more vivid and fascinating than the every-day companions of home and office. Unquestionably, Matisse is more exciting than, say, George De Forest Brush; it doesn't at all follow that Matisse is the better artist. So is a vitriol-throwing suffragette more exciting than a lady.[47]

Concern about modernism's social implications spilled out of the art world and into general public discussion.

---

[43] See E. A. Taylor, "The American Colony of Artists in Paris," *Studio*, 52 (May, 1911), 273; Cox, *Artist and Public*, 38; "A Prophet of the New Painting [Willard Huntington Wright]," *Nation*, 101 (December 23, 1915), 757–58.

[44] See Charles H. Caffin, "Of Verities and Illusions. III. Self-Expression," *Camera Work*, 14 (April, 1906), 25–27.

[45] Frank J. Mather, Jr., "The Present State of Art," *Nation*, 93 (December 14, 1911), 584–87.

[46] Cox, *Artist and Public*, 34.

[47] Frank J. Mather, Jr., "Old and New Art," *Nation*, 96 (March 6, 1913), 241.

Proponents saw it as liberating and expansive. But opponents quickly equated it with social, political, and economic turbulence. The last great artistic innovation, impressionism, had emphasized motion and change but remained basically optimistic. The new modernism seemed to contain a threatening tone in praising condensed imagery, symbols, and the unknown. Some critics feared that its celebration of individual expression was the "harbinger of universal anarchy."[48]

The scope as well as intensity of modernism also alarmed traditionalists. Whatever its variations of individual expression in paint, or of "ism" in thought, the new art represented an international attitude of mind. Spanish, Austrian, German, Russian, and French practitioners made it seem broadly based, especially attractive to younger artists and thus more challenging to established cultural standards than any other recent movement. Paris remained the world's art center, but its works and ideas circulated swiftly through the new highly refined network of art communication. The Left Bank talk of one day was repeated in Amsterdam, Vienna, Milan, and New York the next. And each of these centers fed its own views into the stream of comment. By 1917 the writer Ilya Ehrenburg saw examples of Picasso's work on the walls of an artists' cafe in Stockholm, as he returned to Russia and the revolution.[49]

This pervasiveness disturbed many Americans, who had coincidentally developed concerns for world events in their lifetime. "If it represents an aberration, it represents a world-wide aberration," one commentator noted of the Armory Show in 1913. "The spirit that stirs in it is manifest in all countries. Nothing on so vast a scale has been held, or even dreamed of, before."[50] The Armory Show was important precisely because it focused modernism for Americans

---

[48] Mather, "Newest Tendencies in Art," *Independent*, 74 (March 6, 1913), 510.

[49] Ilya Ehrenburg, *People and Places, 1891–1921*, 233.

[50] "The Greatest Exhibition of Insurgent Art Ever Held," *Current Opinion*, 54 (March, 1913), 230–32.

and demonstrated the new art's variety and momentum. It became easy to say that "the cubists and futurists are own cousins to the anarchists in politics. . . ."[51] And disturbing reverberations remained after all the learned criticism faded. As the banker-collector James Stillman noted: "Something is wrong with the world. . . . These men know."[52] The old ideal of the artist revealing special insights had taken an unexpected turn.

Many Americans saw the new art as further evidence of the Old World's decadence. Those painters still concerned to emphasize nationalistic themes tenuously joined traditionalists to lament this fresh invasion of European culture. As Jerome Myers said of the Armory Show: "Our land of opportunity was thrown wide open to foreign art, unrestricted and triumphant; more than ever before, our great country had become a colony; more than ever before, we had become provincials."[53] Kenyon Cox even argued that its basic emphasis on realistic form would make American art triumphant after faddish abstractionism had passed.[54]

These concerns underlay the sharp debate over modernism's specific content and avowed ambitions. Many critics condemned the prurience they claimed to see in modern figure studies.[55] Others detected a return to anecdote and literary themes in supposedly abstract works. The uninitiated inevitably looked for the figure in Marcel Duchamps' *Nude Descending a Staircase*, only to be told that the picture

[51] New York *Times*, March 16, 1913. See also M. P. Willcocks, "The New Fear," *Forum*, 49 (April, 1913), 401–405.

[52] Quoted in Guy Pène du Bois, *Artists Say the Silliest Things*, 166.

[53] Myers, *An Artist in Manhattan*, 36. See also Christian Brinton, "The Case For American Art," *Century Magazine*, 77 (November, 1908), 351; and Cortissoz, *American Artists*, 18.

[54] Cox, *Artist and Public*, vii–viii, 158–60.

[55] Brown, *American Painting*, 55; Mather, "Newest Tendencies in Art," *Independent*, 74 (March 6, 1913), 510. These sexual themes and subjects are well illustrated in Donald E. Gordon, *Modern Art Exhibitions, 1900–1916*, I, 110–322, esp. numbers 62, 93, 181, 281, 284, 293, 441, 853, 1545. Americans, of course, did not see all this cross-section of work, but this new view of the nude and of sex was well known.

represented planes, motion, and abstract ideas. "So long as it [cubism] prates of people coming down stairs and dancing and walking in a procession, it is contradicting itself and inviting ridicule," the New York *Times* critic insisted.[56] Painters had employed the figure and objects to display paint and design for years. But these "studies" had remained recognizable, whatever their abstract qualities.

On other levels, many painters like Robert Henri could not believe that a picture was an independent design, any more than they accepted light as subject matter.[57] Others who wanted general principles stated through art ultimately found modernism shallow. By 1917, William Glackens spoke for many in saying that "a great deal of this so-called modern art is pure materialism, the pouring out through symbols of a half-baked psychology, a suppressed adolescence."[58] And in 1916, after the first shock waves had passed, Mather represented the view that much modernism was eclectic and derivative:

What the Post-Impressionists actually do is the negation of this doctrine of autonomous emotion. Practically they indulge in a crafty and feeble eclecticism. They imitate recondite and barbaric models—negro sculpture, the neolithic and Bushman paintings, and the Javanese puppets. Against the academicism of culture they set the academicism of savagery. Their case is instructive because it completes the demonstration of the Impressionists. Just as these broke on the truth that there is no art of vision without its mental content, so the Post-Impressionists are breaking upon the corresponding truth that there is no art of emotion pictorially attainable without its visual content.[59]

Interest in the primitive, which made Mather uneasy,

---

[56] See New York *Times*, February 23, 1913, Part VI, p. 15; Mather, "Newest Tendencies in Art," 512; Harriet Monroe in Chicago *Tribune*, March 30, 1913; and Pène du Bois, *Artists Say the Silliest Things*, 170.

[57] Homer, *Robert Henri*, 175–76.

[58] Charles Hirshfield, "'Ash Can' versus 'Modern' Art in America," *Western Humanities Review*, 10 (Autumn, 1956), 353–73.

became a major aspect of the new modernism. Between 1900 and 1914 several European cities hosted elaborate exhibitions of "savage" art, drawn from India, the Near East, Africa, and Oceana. This was one result of the European imperialism that brought strange lands and forgotten peoples into modern consciousness. It also reflected an interest in the evolutionary stages of civilization, and a desire to contrast modern life with that of "simpler" peoples.[60]

Proponents of this controversial primitivism also looked back to earlier artists concerned with simple but powerful statements. The art of the ancient Near East, the Etruscans, Byzantines, that of the early Middle Ages, and folk art in general all gained new importance in the modern imagination. This was part of a search for fresh artistic forms and symbols, but it also revealed a need among moderns for a historic lineage to justify their departures of expression.

Earlier interest in "primitives" such as American Indians and African Berbers focused on artistic color and quaintness. The new primitivism was part of a desire to clarify hidden meanings in art. The moderns believed that "savage" peoples created and responded to art more intensely than did their "civilized" counterparts. Many believed that only a return to the first principles they thought permeated naive and primitive art could revitalize modern culture. Mere beauty in art must give way to a new kind of truth. "The vibration of life itself is the new ideal, where once only the vibration of beauty was sought," a skeptical critic reported in 1913. This required a new departure, "and the

[59] Frank J. Mather, Jr., "Realism in Art," *Nation*, 102 (February 3, 1916), 132.

[60] The impact of primitive art throughout the period is a complex subject, touched on only generally here and in the terms which Americans conceived at the turn of the century. For further information, see Robert Goldwater, *Primitivism in Modern Painting*, which discusses the question in relation to various artistic movements. A list of dates for exhibitions and collections of primitive works for the period 1800–1930 is on pages, 8–9.

leaping-off place is the child's, the savage's, absorption in life, movement, color-play, in sensation devoid of memory, either bitter or sweet."[61]

This kind of response allowed the viewer to enter the creative process without the analysis or reflection that inhibited clarifying emotion. "Nothing less than a new form, based upon ancient primitive forms, that shall express with greater intensity the new feelings and emotions aroused in many by all the objects in the natural world—that is what they are searching for," the critic J. Nilsen Laurvik noted in 1913, "and all modern art that is not dominated by the photographic vision is engaged in the same quest."[62] There was a fresh interest in children's painting, which sympathetic critics praised for spontaneity and lack of inhibition.[63] And others held that the apparently simplified or crude forms in "primitive" art were condensations of complex processes with more emotional truth than the elaborations of civilized art.[64]

The demand for spontaneity was a criticism of the values that controlled complicated and interrelated modern societies. Many modernists believed that "civilization" had repressed universal drives in favoring reason over emotion. Man, in their view, had thought too long; now he must feel, quickly, simply, and completely through an art that relied on basic symbols.[65]

Hostile critics saw this desire for primitive emotions as

---

[61] Willcocks, "The New Fear," *Forum*, 49 (April, 1913), 402–403.

[62] J. Nilsen Laurvik, "Intolerance in Art," *American Scandinavian Review*, 1 (January–February, 1913), 13.

[63] Sadakichi Hartmann, "The Exhibition of Children's Drawings," *Camera Work*, 39 (July, 1912), 45–46.

[64] The English critic Clive Bell stated this well: "The secret of primitive art is the secret of all art, at all times, in all places—sensibility to the profound significance of form and the power of creation." See his *Art*, 185.

[65] See Christopher Gray, *Cubist Aesthetic Theories*, 44; Benjamin De Casseres, "Modernity and the Decadence," *Camera Work*, 37 (January, 1912), 17–19; and J. Nilsen Laurvik, *Is It Art?: Post-Impressionism, Futurism, Cubism*, 30–31.

atavistic, part of an unhealthy emphasis on hidden drives whose release would threaten both social order and individual dignity. In their view, civilization reflected a healthy progress away from irresponsible and chaotic savagery. The modernists were "aping the pleasures of the barbarian, the spirit returning downward to the dust."[66]

Still other commentators argued that condensation of form and emotion were all very well but came at the end not the beginning of the creative process. In this view, people and civilizations moved through stages from disorder and lack of discrimination to order and calm insights. "The last phase belongs to an advanced civilization and is innocent of puerile attempts at 'childish' vision," a New York *Times* critic insisted in 1913.[67] And Mather saw in the new primitivism "an exaggerated variety of sophistication" that could become as stultifying and artificial as any tradition it rebelled against.[68]

Americans analyzed this modernism's general implications in both aesthetic and social terms. But they also reacted to the works of specific painters in order to define modernism's variations. Critics generally used the term "postimpressionist" for artists who moved beyond impressionism without losing some kind of recognizable form. They applied terms like "modernist" and "abstractionist" more loosely to those who replaced realistic form with symbols, color patterns, or geometric designs.

Paul Cézanne first symbolized the transition toward abstractionism. By the first decade of the new century, critics treated him as a world figure, whose paintings were familiar to advanced taste in both Europe and the United States. By 1916 a friend could write Gertrude Stein of a

[66] Brian Hooker, "Cubing the Circle," *Bookman*, 39 (August, 1914), 672–75.

[67] New York *Times*, July 6, 1913, Part V, p. 15.

[68] Frank J. Mather, Jr., "Art," *Nation*, 94 (June 20, 1912), 623. Mather was reviewing the book *The Post-Impressionists* by the English critic C. Lewis Hind.

"Cézanne boom on in this country." [69] Several qualities of both style and intent recommended Cézanne to the American art public. The critic J. Nilsen Laurvik shrewdly noted that "Cézanne is a primitive by nature and not by theory." The French master combined many aspects of the exciting new painting in rather old-fashioned painterly approaches. [70]

Many critics praised the search for grandeur of expression in Cézanne's work. "Humanity grows richer and more interesting in its complexity as civilization advances," the New York Times remarked in 1913, in separating him from the avowed "primitives." "To throw over that complexity, which a great artist like Cézanne synthesizes into a significant and intense simplicity, in order to refer to the primal simplicity empty of spiritual interest which satisfies the savage, seems to us to subtract from the resources of art instead of adding to them." [71] American critics often used Cézanne to illustrate their insistence that clarity of vision was complex and orderly, rather than simple and impulsive.

Others praised his search for first causes, which they missed in impressionism's concern for surface reality. "Cézanne, however, started with the axiom that humanity is most moved by depth, not by surfaces," Charles Caffin said in 1911. "Therefore, to realize depth must be the painter's aim. His designs must be an organized system of planes, composed of objects, plastically real, enveloped in the rhythm of atmospheric depth." [72] This seemed part of Cézanne's effort to control and intensify symbolic action, the central problem of modern painting. "In his canvases

[69] See Walter Pach, "Cézanne—An Introduction," Scribner's Magazine, 44 (December, 1908), 765–68; Thomas Hart Benton, An American in Art, 22–23. The quotation is from Michael Brenner to Gertrude Stein, February 15, 1916, in Donald Gallup (ed.), The Flowers of Friendship: Letters Written to Gertrude, 112–13.

[70] Laurvik, Is It Art?, 3.

[71] New York Times, February 23, 1913, Part VI, p. 15.

[72] Charles H. Caffin, "A Note on Paul Cézanne," Camera Work, 34–35 (April–July, 1911), 47–51.

objects are selected from nature and so arranged one against another that the whole picture vibrates, as it were, under the stress of thrust and opposition," another writer saw in 1915.[73]

The gravity of his compositions appealed to Americans. His work had both a sense of attachment to the past through harmonious design and of ongoing experiment in concern for movement and abstracted forms.[74] Cézanne had a major role in the long process of making painting an expression of the artist's vision, separate from realism and obedient to internal principles alone. "He conceived the subject of a picture solely as a totality of form made up of formal units," the painter Oscar Bluemner noted in 1913.[75] Yet this desire for artistic expression was part of an intense feeling for nature's basic qualities, also bound to attract Americans.

The response to other European postimpressionists was less clear. The few works of Vincent van Gogh which Americans saw appeared amateurish, yet retained "an appalling fascination," as Frank J. Mather noted, even to those who thought him mad.[76] "The van Gogh of great intensities," as the New York *Times* called him in 1915, was an unsettling figure. His personal story was that of the artist as eccentric, or even madman. But his painting radiated a fresh sense of form and color, and an urgency of expression that appealed to many.[77]

[73] Horace Holley, "The Background of Matisse," *New Republic*, 2 (February 20, 1915), 74–76.

[74] See Mather, "Art," *Nation*, 94 (June 20, 1912), 622; Caffin, "A Note on Paul Cézanne," *Camera Work*, 34–35 (April–July, 1911), 48; Pach, "Cézanne—An Introduction," *Scribner's Magazine*, 44 (December, 1908), 765–68; Caffin, *Story of French Painting*, 221–22; New York *Sun*, February 18, 1913; Laurvik, *Is It Art?*, 9.

[75] Oscar Bluemner, "'Audiator et Altera Pars': Some Plain Sense on the Modern Art Movement," *Camera Work*, Special Number (June, 1913), 25–38. See also Amedée Ozenfant, *Foundations of Modern Art*, 70; Gray, *Cubist Aesthetic Theories*, 48–49.

[76] Mather, "Art," *Nation*, 94 (June 20, 1912), 622; and also "Art," *Nation*, 97 (December 18, 1913), which Mather probably also wrote.

[77] New York *Times*, November 28, 1915, Part VI, p. 17.

Henri de Toulouse-Lautrec seemed equally puzzling. American critics predictably found much of his subject matter disagreeable, yet praised his fluid line and intense expression. A reviewer noted in 1909 that his "lithographs are full of weird power; . . . and that those who are capable of looking, as the man who made them certainly did, beneath the surface of things, will find strange and touching beauty in more than one of them. They are well worth a visit—but not to those who are looking for pretty things."[78]

Critics were ambivalent for other reasons toward the few paintings of Henri Rousseau seen in America. Many liked the freshness of his naive vision, but could not take his stilted style seriously.[79] Rousseau provoked a whimsical yet acid response from Kenyon Cox. "For a generation which demands *naiveté* and spontaneity above all other qualities he is a valuable acquisition, for his *naiveté* is the real thing. His work is perfectly innocent and entirely inept, and his pictures resemble the productions on a larger scale of a child of seven. There is no one else like him."[80]

Reaction to Paul Gauguin's work was more varied. He was a striking colorist and decorator, and his late paintings combined strong feeling with noble forms. In that sense, he sometimes seemed a logical successor to Cézanne, though a bolder innovator. But he looked transitional, concerned to create new reality through paint and design, yet desiring old-fashioned emotional response to subject matter, however exotic. Cortissoz probably spoke for many in taking a middle ground. "Gauguin is a bold draftsman and colorist gone wrong midway in the course of his artistic education," he insisted. "Vaguely working in him is a monumental sense of form, which is not, however, realized in the actual results."[81]

[78] Joseph Edgar Chamberlain in the New York *Daily Mail*, December 30, 1909, cited in *Camera Work*, 29 (January, 1910), 53.

[79] *Ibid.*, 33 (January, 1911), 46–50.

[80] Kenyon Cox, "The 'Modern' Spirit in Art," *Harper's Weekly*, 57 (March 15, 1913), 10.

The work of Henri Matisse soon symbolized modernism's general emphasis on unusual designs. The first examples of his work apparently entered the United States in the baggage of Gertrude Stein's brother in 1906, when he returned to assess earthquake damage to family property in San Francisco. The photographer Edward Steichen also told Alfred Stieglitz of Matisse after a visit to Paris in 1907. This connection produced a show for the Frenchman at Photo-Secession in April, 1908. By 1912. Matisse was well known in the art world, and some four thousand people visited the exhibition of his sculpture at Stieglitz's gallery.[82]

Superficially, Matisse seemed less connected to the general impressionist tradition than did Cézanne or even Toulouse-Lautrec and Gauguin. Many early critics saw him as a major spokesman in figure studies for sensuous primitivism, "the turning of humanity back toward its brutish beginnings."[83] Others found his work "childish, crude and amateurish. . . ," part of a "pose of intentional naiveté," designed merely to attract attention.[84]

Yet this first criticism, like so many others, faded in favor of praise for Matisse's fresh designs and especially for his success at depicting arrested motion in figures. The poet-

[81] New York *Tribune*, February 17, 1913. See also Mather, "Art," *Nation*, 94 (June 20, 1912), 622; Frederick James Gregg, *For and Against: Views on the International Exhibition Held in New York and Chicago*, 21; Philadelphia *Inquirer*, February 23, 1913; Cox, "The 'Modern' Spirit in Art," *Harper's Weekly*, 57 (March 15, 1913), 10; and Henry McBride, "Gauguin's Rebirth," *Dial*, 69 (October, 1920), 397–400.

[82] Sarah Stein to Gertrude Stein, October 8, 1906, in Gallup (ed.), *Flowers of Friendship*, 37; Dorothy Norman, *America and Alfred Stieglitz*, 73–74; Paul B. Haviland, "Photo-Secession Notes," *Camera Work*, 38 (April, 1912), 37.

[83] New York *Times*, February 23, 1913, Part VI, p. 15 Some early criticism is recorded in "Henri Matisse at the Little Galleries," *Camera Work*, 23 (July, 1908), 10–12.

[84] Boston *Transcript*, Febraury 17, 1913, quoted in Brown, *Story of the Armory Show*, 143–44. Kenyon Cox was more acid: "As to Matisse, I am no longer in doubt; it is not madness that stares at you from his canvases, but leering effrontery." See "The 'Modern' Spirit in Art," *Harper's Weekly*, 57 (March 15, 1913), 10.

critic Gellett Burgess, who saw some Matisses at the 1910 Salon des Indépendants in Paris, had a predictable first reaction. "If you can imagine what a particularly sanguinary little girl of eight, half-crazed with gin, would do to a white-washed wall, if left alone with a box of crayons, then you will come near to fancying what most of the work was like." But Burgess recognized the great sense of motion and power in the work, and its serious purpose.[85] Many observers went through the cycle of taste Charles Caffin recorded. "Meanwhile, after I had been with his pictures some time, they exerted a spell upon my imagination. So much so, that after I had left them I could not immediately look at 'ordinary' pictures. For the time, at least, the latter seemed banal in the comparative obviousness of their suggestion."[86]

By the eve of World War I, advanced taste accepted "that mixture of sophistication and voluntary savagery which is epitomized in the work of Henri Matisse."[87] And despite a dislike of his apparent disorder, Mather praised Matisse's intent both in design and emotional effect:

Matisse conceives the body as a powerful machine working within certain limits of balance. The minute form of the tackles and levers does not signify for him; what counts is the energy expended and the eloquent pauses which reveal the throb of the mechanism. The important thing is that muscles should draw over the bone pulleys, that the thrust of a foreshortened limb should be keenly felt, that all the gestures should fuse in a dynamic pattern.[88]

Many others praised his obvious energy and challenges to

[85] Quoted in John I. H. Bauer, *Revolution and Tradition in Modern American Art*, 35–36.

[86] Charles H. Caffin, "Henri Matisse and Isadora Duncan," *Camera Work*, 25 (January, 1909), 20.

[87] Brinton, "Evolution Not Revolution in Art," *International Studio*, 69 (April, 1913), xxxii.

[88] Quoted in *Camera Work*, 30 (April, 1910), 50. Mather also wrote Cox privately: "What I admire in Matisse is what Vasari calls *furia*, a dynamic impression that I take it is compatible with very faulty construction." Mather to Kenyon Cox, January 16, 1912, Cox papers, AALCU.

established formal art, even when disliking his painting. Matisse probably received more sympathetic treatment in the United States than in France.[89]

Pablo Picasso, and the cubism which critics took his work to epitomize, caused shock. His first American show in 1911 surprised even sympathetic observers. Some thought the works an elaborate hoax, designed to summarize the clichés in modernism. Others believed he might be sincere, but had created a feeble eclecticism of "childish wooden images, Alaskan totem poles and gargoyles smeared with green paint, or weird geometric jumbles. . . ."[90] Royal Cortissoz had a field day with the cubist works at the Armory Show:

. . . with Picasso and the rest of the Cubists, the farce grows wilder. They throw upon the canvas a queer agglomeration of line and color, in which one may divine in a fragmentary way elements of the human form. The fragments possess here and there some expressive qualities. It is like the monstrous potato or gourd which the farmer brings to the village store to see if his cronies can make out in certain "bumps" which he indicates the resemblance he has found to General Grant or the late P. T. Barnum. It is even more like what one would contemplate if a perfectly respectable wombat, finding himself in the midst of one of those gigantic colored vessels which stand in a druggist's window, should suddenly go quite mad, thrashing about him and causing great havoc.[91]

Though Picasso's supporters were not numerous, his work won a small audience. Sympathetic fellow painters saw him as a major figure in the movement to make painting an expression of the artist's vision with no overt attach-

[89] See two articles apparently by Frank J. Mather, Jr.: "The Pennsylvania Academy," *Nation*, 90 (February 3, 1910), 123; and "Drawings by Henri Matisse," *Nation*, 90 (March 17, 1910), 272–73, for Matisse's apparent popularity. See also Alfred H. Barr, Jr., *Matisse: His Art and His Public*, 104–106, 112, 114.

[90] Quoted in *Camera Work*, 36 (October, 1911), 49.

[91] New York *Tribune*, February 17, 1913.

ments to nature. The Mexican-born artist Marius de Zayas, influential in the American avant-garde, patiently explained Picasso's intentions. "Picasso tries to produce with his work an impression, not with the subject but the manner in which he expresses it," he noted in 1911. "He receives a direct impression from external nature, he analyzes, develops and translates it, and afterwards executes it in his own particular style, with the intention that the picture should be the pictorial equivalent of the emotion produced by nature." Picasso thus typified the movement away from realism to painterly design. "In presenting his work he wants the spectator to look for the emotion or idea generated from the spectacle, and not the spectacle itself."[92]

Two years later, Christian Brinton praised Picasso's ability to reduce form and experience to powerful symbolic imagery, so that "we are at last freed from all taint of nature imitation and watch unfold before us a world of visual imagery existing of and for itself alone."[93] In due course, others saw that these condensations and symbols were "his method of expression," and urged art lovers simply to take or leave his designs and gestures.[94] Many critics praised Picasso's obvious skill at designing and in condensing vivid imagery.[95] The prewar art world did not embrace his work but laid the ground for growing appreciation in the following generation.

The work of these and other individual painters clarified the "modernism" that swept the art world after 1900. The

[92] Marius de Zayas, "Pablo Picasso," *Camera Work*, 34–35 (April–July, 1911), 65–67. This article was reprinted as a pamphlet for the Photo-Secession Picasso show in April, 1911.

[93] Brinton, "Evolution Not Revolution in Art," *International Studio*, 69 (April, 1913), xxxii. Like critics of old, Brinton thought this reflected Picasso's "austere, Iberian temperament. . . ."

[94] New York *Times*, December 21, 1915.

[95] See reviews cited in *Camera Work*, 42–43 (April–July, 1913), 47; Horace Holley, "The Background of Matisse," *New Republic*, 2 (February 20, 1915), 74–76; Homer, *Robert Henri*, 286, n. 28; Herschell B. Chipp (ed.), *Theories of Modern Art*, 233, n. 1; and Richardson, *Modern Art and Scientific Thought*, 104–27.

scene was exciting, as time seemed to speed up to accommodate artistic changes. This sense of rapidity enhanced modernism's social implications. Even amid world war in 1916, Willard Huntington Wright believed that a major change in consciousness had occurred. "We are in the midst of the splendid beginnings of a new Renaissance in art—an epoch whose means and discoveries have opened the door to an infinitude of possibilities."[96] But amid all the clamor over innovation, most modernists were careful to claim a lengthy lineage, lest the public think them transitory. They insisted that modern art's purposes, and many of its forms, were rooted in ancient experiences.[97]

Of course, homage to this lineage did not deny the new art's special qualities. Its proponents insisted that every generation interpreted reality anew. Modernist forms merely showed that contemporary life was complex, ambivalent, and intense. Representational art could no longer depict or analyze it. Education, communication, and fresh desires for strong individual experience all made externals merely symbolic to the sensitive mind. As Charles Caffin said in 1908, "regarded as an art of representation, [painting] is but food for children, fit only for men and women whose minds have not passed beyond the child stage of picture books."[98]

[96] Willard Huntington Wright, "Art, Promise and Failure," Forum, 55 (January, 1916), 42. See also Mary Fanton Roberts, "Science in Art, As Shown in the International Exhibition of Painting and Sculpture," Craftsman, 24 (May, 1913), 216–18; James Gibbons Huneker, "The Melancholy of Masterpieces," Scribner's Magazine, 56 (July, 1914), 136; Birge Harrison, "The New Art in America," Scribner's Magazine, 57 (March, 1915), 394.

[97] Jay and Gove Hambidge, "The Ancestry of Cubism," Century Magazine, 87 (April, 1914), 869–75; Wright, "The Aesthetic Struggle in America," Forum, 55 (February, 1916), 201–20; Brinton, "Evolution Not Revolution in American Art," International Studio, 69 (April, 1913), xxvii–xxxv; and Andre Tridon, "America's First Aesthetician [Willard Huntington Wright]," Forum, 55 (January, 1916), 124–28.

[98] Charles H. Caffin, "The Art of Edmund C. Tarbell," Harper's Monthly, 117 (June, 1908), 66.

The modern artists' new view of reality was derived from the changing relationships of objects. ". . . it is the vision of things and of their relation to one another and that of ourselves to them, in which modern life and art differs from the past," Oscar Bluemner insisted.[99] This sense of relative and intense relationships permeated science and philosophy as well as the arts. And the new moderns saw their art as another expression of idealism over materialism, especially that which accompanied late nineteenth-century industrialism.[100] A desire for unifying and universal emotion underlay the modernists' use of symbols, condensed design, and unusual relationships in their pictures. As Wright said: "Now, the modern men, in the main, are striving to divest these fundamental qualities of all superficial matter, to state them purely and, by so doing, to increase the emotional reaction of the picture."[101]

The new art also involved a strong sense of personal adventure for both artist and viewer. This appealed to those who rejected rules and threatened those who feared what the rules controlled. The New York *Times* caught the sense of this change in contrasting impressionism with the new modernism, noting that "Monet and Pissarro and Sisley and their company see Nature in arrest. With them it is always 'I am,' not 'I am becoming.'"[102]

The effort to depict symbolic motion became "an always aspiring unrest" among the new artists.[103] It testified to a

---

[99] Bluemner, "'Audiator et Altera Pars,' Some Plain Sense on the Modern Art Movement," *Camera Work*, Special Number (June, 1913), 32–33.

[100] Laurvik, "Intolerance in Art," *American Scandinavian Review*, 1 (January–February, 1913), 14.

[101] Willard Huntington Wright, "Foreword," in *Forum Exhibition of Modern American Painters*, 40; and Eddy, *Cubists and Post-Impressionists*, 112.

[102] New York *Times*, February 23, 1913, Part VI,p. 15, reviewing the Armory Show.

[103] Christian Brinton, "Foreword," In *Forum Exhibition of Modern American Painting*, 29; and New York *Times*, March 21, 1915, Part V, p. 23, reviewing a National Academy of Design show.

need to capture and understand "a world rebuilt and reimagined from day to day." [104] This was an effort to control and understand the force of change in individual lives. On another level, it was a restatement of the old ideal of the artist as finder of special truths and creator of intense emotions. [105]

The wave of modernism crested in the pre–World War decade amid intense controversy. Despite complaints that critics misunderstood it, many promoderns believed the American art public tolerant enough to grant a fair hearing. The painter Francis Picabia thought the traditional American interest in the new would help the moderns' cause. And Arthur Jerome Eddy insisted in 1914 that "America . . . will absorb all that is good in the extreme modern movement and reject what is bad." [106] A special Providence would thus guide America in art as well as politics and economics.

The dramatic new art won some influential patrons. The collector John Quinn embraced both its visual appeal and its applicability to modern life. ". . . after studying the works of the Cubists and Futurists, it makes it hard to stomach the sweetness, the prettiness and the [cloying] sentiment of some of the other work," Quinn wrote a friend in 1913. [107] And he thought the critics who rejected the moderns for being nonrepresentational had missed the point. "When one leaves the exhibition," he noted of the Armory Show, "one goes outside and sees the lights streaking up and down

[104] Holley, "The Background of Matisse," *New Republic*, 2 (February 20, 1915), 74–76. Mather attacked this ideal of constant change in "Newest Tendencies in Art," *Independent*, 74 (March 6, 1913), 509.

[105] See, for example, Walter Pach, "The Point of View of the Moderns," *Century Magazine*, 87 (April, 1914), 861.

[106] Eddy, *Cubists and Post-Impresionsists*, 3. The Picabia citation is to an interview in New York *Times*, February 16, 1913, Part V, p. 9. See also "'Audiator et Altera Pars,' Some Plain Sense on the Modern Art Movement," *Camera Work*, Special Number (June, 1913), 25; and Hutchins Hapgood, cited in the same article, 42–43 (April–July, 1913), 45.

[107] John Quinn to George W. Russell, March 2, 1913, cited in B. L. Reid, *The Man From New York: John Quinn and His Friends*, 151.

the tall buildings and watches their shadows, and feels that the pictures that one has seen inside after all have some relation to the life and color and rhythm and movement that one sees outside." [108] There was a strong sense that whatever its present excesses, modernist abstraction was the wave of the future because it defined an infinite reality. "The Cubists have already shown the possibility of an expression in painting without representation," Walter Pach noted in 1914. "[It] will be long before the future arrives at the limit of ideas to be rendered by such art." [109]

The harshest critics took the new art with equal seriousness, if to different conclusions. They could not see any need for new styles. Nor could they accept random individual expression over the cohesion they thought necessary to sustain a large environment for art in society. Modernism seemed to them a wrecking influence that poured into the American art scene just when it had stabilized and become a major part of world culture. They feared the attractions of any new art to a public still lacking a firm tradition. In the end they took a fatalistic comfort in believing that modernism was a passing fad, and preferred to face it rather than try to repress it. [110]

Other painters remained ambivalent toward the new art. "The Eight," later styled the "Ashcan School," included the best nationalist artists. They generally accepted the moderns' assaults on academicism yet disliked the new painting's full implications. In their revolt against a stylized impressionism, they desired a broadly painted subject matter. They rejected surface elegance and turned for subjects to daily life in general and urban life in particular. They believed in the artist's independent vision, but really wanted

---

[108] *Ibid*.

[109] Pach, "The Point of View of the Moderns," *Century Magazine*, 87 (April, 1914), 863.

[110] Cox, "The 'Modern' Spirit in Art," *Harper's Weekly*, 57 (March 15, 1913), 10; Frank J. Mather, Jr., "The International Art Exhibition," *Nation*, 96 (February 20, 1913), 174; and Royal Cortissoz to Kenyon Cox, n.d. [1913], Cox papers, AALCU.

it for a broader audience than painters, however "modern." Their modernism basically was one of facing contemporary life, not of seeking alternate visions of reality. They painted in active verbs, and won an important audience through vigorous, colorful art based on modern life. But formalists like Mather found them restricted and parochial; moderns thought them naive and old-fashioned.[111]

The native American modernists were overshadowed in the influx of European art and ideas. Both critics and the art public inevitably found Picasso and Matisse more intriguing than Arthur Dove, Max Weber, or Stanton Macdonald-Wright. And the Americans remained peripheral to world modernism, as they had to the first impressionism a generation earlier. They often relied on the moderns' style without accepting or understanding its implications.[112] The first American abstractionists' work seemed less strong and personal than did its European counterparts.

Many people believed, or hoped, the new art would be a war casualty after 1914. The demands for personal sacrifice that accompanied the conflict's early idealism would surely kill anarchy in art. "It seems to me that if this war does nothing else it is bound to give the *coup de grace* to the art of personal exploitation," Kenyon Cox wrote Frank Mather in 1915. "The world will be too seriously occupied to puzzle itself with any art that is not serious and comprehensive."[113] If modernism was an aspect of Old World de-

[111] See Homer, *Robert Henri*, 84, 131; Birge Harrison, "The Future of American Art," *North American Review*, 189 (January, 1909), 33; Duncan C. Phillips, Jr., "The City in Painting and Etching," *Scribner's Magazine*, 53 (February, 1913), 265–68; Frank J. Mather, Jr., "The Independent Artists," *Nation*, 90 (April 7, 1910), 360–61, and the same author's "Realism in Art," *Nation*, 102 (February 3, 1916), 130–31.

[112] See Oliver Larkin, *Art and Life in America*, 347–68; Brown, *American Painting From the Armory Show to the Depression*, 71–166; Bauer, *Revolution and Tradition in Modern American Art*, 34–64; and Mahonri Sharp Young, *Early American Moderns: Painters of the Stieglitz Group*.

[113] Kenyon Cox to Frank J. Mather, Jr., November 12, 1915, Mather papers, PUL.

cadence, or the work of a few marginal artists, as the most conservative critics believed, it would surely die in a conflict dedicated to nobility and broad social purpose.[114]

But as the war progressed with unexpected results, the promoderns saw many levels of vindication. If society was mad, the artist might well pursue a private vision. Culture, it seemed, was only surface deep in mass societies. The conflict's very barbarities seemed to prove the moderns' insistence that a new era had dawned—one that would emphasize the hitherto suppressed aspects of life. The new art of symbols, condensed forms, and refracted vision might dominate the postwar world.[115]

Modernism's legacy was unclear. It had obviously fractured whatever unity prevailed in American art in 1900. Twenty years later, each of these fracture lines carried a definable art style. Impressionism, postimpressionism, and varieties of abstractionism seemed preeminent. But strong interest in social realism, landscape, anecdote, and genre unrelated to modernism remained.

The intense debate over modernism's implications both in the art world and the larger community revealed how far American art had come since 1865. In an external sense the great cultural themes of the post–Civil War era remained. But the experiences of the intervening years made them now seem processes rather than attainable goals. Art was an important aspect of national life in 1914. Its variety and complexity testified to the changes that overtook the United States as it became an industrial society and world power. American society had developed a cultural sense as obvi-

[114] Duncan Phillips, a major impressionist collector, wrote in 1917: "War is a good cleanser. We need war. For if war itself is a madness it is also a cure for madness." See "Fallacies of the New Dogmatism in Art, Part I," *American Magazine of Art*, 9 (December, 1917), 44; and also E. C. Maxwell, "Nationalism and the Art of the Future," *International Studio*, 62 (September, 1917), lxxvii.

[115] See Brinton, "Foreward," *Forum Exhibition of Modern American Painting*, 27.

ous, and often as important, as its concern for achievement in other sectors of life. A self-sustaining, questioning art world of producers and consumers, oriented toward national ambitions and world models, had developed to sustain art. Many individuals had found enrichment and expression through art, however bewildering and challenging its complexities seemed.

Inside the artistic process, an intense long-term interest in defining changing reality seemed dominant between 1865 and 1920. Both artists and patrons sought complexity and mystery to complement the increasing complexity in observable life. A desire for "realism" was thus central in producing new styles and purposes in art. The realism of the mid-nineteenth century tried to depict the reality of the average eye. Its successor, a broad impressionism as well as a specific impressionism, suffused this realism with a new sense of mood and change in the observable world. The latest successor, a broadly defined tendency toward abstraction, whatever its "ism," focused on the condensed meanings in specific art forms and in cultural life in general.

It was characteristic of the total period that as strong a desire for predictable order as for unpredictable experiment accompanied these changes. Realism was the broad intent of the era's major styles. But each change of emphasis, usually first seen as a new way of painting as in impressionism or abstraction, provoked sharp dissent because it seemed to threaten orderly development.

What lay beyond the war in 1914 was anyone's guess. Modernism dominated the conversation but did not overwhelm all the talkers. Yet its central thrust would shape longterm artistic developments. It turned innovative painting, always the most prestigious and widely discussed aspect of art, from external reality to the ceaseless depiction of first causes and implications. It injected a fresh stream of ambivalent ideas into the art world. It challenged the inherited belief that any one kind of art could dominate the scene and fortified the tendency to make new art the province of

elites separated from mass culture. This was a major result of turning art from the eye to the mind, and from the present world to the imagination. The reverberations of such a shift would affect all future American art.

# Bibliography

## I. MANUSCRIPTS

*Location*

| | |
|---|---|
| American Academy of Arts and Letters, General Collection | AAAL |
| Samuel Putnam Avery | AAA |
| Cecilia Beaux | AAA |
| Martin Birnbaum | AAA |
| Robert F. Blum | AAA |
| Martin Brimmer | AAA |
| Century Magazine | AAA |
| William Merritt Chase | AAA |
| Titus Munson Coan | NYHS |
| Kenyon Cox | AALCU |
| Kenyon Cox | OCL |
| Thomas Wilmer Dewing | FGA |
| Isabella Stewart Gardner Museum, General Collections | GM |
| Phillip Leslie Hale | AAA |
| Sylvester Rosa Koehler | AAA |
| MacBeth Gallery | AAA |
| Jervis McEntee | AAA |
| Dodge McKnight | AAA |
| Homer Martin | AAA |
| Daniel Gregory Mason | BLCU |
| Frank J. Mather, Jr. | PUL |
| Brander Matthews | BLCU |
| Pennsylvania Academy of Fine Arts, General Collection | PAFA |
| Mary Fanton Roberts | AAA |
| Theodore Robinson | FARL |
| Fitzwilliam Sargent | AAA |

| | |
|---|---|
| John Singer Sargent | AAA |
| Sartain Family | AAA |
| Elmer Boyd Smith | AAA |
| Edmund C. Stedman | BLCU |
| Abbott H. Thayer | FGA |
| Dwight W. Tryon | FGA |
| Elihu Vedder | AAA |
| Frederick P. Vinton | AAA |
| J.Q.A. Ward | NYHS |
| John F. Weir | AAA |
| Richard Grant White | NYHS |
| Stanford White | NYHS |

## II.  PUBLISHED MEMOIRS AND LETTERS

Albright, Adam Emory. *For Art's Sake*. Chicago, Lakeside Press, 1953.

Aldrich, Lillian W. *Crowding Memories*. Boston, Houghton Mifflin, 1920.

Anderson, Margaret. *My Thirty Years War: An Autobiography*. New York, Covici, Friede, 1930.

Armstrong, D. Maitland. *Day Before Yesterday*. New York, Charles Scribner's Sons, 1920.

Arnold, Matthew. *Civilization in the United States*. Boston, Cupples and Hurd, 1888.

Atherton, Gertrude. *Adventures of a Novelist*. New York, Liveright, 1932.

Austin, Mary. *Earth Horizon: Autobiography*. New York, Houghton Mifflin, 1932.

Ball, Thomas. *My Threescore Years and Ten*. Boston, Roberts Bros., 1892.

Beaux, Cecilia. *Background With Figures*. New York, Houghton, Mifflin, 1930.

Benjamin, S. G. W. *Life and Adventures of a Free Lance*. Burlington, Vt., Free Press, 1914.

Benton, Thomas Hart. *An American in Art*. Lawrence, University Press of Kansas, 1969.

————. *An Artist in America*. 3d ed. Columbia, University of Missouri Press, 1968.

Biddle, George. *An American Artist's Story*. Boston, Little, Brown, 1939.

Bishop, Joseph Bucklin. *Notes and Anecdotes of Many Years*. New York, Charles Scribner's Sons, 1925.

Bowen, Catherine Drinker. *Family Portrait*. Boston, Little, Brown, 1970.

Brewer, Nicholas R. *Trails of a Paintbrush*. Boston, Christopher Publishing House, 1938.

Brownell, Gertrude Hall. *William Crary Brownell*. New York, Charles Scribner's Sons, 1933.

Champney, Benjamin. *Sixty Years' Memories of Art and Artists*. Woburn, Mass. n.p., 1900.

Child, Theodore. *Summer Holidays*. New York, Harper, 1889.

Dana, Nathalie. *Young in New York: A Memoir of a Victorian Girlhood*. New York, Doubleday, 1963.

Davis, Richard Harding. *About Paris*. New York, Harper, 1895.

Dell, Floyd. *Homecoming: An Autobiography*. New York, Farrar and Rinehart, 1933.

Elliott, Maude Howe. *This Was My Newport*. Cambridge, Mythology Co., 1944.

————. *Three Generations*. Boston, Little, Brown, 1923.

Ellsworth, William Webster. *A Golden Age of Authors*. New York, Houghton Mifflin, 1919.

Flagg, James Montgomery. *Roses and Buckshot*. New York, G.P. Putnam's Sons, 1946.

Freeman, James Edward. *Gatherings From an Artist's Portfolio*. 2 vols. New York, D. Appleton, 1877–83.

French, Mary. *Memoirs of a Sculptor's Wife*. Boston, Houghton Mifflin, 1928.

Fuchs, Emil. *With Pencil, Brush and Chisel: The Life of an Artist*. New York, G.P. Putnam's Sons, 1925.

Gardner, Constance (ed.). *Some Letters of Augustus Peabody Gardner*. Boston, Houghton Mifflin, 1920.

Garland, Hamlin. *Roadside Meetings*. New York, Macmillan, 1930.

Gaunt, William. *Aesthetic Adventure*. New York, Harcourt, Brace, 1945.

————. *Victorian Olympus*. London, J. Cape, 1952.

Gilder, Rosamond (ed.). *Letters of Richard Watson Gilder*. Boston, Houghton Mifflin, 1916.

Guggenheim, Margaret. *Confessions of an Art Addict*. New York, Macmillan, 1960.

Hale, Nancy. *The Life in the Studio*. Boston, Little, Brown, 1969.

Hall, Florence Howe. *Memories Grave and Gay*. New York, Harper, 1918.

Hapgood, Hutchins. *A Victorian in the Modern World*. New York, Harcourt, Brace, 1939.

Harrison, Constance Cary. *Recollections Grave and Gay*. New York, Charles Scribner's Sons, 1911.

Hartley, Marsden. *Adventures in the Arts*. New York, Boni and Liveright, 1921.

Hartrick, A.S. *A Painter's Pilgrimage Through Fifty Years*. Cambridge, Cambridge University Press, 1939.

Healy, G.P.A. *Reminiscences of a Portrait Painter*. Chicago, A.C. McClurg, 1894.

Hind, C. Lewis. *Art and I*. New York, John Lane, 1921.

Hone, Joseph (ed.). *J. B. Yeats: Letters to His Son W. B. Yeats and Others 1869–1922*. New York, E. P. Dutton, 1946.

Horstmann, G. Henry. *Consular Reminiscences*. Philadelphia, J. B. Lippincott, 1886.

Hosmer, Harriet. *Letters and Memories*. Boston, Moffat and Yard, 1912.

Huneker, James Gibbons. *Steeplejack*. 2 vols. New York, Charles Scribner's Sons, 1925.

Huneker, Josephine (ed.). *Letters of James Gibbons Huneker*. New York, Charles Scribner's Sons, 1922.

James, Henry. *Autobiography*. New York, Criterion Books, 1956.

John, Augustus. *Chiaroscuro: Fragments of an Autobiography*. London, J. Cape, 1952.

Johnson, Robert Underwood. *Remembered Yesterdays*. Boston, Little, Brown, 1923.

Josephson, Matthew. *Life Among the Surrealists*. New York, Holt, Rinehart & Winston, 1962.

Kent, Henry Watson. *What I am Pleased to Call my Education*. New York, Grolier Club, 1949.

Kent, Rockwell. *It's Me, O Lord*. New York, Dodd, Mead, 1955.

Kreymborg, Alfred. *Troubadour: An Autobiography*. New York,

Liveright, 1925.

Linton, William J. *Threescore and Ten Years, 1829–1890*. New York, Charles Scribner's Sons, 1894.

Longfellow, Ernest Wadsworth. *Random Memories*. Boston, Houghton Mifflin, 1922.

Low, Will H. *A Chronicle of Friendships*. New York, Charles Scribner's Sons, 1908.

——. *A Painter's Progress*. New York, Charles Scribner's Sons, 1910.

Luhan, Mabel Dodge. *Movers and Shakers*. New York, Harcourt, Brace, 1936.

Matthews, Brander. *These Many Years: Recollections of a New Yorker*. New York, Charles Scribner's Sons, 1917.

Moore, George. *Memoirs of My Dead Life*. London, Heinneman, 1906.

Morris, Harrison S. *Confessions in Art*. New York, Sears Publishing Co., 1930.

Myers, Jerome. *Artist in Manhattan*. New York, American Artists Group, 1940.

Neuhaus, Eugen. *Drawn From Memory: A Self Portrait*. Palo Alto, Pacific Books, 1964.

Pach, Walter. *Queer Thing, Painting*. New York, Harper, 1938.

Peabody, Marian Lawrence. *To Be Young Was Very Heaven*. Boston, Houghton Mifflin, 1967.

Péne du Bois, Guy. *Artists Say the Silliest Things*. New York, American Artists Group, 1940.

Pennell, Elizabeth Robbins. *The Life and Letters of Joseph Pennell*. 2 vols. Boston, Little, Brown, 1929.

Pennell, Joseph. *The Adventures of an Illustrator*. Boston, Little, Brown, 1925.

Robertson, W. Graham. *Life Was Worth Living*. New York, Harper, 1931.

Rockwell, Norman. *My Adventures as an Illustrator*. New York, Doubleday, 1960.

Rothenstein, William. *Men and Memories*. 3 vols. New York, Coward-McCann, 1931–40.

Saint-Gaudens, Homer. *The American Artist and His Times*. New York, Dodd, Mead, 1941.

Sargent, Winthrop. *Geniuses, Goddesses and People*. New York,

E. P. Dutton, 1949

Sartain, John. *Reminiscences of a Very Old Man*. New York, D. Appleton, 1899.

Schack, William. *And He Sat Among the Ashes*. New York, American Artists Group, 1939.

Seligman, Herbert J. (ed.). *Letters of John Marin*. New York, An American Place, 1931.

Seymour, Ralph Fletcher. *Some Went This Way*. Chicago, R. F. Seymour, 1945.

Sherwood, Herbert F. (ed.). *H. Siddons Mowbray, Mural Painter, 1858–1928*. Stamford, Conn., n.p., 1928.

Simmons, Edward. *From Seven to Seventy*. New York, Harper, 1922.

Sloan, John. *Gist of Art*. New York, American Artists Group, 1939.

Smith, Corinna Lindon. *Interesting People*. Norman, University of Oklahoma Press, 1962.

Smith, Logan Pearsall. *Unforgotten Years*. Boston, Little, Brown, 1939.

Stein, Gertrude. *Autobiography of Alice B. Toklas*. New York, Harcourt, Brace, 1933.

Stillman, William J. *Autobiography of a Journalist*. 2 vols. Boston, Houghton Mifflin, 1901.

Sutton, Denys (ed.). *Letters of Roger Fry*. 2 vols. New York, Random House, 1972.

Taber, Edwin Martin. *Stowe Notes*. Boston, Houghton Mifflin, 1913.

Thornton, Alfred. *The Dairy of an Art Student of the Nineties*. London, Sir Isaac Pitman and Sons, 1938.

Ticknor, Caroline. *May Alcott: A Memoir*. Boston, Little, Brown, 1928.

Vedder, Elihu. *The Digressions of V*. Boston, Houghton Mifflin, 1910.

Vollard, Ambroise. *Recollections of a Picture Dealer*. London, Constable, 1936.

Wheeler, Candace. *Yesterdays in a Busy Life*. New York, Harper, 1918.

Wickey, Harry. *Thus Far: The Growth of an American Artist*. New York, American Artists Group, 1941.

Woods, Alice. *Edges*. Indianapolis, Bowen-Merrill Co., 1902.

Young, Art. *Art Young: His Life and Times*. New York, Sheridan House, 1939.

———. *On My Way*. New York, Horace Liveright, 1928.

## III. HISTORY

Barker, Virgil. *Critical Introduction to American Painting*. New York, Whitney Museum of American Art, 1931.

Baur, John I. H. *American Painting in the Nineteenth Century*. New York, Praeger, 1953.

Cahill, Holger, and Alfred H. Barr, Jr. *Art in America in Modern Times*. New York, Reynall, 1934.

Chmaj, Betty E. "The Double Attraction: A History of the National Artistic Will, 1890–1917." Ph.D. dissertation, University of Michigan, 1961.

Egbert, Donald Drew. *Social Radicalism and the Arts: Western Europe*. New York, Alfred Knopf, 1970.

Fink, Sister Mary Joanna. "The Concept of the Artist and Creative Genius in American Naturalistic Fiction." Ph.D. dissertation, University of Notre Dame, 1965.

Flexner, James T. *Nineteenth Century American Painting*. New York, Charles Scribner's Sons, 1970.

———. *That Wilder Image: The Painting of America's Native School from Thomas Cole to Winslow Homer*. Boston, Little, Brown, 1962.

Frankenstein, Alfred V. *After the Hunt: William Harnett and Other American Still Life Painters 1870–1900*. Berkeley, University of California Press, 1953.

Hagen, Oskar. *The Birth of the American Tradition in Art*. New York, Charles Scribner's Sons, 1940.

Hansen, Hans Jurgen (ed.). *Late Nineteenth Century Art*. New York, McGraw-Hill, 1972.

Harris, Neil. *The Artist in American Society: The Formative Years, 1790–1860*. New York, Braziller, 1968.

Hartmann, Sadakichi. *A History of American Art*. Boston, L. C. Page, 1901.

Hauser, Arnold. *The Social History of Art*. 4 vols. New York, Vintage Books, n.d.

Hills, Patricia. *The Painters' America: Rural and Urban Life, 1810–*

*1910*. New York, Whitney Museum of American Art, 1974.

Howat, John K., et al. *Nineteenth Century America: Paintings and Sculpture*. New York, Metropolitan Museum of Art, 1970.

Hughes, H. Stuart. *Consciousness and Society*. New York, Alfred Knopf, 1958.

Isham, Samuel. *The History of American Painting*. New York, Macmillan, 1905.

Jackman, Rilla E. *American Arts*. New York, Rand McNally, 1940.

Larkin, Oliver W. *Art and Life in America*. rev. ed. New York, Holt, Rinehart Winston, 1960.

Lynes, Russell. *The Art Makers of Nineteenth Century America*. New York, Atheneum, 1970.

———. *The Tastemakers*. New York, Harper, 1954.

McCoubrey, John W. *American Tradition in Painting*. New York, Braziller, 1963.

Mather, Frank J., Jr. *Estimates in Art, Series II*. New York, Henry Holt, 1931.

———. *Modern Painting: A Study of Tendencies*. New York, Henry Holt, 1927.

Mellquist, Jerome. *The Emergence of an American Art*. New York, Charles Scribner's Sons, 1942.

Miller, Lillian B. *Patrons and Patriotism: The Encouragement of the Fine Arts in the United States, 1790–1860*. Chicago, University of Chicago Press, 1966.

Münsterberg, Hugo. *The Americans*. New York, McClure, Phillips, 1904.

Muther, Richard. *History of Modern Painting*. 4 vols. New York, E. P. Dutton, 1907.

Narodny, Ivan. *American Artists*. New York, Roerich Museum Press, 1929.

Neil, J. Meredith. *Toward a National Taste: America's Quest for Aesthetic Independence*. Honolulu, University Press of Hawaii, 1975.

Neuhaus, Eugen. *The History and Ideals of American Art*. Palo Alto, Stanford University Press, 1931.

Novak, Barbara. *American Painting of the Nineteenth Century*. New York, Praeger, 1969.

Nuhn, Ferner. *The Wind That Blew From the East: A Study of the Orientation of American Culture*. New York, Harper, 1942.

Phythian, John Ernest. *Fifty Years of Modern Painting: Corot to*

*Sargent*. New York, E. P. Dutton, 1908.

Porter, James A. *Modern Negro Art*. New York, Dryden Press, 1943.

Pousette-Dart, Nathaniel. *American Painting Today*. New York, Hastings House, 1956.

Prown, Jules David, and Barbara Rose. *American Painting*. New York, World Publishing Co., 1969.

Rothenstein, John. *A Pot of Paint: The Artists of the 1890's*. New York, Covici, Friede, 1929.

Schaefer, Herwin. *Nineteenth Century Modern: The Functional Tradition in Victorian Design*. New York, Praeger, 1970.

Soby, James Thrall, and Dorothy G. Miller. *Romantic Painting in America*. New York, Museum of Modern Art, 1943.

Young, Mahonri Sharp. "The Tile Club Revisited," *American Art Journal*, 2 (Fall, 1970), 81–91.

## IV. CRITICISM

Abrams, Meyer H. *The Mirror and the Lamp: Romantic Theory and the Critical Tradition*. New York, Oxford University Press, 1952.

"Art Criticism," *Scribner's Magazine*, 18 (May, 1879), 135–36.

"Art Gossip: Our Artistic Outlook," *Art Age*, 6 (September, 1887), 36.

"Art: New York," *Atlantic Monthly*, 29 (March, 1872), 374–75.

"Artistic Criticism," *American Architect and Building News*, 1 (April 22, 1876), 130–31.

Baker, Marilyn Claire. "The Art Theory and Criticism of Willard Huntington Wright." Ph.D. dissertation, University of Wisconsin, 1975.

Bell, Clive. *Art*. New York, Frederick A. Stokes, 1913.

Benjamin, S.G.W. "The Exhibitions. VII. The National Academy of Design," *American Art Review*, 2 (1881), 21–29.

Bowles, J.M. "Art in Life," *Brush and Pencil*, 1 (November, 1897), 22–23.

Brimo, René. *L'Evolution du Gout aux Etats-Unis*. Paris, James Fortune, 1938.

Brinton, Christian. "Art and Ideas," *Putnam's Monthly*, 2 (April, 1907), 121–27.

Brooks, Van Wyck. *Fenollosa and His Circle*. New York, E. P. Dutton, 1962.

Caffin, Charles H. *Art for Life's Sake.* New York, Prang Co., 1913.
———. "Arthur Hoeber—An Appreciation," *New England Magazine*, 28 (April, 1903), 223–33.
Cary, Elisabeth Luther. "Art Critics and Art Interpreters," *Putnam's Monthly*, 3 (December, 1907), 356–61.
Child, Theodore. *Art and Criticism.* New York, Harper, 1892.
———. *The Desire of Beauty: Being Indications For Aesthetic Culture.* New York, Harper, 1892.
Coan, Titus Munson. "Critic and Artist," *Lippincott's Magazine*, 13 (March, 1874), 355–63.
Coffin, William A. "A Word About Painting," *Scribner's Magazine*, 15 (May, 1894), 499–504.
"Concerning Painters Who Would Express Themselves in Words," *Scribner's Magazine*, 26 (August, 1899), 254–56.
Cook, Clarence. "The Cry From the Studios," *Galaxy*, 3 (February 15, 1867), 435–40.
Cortissoz, Royal. *Art and Common Sense.* New York, Charles Scribner's Sons, 1913.
———. *The Painter's Craft.* New York, Charles Scribner's Sons, 1930.
———. "The Painter With Something to Say," *Scribner's Magazine*, 84 (December, 1928), 752–60.
———. *Personalities in Art.* New York, Charles Scribner's Sons, 1925.
———. "Some Discursive Reflections on the Art of Art Criticism," *Scribner's Magazine*, 74 (December, 1923), 762–68.
Cox, Kenyon. *Artist and Public, and Other Essays on Art Subjects.* New York: Charles Scribner's Sons, 1914.
———. *The Classic Point of View.* New York, Charles Scribner's Sons, 1911.
———. *Concerning Painting.* New York, Charles Scribner's sons, 1917.
———. *Old Masters and New.* New York, Fox, Duffield and Co., 1905.
———. *Painters and Sculptors.* New York, Fox, Duffield and Co., 1907.
Cranch, C. P. "Art-Criticism Reviewed," *Galaxy*, 4 (May, 1867), 77–81.
Croly, Herbert. "Art and Life," *Architectural Record*, 1 (October–December, 1891), 219–27.
Desmond, Harry W. "Criticism," *Scribner's Magazine*, 36 (July, 1904), 125–28.

Eddy, Arthur Jerome. *Delight: The Soul of Art.* Philadelphia, J. B. Lippincott, 1902.

Edel, Leon. "Henry James as an Art Critic," *American Art Journal,* 6 (November, 1974), 4–14.

"Evolution of Artistic Taste," *Scribner's Magazine,* 20 (September, 1896), 389–90.

"A Few Words About Art Criticism," *Nation,* 2 (March 29, 1866), 409.

Flexner, James T. "Tuckerman's *Book of the Artists,*" *American Art Journal,* 1 (Fall, 1969), 53–57.

Fowler, Frank. "Art Criticism From the Standpoint of the Painter," *Scribner's Magazine,* 37 (January, 1905), 125–28.

———. "The New Heritage of Painting of the Nineteenth Century," 30 (August, 1901), 253–56.

"French and English Art-Writer's," *Atlantic Monthly,* 24 (July, 1869), 119–25.

Garland, Hamlin. *Crumbling Idols.* Cambridge, Harvard University Press, 1960.

Gorren, Aline, "American Society and the Artist," *Scribner's Magazine,* 26 (April, 1899), 628–33.

Grosser, Maurice. *The Critic's Eye.* New York, Bobbs-Merrill, 1962.

———. *The Painter's Eye.* New York, Rinehart, 1951.

Hamerton, Philip Gilbert. *Thoughts About Art.* Boston, Roberts Bros., 1899.

Hapgood, Norman. "American Art Criticism," *Bookman,* 6 (September, 1897), 45–47.

Heckman, Wallace. "What Is the Use of Art," *Brush and Pencil,* 4 (July, 1899), 191–96.

Hoeber, Arthur. "The Art of the Month," *Bookman,* 9 (March, 1899), 47–55.

Huneker, James Gibbons. "The Melancholy of Masterpieces," *Scribner's Magazine,* 56 (July, 1914), 133–36.

———. *Promenades of an Impressionist.* New York, Charles Scribner's Sons, 1910.

James, Henry. *The American Scene.* New York, Harper, 1907.

———. "On Some Pictures Lately Exhibited," *Galaxy,* 20 (July, 1875), 89–97.

———. *The Painter's Eye.* Cambridge, Harvard University Press, 1956.

———. *Picture and Text.* New York, Harper, 1893.

Jarves, James Jackson. *The Art Idea.* Cambridge, Harvard University Press, 1960.

Kavolis, Vytautas. *Artistic Expression: A Sociological Analysis.* Ithaca, Cornell University Press, 1968.

Kies, Emily Bardack. "The City and the Machine: Urban and Industrial Illustration in America, 1880–1900". Ph.D. dissertation, Columbia University, 1971.

La Farge, John. *Considerations on Painting.* New York, Macmillan, 1895.

"Lay Art Criticism," *Art Amateur*, 5 (August, 1881), 46.

Logan, Mary. "The New Art Criticism," *Atlantic Monthly*, 76 (August, 1895), 263–70.

Low, Will H. "A Century of Painting," *McClure's Magazine*, 7 (September, 1896), 293–94, and 7 (October, 1896), 415–26.

Low, Will H., and Kenyon Cox. "The Nude in Art," *Scribner's Magazine*, 12 (December, 1892), 741–49.

Mabie, Hamilton Wright. *American Ideals, Character and Life.* New York, Macmillan, 1913.

MacColl, D.S. *Nineteenth Century Art.* Glasgow, J. Maclehose and Son, 1902.

Mather, Frank J., Jr. "Authority in Art Criticism," *Scribner's Magazine*, 48 (December, 1910), 766–68.

———. *Concerning Beauty.* Princeton, Princeton University Press, 1935.

———. "John Ruskin," *Nation*, 95 (September 19, 1912), 267–69.

Miller, Charles Henry. *The Philosophy of Art in America.* New York, W. R. Jenkins, 1885.

"The Moral Influence of Art," *Art Amateur*, 5 (July, 1881), 35–36.

"Nebulae," *Galaxy*, 1 (June 1, 1866), 272–73.

Nochlin, Linda. *Realism.* New York, Penguin Books, 1971.

Noyes, Carleton. *The Enjoyment of Art.* New York, Houghton Mifflin, 1903.

———. *The Gate of Appreciation: Studies in the Relation of Art to Life.* Boston, Houghton Mifflin, 1907.

O'Doherty, Barbara Novak. "Some American Words; Basic Aesthetic Guildlines, 1825–1870," *American Art Journal*, 1 (Spring, 1969), 78–91.

Pach, Walter. *Ananias; or, the False Artist.* New York, Harper, 1928.

"Picture Criticism," *Art Amateur*, 13 (August, 1885), 46.

Plagens, Peter. "The Critics: Hartmann, Huneker, De Casseres," *Art in America*, 61 (July–August, 1973), 67–71.

Pond, A. B. "The Relation of Art to the Public Welfare," *Brush and Pencil*, 4 (May, 1899), 99–103.

Rich, Daniel Catton. "The Conscience of a Critic: Henry McBride (1867–1962)," *Arts Magazine*, 37 (November, 1962), 48–52.

Rich, Daniel Catton (ed.). *The Flow of Art: Essays and Criticisms of Henry McBride*. New York, Atheneum, 1976.

Rothenstein, John. *Nineteenth Century Painting: A Study in Conflict*. London, John Lane, 1932.

Schwab, Arnold T. *James Gibbons Huneker: Critic of the Seven Arts*. Stanford, Stanford University Press, 1963.

Simoni, John Peter. "Art Critics and Criticism in Nineteenth Century America." Ph.D. dissertation, Ohio State University, 1958.

Spector, Jack J. *The Aesthetics of Freud: A Study in Psychoanalysis and Art*. New York, Praeger, 1972.

Steegmuller, Francis. *The Two Lives of James Jackson Jarves*. New Haven, Yale University Press, 1951.

Stein, Roger B. *John Ruskin and Aesthetic Thought in America, 1840–1900*. Cambridge, Harvard University Press, 1967.

Stillman, W. J. "The Decay of Art," *New Princeton Review*, Series 5, Vol. 2 (July, 1886), 20–36.

———. "Realism and Idealism," *Nation*, 41 (December 31, 1885), 545–46.

Sturgis, Russell. "American Painters: The National Academy Exhibition," *Galaxy*, 4 (June, 1867), 226–36.

———. *The Appreciation of Pictures*. New York, Baker and Taylor, 1905.

———. "Art Criticism and Ruskin's Writings on Art," *Scribner's Magazine*, 27 (April, 1900), 509–12.

———. "Artists With Theories, Convictions and Principles [The Pre-Raphaelites]," *Scribner's Magazine*, 40 (August, 1906), 125–28.

———. *The Interdependence of the Arts of Design*. Chicago, A. C. McClurg, 1905.

———. "Painting," *Forum*, 34 (January, 1903), 404–23.

"This Transitional Age in Art," *Century Magazine*, 87 (April, 1914), 825–64.

Triggs, Oscar Lovell. "Democratic Art," *Forum*, 26 (September, 1898), 66–79.

Van Dyke, Henry J. "Art and Ethics," *Princeton Review*, Series 4, Vol. 11 (January, 1883), 91–110.

Van Dyke, John Charles. *Art for Art's Sake*. New York, Charles Scribner's Sons, 1893.

———. *How to Judge of a Picture*. New York, Chautauqua Press, 1888.

———. *The Meaning of Pictures*. New York, Charles Scribner's Sons, 1903.

———. *Modern French Masters*. New York, Century Co., 1896.

————. *Principles of Art*. New York, Ford, Howard and Hulbert, 1887.

————. *What Is Art?* New York, Charles Scribner's Sons, 1910.

Van Rensselaer, Mariana G. "American Art and the Public," *Scribner's Magazine*, 74 (November, 1923), 637–40.

————. "The New York Art Season," *Atlantic Monthly*, 48 (August, 1881), 193–202.

————. "Some Aspects of Contemporary Art," *Lippincott's Magazine*, 22 (December, 1878), 706–18.

Venturi, Lionello. *Art Criticism Now*. Baltimore, Johns Hopkins Press, 1941.

"What is Art Criticism?" *Nation*, 2 (April 19, 1866), 504–506.

Winner, Viola Hopkins. *Henry James and the Visual Arts*. Charlottesville, University Press of Virginia, 1970.

Wister, Sarah B. "The Art-Experience of an Ignoramus," *Lippincott's Magazine*, 15 (June, 1875), 712–17.

Wright, Carroll D. "The Practical Value of Art," *Munsey's Magazine*, 17 (July, 1897), 562–68.

# V.  ART TRAINING IN AMERICA

Adams, Charlotte. "Artists' Models in New York," *Century Magazine*, 25 (February, 1883), 569–77.

"Art and Art-Life in New York," *Lippincott's Magazine*, 29 (June, 1882), 597–605.

"The Art Schools of the United Sates," *Appleton's Art Journal*, 1 (1875), 28–30.

"At the Studios," *Appleton's Journal*, 13 (March 27, 1875), 409–10.

Baury, Louis. "The Message of Bohemia," *Bookman*, 34 (November, 1911), 256–66.

————. "The Message of Proletaire," *Bookman*, 34 (December, 1911), 400–404.

Baxter, Sylvester. "The Art-Schools of Boston," *Appleton's Art Journal*, 4 (1878), 189–90.

Bishop, William H. "Young Artists' Life in New York," *Scribner's Magazine*, 19 (January, 1880), 355–68.

Bisland, Elizabeth. "The Studios of New York," *Cosmopolitan*, 7 (May, 1889), 4–22.

Brown, Bolton Coit. "What Should an Art School Be?" *Overland*

*Monthly*, Series 2, Vol. 19 (March, 1892), 301–17.

Brownell, William C. "The Art Schools of New York," *Scribner's Magazine*, 16 (October, 1878), 761–81.

———. "The Art Schools of Philadelphia," *Scribner's Magazine*, 18 (September, 1879), 737–50.

Carter, Susan Nichols. "The National Academy of Design," *Appleton's Journal*, 8 (September 21, 1872), 325–28.

Clark, John S. "The Artist and Art Instruction in Public Schools," *Modern Art*, 4 (Spring, 1896), 40–44.

Cooper, W.A. "Artists in Their Studios," *Godey's Magazine*, 130 (January, 1895), 291–305.

De Kay, Charles. "Organization Among American Artists," *International Monthly*, 1 (January, 1900), 84–98.

Fairbanks, C. M. "New York as an Art Center," *Chautauquan*, 13 (June, 1891), 330–33.

———. "The Social Side of Artist Life," *Chautauquan*, 13 (September, 1891), 746–51.

Fowler, Frank. "Opportunities for Art Study in New York," *Scribner's Magazine*, 48 (August, 1910), 253–56.

Glueck, Grace. "100 Years at the Art Students League," *Art News*, 74 (May, 1975), 40–42.

Harwood, W. S. "The Art Schools of America," *Cosmopolitan*, 18 (November, 1894), 27–34.

Knaufft, Ernest. "Our American Art Schools, *Art Amateur*, 24 (1890–1891), *passim*.

La Farge, C. Grant. "The Education of the Artist," *Scribner's Magazine*, 58 (August, 1915), 257–60.

Landgren, Marchal E. *Years of Art: The Story of the Art Students League of New York*. New York, R. M. McBride, 1940.

E.T.L. "Studio Life in New York," *Appleton's Art Journal*, 3 (1877), 267–68.

Low, Will H. "The Education of the Artist, Here and Now," *Scribner's Magazine*, 25 (June, 1899), 765–68.

———. "A Letter to a Young Gentleman Who Proposes to Embrace the Career of Art," *Scribner's Magazine*, 4 (August, 1888), 381–84.

McCoy, Garnett. "Visits, Parties, and Cats in the Hall: The Tenth Street Studio Building and Its Inmates in the Nineteenth Century," *Archives of American Art Journal*, 6 (January, 1966), 1–8.

Mather, Frank J., Jr. "The Discovery of Artistic America," *Nation*, 90 (January 27, 1910), 96–97.

———. "University Study of Art in America," *Scribner's Magazine*, 53 (April, 1913), 527–30.

"New York Art Schools," *Art Amateur*, 12 (December, 1884), 13.

Parry, Albert. *Garrets and Pretenders: A History of Bohemianism in America*. New York, Dover Publications, 1960.

Perkins, Charles C. *Art Education in America*. Cambridge, The Riverside Press, for the American Social Science Association, 1870.

Porter, A. Kingsley. "Problems of the Art Professor," *Scribner's Magazine*, 65 (January, 1919), 125–28.

Pyle, Katharine. "Some Types of Artists' Models," *Cosmopolitan*, 21 (May, 1896), 14–21.

Shelton, William Henry. "Artist Life in New York in the Days of Oliver Horn," *Critic*, 43 (July, 1903), 31–40.

"The Study of Art," *Chautauquan*, 3 (April, 1883), 416.

Twombly, Mary. "The Art Students League of New York," *Bookman*, 12 (November, 1900), 248–55.

Van Dyke, John C. "The Art Students League of New York," *Harper's Monthly*, 83 (October, 1891), 688–700.

Weir, John F. "Popular Art-Education," *North American Review*, 132 (January, 1881), 64–78.

Whitman, Sarah. "Art in the Public Schools," *Atlantic Monthly*, 79 (May, 1897), 617–23.

———. "The Pursuit of Art in America," *International Review*, 12 (January, 1882), 10–17.

## VI. ART TRAINING IN EUROPE

"The Academy of Fine Arts [of Paris]," *Nation*, 54 (January 28, 1892), 67–68, and 54 (February 1, 1892), 106–107.

"The American Art Club of Munich," *Art Amateur*, 11 (September, 1884), 75–76.

"The American Educational Art Institute [of Paris]," *Critic*, 26 (June 29, 1895), 485.

"Art Life in Rome," *Art Amateur*, 13 (July, 1885), 30.

"The Art Student in Paris," *Art Amateur*, 27 (June, 1892), 10.

"Art-Student Life in Munich," *Art Amateur*, 31 (July, 1894), 30–31.

"Art Study Abroad," *Nation*, 3 (September 6, 1866), 195–96.

Atkinson, J. Beavington. "Düsseldorf: Its Old School and Its New Academy," *Art Journal*, 6 (1880), 97–100.

Avery, Henry O. "The Paris School of Fine Arts," *Scribner's Magazine*, 2 (October, 1887), 387–403.

Aylward, Emily Meredyth. "The American Girls' Art Club in Paris," *Scribner's Magazine*, 16 (November, 1894), 598–605.

Bacon, Henry. *Parisian Art and Artists*. Boston, J. R. Osgood, 1882.

———. *A Parisian Year*. Boston, Roberts Bros., 1882.

Baedeker, Karl. *Paris and Environs*. Leipsig, Baedeker, 1898.

———. *Southern Germany and Austria*. Leipsig, Baedeker, 1887.

Becker, George J., and Edith Phillips. *Paris and the Arts, 1851–1896: From the Goncourt Journal*. Ithaca, Cornell University Press, 1971.

Benson, Eugene. "A German Art-City: Munich and Its Art," *Appleton's Journal*, 7 (February 17, 1872), 182–83.

———. "Paris and the Parisians," *Galaxy*, 4 (September, 1867), 666–74.

Bizardel, Yvon. *American Painters in Paris*. New York, Macmillan, 1960.

Brownell, William C. *French Traits*. New York, Charles Scribner's Sons, 1897.

———. "New York After Paris," *New Princeton Review*, Series 5, Vol. 6 (July, 1888), 80–96.

Burchell, S. C. *Imperial Masquerade: The Paris of Napoleon III*. New York, Atheneum, 1971.

Child, Theodore. *The Praise of Paris*. New York, Harper 1893.

Copley Society of Boston. *The Art Student in Paris*. Boston, Boston Art Students Association, 1887.

Dabo, Leon Scott. "Art and American Students," *Arena*, 30 (November, 1903), 499–504.

Davis, Richard Harding. *About Paris*. New York, Harper, 1895.

De Kay, Charles. "Munich as an Art Center," *Cosmopolitan*, 13 (October, 1892), 643–53.

de Vere, Schele. "Art Schools in Southern Germany," *Appleton's Journal*, 8 (November 30, 1872), 606–607.

Easton, Malcolm. *Artists and Writers in Paris: The Bohemian Idea*. London, Edward Arnold, 1964.

Evans, E. P. "Artists and Art Life in Munich," *Cosmopolitan*, 9 (May, 1890), 3–14.

Fink, Lois. "American Artists in France, 1850–1897," *American Art Journal*, 5 (November, 1973), 32–49.

Fox, Daniel M. "Artists in the Modern State: Nineteenth Century Background," *Journal of Aesthetics and Art Criticism*, 22 (Winter, 1963), 135–48.

Furness, H. W. "The Town of Trilby," *Critic*, 29 (October 31, 1896), 269–70.

Gillis, John R. *Youth and History: Tradition and Change in European Age Relations 1770–Present*. New York, Academic Press, 1974.

"Glimpses of Parisian Art," *Century Magazine*, 31 (December, 1880), 169–180: 22 (January, 1881), 423–31; 22 (March, 1881), 734–43.

Hemmings, F.W.J. *Culture and Society in France 1848–1898*. New York, Charles Scribner's Sons, 1971.

Hooper, Lucy H. "The American Colony in Paris," *Appleton's Journal*, 11 (June 20, 1874), 779–81.

James, Henry. "Our Artists in Europe," *Harper's Monthly*, 79 (June, 1889), 50–66.

Janvier, Thomas A. "The World's Art Center [Paris]," *Critic*, 23 (September 23, 1893), 191.

Keyzer, Frances. "Some American Artists in Paris," *Studio*, 13 (May, 1898), 246–52.

"Letters From a French Atelier," *Living Age*, 204 (February 9, 1895), 369–80.

Linson, Corwin K. "With the Paris Art Student," *Frank Leslie's Popular Monthly*, 34 (September, 1892), 289–302.

Low, Will H. "The American Art Student in Paris," *Scribner's Magazine*, 34 (October, 1903), 509–12.

Mandel, Richard. *Paris 1900*. Toronto, University of Toronto Press, 1967.

Morrow, W. C. *Bohemian Paris of Today*. Philadelphia, J. B. Lippincott, 1900.

Nieriker, May Alcott. *Studying Art Abroad and How to do It Cheaply*. Boston, Roberts Bros., 1879.

Nott, Phebe D. "Paris Art-Schools," *Lippincott's Magazine*, 27 (March, 1881), 269–76.

Parker, Lawton S. "Another View of Art Study in Paris," *Brush and Pencil*, 11 (October, 1902), 11–16.

Peterson, Alice Fessenden. "The American Art Student in Paris," *New England Magazine*, 2 (August, 1890), 669–76.

Richardson, Joanna. *The Bohemians: La Vie de Bohéme in Paris 1830–1914*. New York, A. S. Barnes, 1971.

———. *La Vie Parisienne*. New York, Viking Press, 1972.

Rowell, F. "Art Life in Paris," *Chautauquan*, 30 (January, 1900), 405–14.

Rudorff, Raymond. *The Belle Epoque: Paris in the Nineties*. New York, Saturday Review Press, 1973.

Sarcey, Francisquem "Murger and Bohemia," *Cosmopolitan*, 20 (February, 1896), 332–33.

Shirley-Fox, John. *An Art Student's Reminiscences of Paris in the Eighties*. London, Mills and Boon, 1909.

Sisson, Thiebault. "The Beautiful Models of Paris," *Cosmopolitan*, 18 (March, 1895), 529–40.

Sutherland, J. "An Art Student's Year in Paris," *Art Amateur*, 32 (January, 1895), 52; (February, 1895), 86; 32 (March, 1895), 108.

Taylor, E. A. "The American Colony of Artists in Paris," *Studio*, 52 (May, 1911), 263–280; 53 (July, 1911), 103–15; 55 (May, 1912), 280–90.

Thompson, Vance. "American Artists in Paris," *Cosmopolitan*, 29 (May, 1900), 17–29.

Walker, Katherine C. "American Studios in Rome and Florence," *Harper's Monthly*, 33 (June, 1866), 101–105.

Watts, Anna Mary. *An Art Student in Munich*. Boston, Ticknor, Reed and Fields, 1854.

Whiteing, Richard. "The American Student at the Beaux-Arts," *Century Magazine*, 23 (December, 1881), 259–72.

Williams, Roger L. *Gaslight and Shadows: The Paris of Napoleon III, 1851–1870*. New York, Macmillan, 1957.

Wright, Margaret Bertha. "Art Student Life in Paris," *Art Amateur*, 3 (September, 1880), 70–71.

Wuerpel, E. H. "American Artists' Association of Paris," *Cosmopolitan*, 20 (February, 1896), 402–409.

## VII. FOREIGN INFLUENCES

Baker, Paul R. *The Fortunate Pilgrims: Americans in Italy 1800–1860*. Cambridge, Harvard University Press, 1964.

Benjamin, S.G.W. *Contemporary Art in Europe*. New York, Harper, 1877.

———. "The Practice and Patronage of French Art," *Atlantic Monthly*, 36 (September, 1875), 257–69.

Bermingham, Peter. *American Art in the Barbizon Mood*. Washington, National Collection of Fine Arts, 1975.

———. "Barbizon Art in America." Ph.D. dissertation, University of Michigan, 1972.

Blumenthal, Henry. *American and French Culture: Interchanges in Art, Science, Literature and Society*. Baton Rouge, Louisiana State University Press, 1975.

Boime, Albert. *The Academy and French Painting in the Nineteenth Century*. London, Phaidon, 1970.

Bouret, Jean. *The Barbizon School and Nineteenth Century French Landscape Painting*. Greenwich, Conn., New York Graphic Society, 1972.

Bowie, Henry P. "The Essential Principles of Japanese Painting," *Scriber's Magazine*, 53 (March, 1913), 399–402.

Boyeson, H. H. "Norwegian Painters," *Scribner's Magazine*, 12 (December, 1892), 756–70.

Brinton, Christian. "German Painting of Today," *Scribner's Magazine*, 45 (February, 1909), 129–43.

———. "Franz von Lenbach," *Critic*, 39 (December, 1901), 503–11.

———. "A Group of Modern English Painters," *Harper's Monthly*, 121 (July, 1910), 236–44.

———. "Russia's Greatest Painter—Ilia Repin," *Scribner's Magazine*, 40 (November, 1906), 513–23.

———. "Scandinavian Painters of Today," *Scribner's Magazine*, 52 (December, 1912), 647–61.

———. "Two Great Spanish Painters: Sorolla and Zuloaga," *Century Magazine*, 78 (May, 1909), 26–36.

Brooks, Van Wyck. *The Dream of Arcadia*. New York, E. P. Dutton, 1958.

Brownell, William C. *French Art*. New York, Charles Scribner's Sons, 1892.

———. "French Art. III. Realistic Painting," *Scribner's Magazine*, 12 (November, 1892), 604–27.

Cabot, Walter M. "Some Aspects of Japanese Painting," *Atlantic Monthly*, 95 (June, 1905), 804–13.

Caffin, Charles H. *The Story of French Painting*. New York, Century Co., 1911.

———. *The Story of Spanish Painting*. New York, Century Co., 1910.

Champa, Kermit, and Kate Champa. *German Painting of the Nineteenth Century*. New Haven, Yale University Art Gallery, 1970.

Chase, Emma Eames. "Dutch Painters at Home," *Century Magazine*, 37 (March, 1889), 755–65.

Child, Theodore. "Some Modern French Painters," *Harper's Monthly*, 80 (May, 1890), 817–42.

Cortissoz, Royal. "The Genius of Spain in New York," *Scribner's Magazine*, 49 (June, 1911), 765–68.

———. "The Present State of European Painting," *Atlantic Monthly*, 98 (November, 1906), 684–93.

Cox, Kenyon. "The Art of Millet," *Scribner's Magazine*, 43 (March, 1908), 328–40.

Denio, Elizabeth. "Modern Italian Art," *Brush and Pencil*, 12 (July, 1903), 246–52.

Diercks, Gustav. "Decadence of Art in Present-Day Spain," *Brush and Pencil*, 12 (July, 1903), 233–42.

*The Düsseldorf Academy and the Americans*. Atlanta, High Museum of Art, 1973.

Eaton, D. Cady. *A Handbook of Modern French Painting*. New York, Dodd, Mead, 1914.

Fink, Lois. "The Role of France in American Art, 1850–1870." Ph.D. dissertation, University of Chicago, 1969.

Fowler, Frank. "Some Modern German Paintings at the Metropolitan Museum," *Scribner's Magazine*, 45 (June, 1909), 765–68.

Gaunt, William. *The Restless Century: Painting in Britain 1800–1900*. New York, Praeger, 1972.

Hamerton, Philip Gilbert. *Modern Schools of Art, American and European*. New York, A. S. Barnes, 1880.

———. *The Present State of the Fine Arts in France*. London, Seeley and Co., 1892.

Harrison, Birge. "The New Departure in Parisian Art," *Atlantic Monthly*, 66 (December, 1890), 753–64.

Herbert, Robert L. *Barbizon Revisited*. New York, Clarke and Way, 1962.

———. "City vs. Country: The Rural Image in French Painting from Millet to Gaugin," *Artforum*, 8 (February, 1970), 44–55.

Hind, C. Lewis. "American Paintings in Germany," *Studio*, 50 (August, 1910), 178–90.

Hoppin, W. J. "A Glimpse of Contemporary Art in Europe," *Atlantic Monthly*, 32 (August, 1873); and 32 (September, 1873), 257–67.

Isham, Samuel. "French Painting at the Beginning of the Twentieth Century," *Scribner's Magazine*, 38 (September, 1905), 381–84.

Jones, Jenkins Lloyd. "Jean François Millet," *New England Magazine*, 1 (December, 1889), 367–71.

La Farge, John. "A History of Japanese Art," *International Monthly*, 3 (May, 1901), 590–96.

———. "Ruskin, Art and Truth," *International Monthly*, 2 (November, 1900), 510–26.

Larned, Walter Cranston. "Millet and Recent Criticism," *Scribner's*

*Magazine*, 8 (August, 1890), 390–92.

Laughton, Bruce. *Philip Wilson Steer 1860–1942*. Oxford, Clarendon Press, 1971.

Laurin, Carl, et al. *Scandinavian Art*. New York, American-Scandinavian Foundation, 1922.

Low, Will H. "A Century of Painting: Italy," *McClure's Magazine*, 7 (August, 1896), 225–33.

Macgahan, B. "Verestchagin and His Work," *Lippincott's Magazine*, 44 (August, 1889), 232–37.

Mather, Frank J., Jr. "Far Eastern Painting. I. China," *Nation*, 93 (August 17, 1911), 150–53. and "Far Eastern Painting. II. Japan," 93 (August 24, 1911), 174–76.

————. "The Paintings of Sorolla," *Nation*, 90 (March 3, 1910), 219–22.

"Meissonier," *Appleton's Journal*, 2 (September 11, 1869), 119.

Meltzer, Charles Henry. "Zuloaga—Art Insurgent," *Cosmopolitan*, 50 (January, 1911), 177–85.

Michener, James A. *The Floating World*. London, Secker and Warburg, 1954.

"Modern French Painting," *Atlantic Monthly*, 22 (July, 1868), 88–95.

Mollett, John W. *The Painters of the Barbizon*. London, S. Low, 1890.

Moore, Charles H. "The Modern Art of Painting in France," *Atlantic Monthly*, 68 (December, 1891), 805–16.

Osgood, Samuel. "American Artists in Italy," *Harper's Monthly*, 41 (August, 1870), 420–26.

"The Paintings of Meissonier," *Nation*, 63 (December 24, 1896), 476–78.

Perdicaris, Ion. "English and French Painting," *Galaxy*, 2 (October, 1866), 378–80.

"Pre-Raphaelitism," *Nation*, 1 (August 31, 1865), 273–74.

Prescott, Edward Bowen. "Modern Spanish Art," *Harper's Monthly*, 76 (March, 1888), 491–516.

Priestley, J. B. *The Edwardians*. New York, Harper and Row, 1970.

Réau, Louis. *L'Art français aux États-Unis*. Paris, H. Laurens, 1926.

Reid, Dennis. *A Concise History of Canadian Painting*. Toronto, Oxford University Press, 1933.

Rhodes, Albert. "A Day with French Painters," *Galaxy*, 16 (July, 1873), 5–15.

Shattuck, Roger. *The Banquet Years: The Arts in France, 1885–1918*. New York, Harcourt, Brace, 1958.

Sloane, Joseph C. *French Painting Between the Past and Present: Artists, Critics, and Traditions from 1848 to 1870.* Princeton, Princeton University Press, 1951.

Smith, Charles Sprague. *Barbizon Days.* New York, A. Wessels Co., 1906.

Strahan, Edward [Earl Shinn]. *Etudes in Modern French Art.* New York, R. Worthington Co., 1882.

Stranahan, C.H. *A History of French Painting.* New York, Charles Scribner's Sons, 1888.

Titherington, R. H. "Jean Léon Gérôme," *Munsey's Magazine,* 35 (June, 1906), 279–87.

Van Laer, Alexander T. "Some Aspects of Modern Dutch Art," *Scribner's Magazine,* 58 (July, 1915), 125–28.

Van Vorst, Marie. *Modern French Masters.* Paris and Union Square, New York City, Brentano's, 1904.

Waern, Cecilia. "The Modern Group of Scandinavian Painters," *Scribner's Magazine,* 25 (June, 1899), 643–56.

Wells, C. L. "Art in Italy," *Appleton's Art Journal,* 2 (1876), 153–54.

Wells, Clara. "Art in Rome," *Appleton's Art Journal,* 3 (1877), 56–57.

Whitman, Sidney. "Franz von Lenbach," *Harper's Monthly,* 102 (February, 1901), 398–405.

## VIII. THE AMERICAN SCENE

"About an American School of Art," *Scribner's Magazine,* 10 (July, 1875), 380–81.

Alexander, John W. "Is Our Art Distinctly American?", *Century Magazine,* 87 (April, 1914), 826–28.

"Art and Life," *Current Literature,* 30 (June, 1901), 732–33.

"Art as a Steady Diet," *Scribner's Magazine,* 17 (January, 1879), 438–39.

Benjamin, S.G.W. "American Art Since the Centennial," *New Princeton Review,* Series 5, Vol. 4 (July, 1887), 14–30.

————. *Art in America: A Critical and Historical Approach.* New York, Harper, 1880.

————. *Contemporary Art in America.* New York, Harper, 1887.

————. *Our American Artists.* Boston, D. Lathrop, 1879.

————. "Present Tendencies of American Art," *Harper's Monthly,* 58 (March, 1879), 481–96.

Boyesen, Bayard. "The National Note in American Painting," *Putnam's Monthly,* 4 (May, 1908), 131–34.

Brinton, Christian. "The Case for American Art," *Century Magazine*, 77 (November, 1908), 351–61.

———. "The New Spirit in American Painting," *Bookman*, 27 (June, 1908), 351–61.

Brownell, W. C. "The Younger Painters of America, Part I," *Scribner's Magazine*, 20 (May, 1880), 1–15; Part II, 20 (July, 1880), 321–35; Part III, 22 (July, 1881), 321–34.

Bryant, Lorinda Munson. *American Pictures and Their Painters.* New York, John Lane, 1917.

Caffin, Charles H. *American Masters of Painting.* New York, Doubleday, 1902.

———. *The Story of American Painting.* New York, Frederick A. Stokes, 1907.

Child, Theodore. "American Artists at the Paris Exposition," *Harper's Monthly*, 79 (September, 1889), 489–521.

Cone, Ada. "The Art Problem in the United States," *Contemporary Review*, 80 (September, 1901), 373–94.

Cook, Clarence. *Art and Artists of Our Time.* 3 vols. New York, Selmar Hess, 1888.

———. "Art in America in 1883," *Princeton Review*, Series 4, Vol. 11 (May, 1883), 311–20.

Corey, M. G. "Art and American Society," *Cosmopolitan*, 46 (March, 1909), 432–38.

Cortissoz, Royal. *American Artists.* New York, Charles Scribner's Sons, 1923.

Cox, Kenyon. "The American School of Painting," *Scribner's Magazine*, 50 (November, 1911), 765–68.

Croly, Herbert. "American Artists and Their Public," *Architectural Record*, 10 (January, 1901), 256–62.

———. "New World and the New Art," *Architectural Record*, 12 (June, 1902), 134–53.

"Democracy and Fine Art," *Architectural Record*, 14 (September, 1903), 227–32.

Downes, William Howe. *Twelve Great Artists.* Boston, Little, Brown, 1900.

———. "Later American Masters," *New England Magazine*, 14 (April, 1896), 131–51.

Durand-Gréville, E. "Correspondance d'Amérique: L'Art aux États-Unis," *Gazette des Beaux-Arts*, 28 (1886), 255–64.

Fuller, Henry B. "Art in America," *Bookman*, 10 (November, 1899), 218–24.

Harrison, Birge. "The Future of American Art," *North American*

*Review*, 189 (January, 1909), 24–34.

Henri, Robert. "Progress in Our National Art . . . ," *Craftsman*, 15 (January, 1909), 387–401.

Hoeber, Arthur. "Concerning Our Ignorance of American Art," *Forum*, 39 (January, 1908), 352–61.

Koehler, S. R. *American Art*. New York, Cassell and Co., 1886.

Low, Will H. "National Expression in American Art," *International Monthly*, 2 (March, 1901), 231–51.

McSpadden, J. Walker. *Famous Painters of America*. New York, T. Y. Crowell, 1907.

Mechlin, Leila. "Trend of American Art," *Cosmopolitan*, 41 (June, 1906), 177–184.

Millett, Francis D. "What Are Americans Doing in Art?", *Century Magazine*, 43 (November, 1891), 46–49.

Montgomery, Walter (ed.). *American Art and American Art Collections*. Boston, Walker Co., 1889.

Partridge, William Ordway. *Art For America*. Boston, Roberts Bros., 1894.

———. "The Demands of Art in This New Republic," *Arena*, 30 (September, 1903), 225–30.

———. "A National Art Exhibition," *Review of Reviews*, 22 (August, 1900), 198–201.

"The Progress of Painting in America," *North American Review*, 124 (May, 1877), 452–64.

Quilibet, Philip. "The Growth of American Taste for Art," *Galaxy*, 23 (February, 1877), 268.

Roberts, Mary Fanton. "Is America Selling Her Birthright in Art for a Mess of Pottage?", *Craftsman*, 11 (March, 1907), 656–70.

———. "The Younger American Painters Today: Are They Creating a National Art?", *Craftsman*, 13 (February, 1908), 512–32.

Sheldon, George W. *American Painters*. New York, D. Appleton, 1881.

———. *Hours With Art and Artists*. New York, D. Appleton, 1882.

———. *Recent Ideals of American Art*. 3 vols. New York, D. Appleton, 1888.

Swift, Samuel. "Americanism in Art," *Brush and Pencil*, 15 (1905), 51–57.

Tilliam, Sidney, "Culture in a Democracy: Three Centuries of American Painting," *Arts Magazine*, 39 (April, 1965), 36–43.

Tuckerman, Henry T. *Book of the Artists: American Artist Life*. New York, G. P. Putnam's Sons, 1867.

Van Dyke, John C. *American Painting and Its Tradition*. New York,

Charles Scribner's Sons, 1919.

Van Rensselaer, Mariana G. *Six Portraits*. Boston, Houghton Mifflin, 1889.

Weir, John F. "American Art: Its Progress and Prospects," *Princeton Review*, Series 4, Vol. 1 (May, 1878), 815–29.

Whitman, Sarah W. "The Pursuit of Art in America," *International Review*, 12 (January, 1882), 10–17.

## IX.  MURAL PAINTING

Blashfield, Edwin Howland. *Mural Painting in America*. New York, Charles Scribner's Sons, 1913.

Brinton, Selwyn. "Modern Mural Decoration in America," *Studio*, 51 (December, 1910), 175–90.

Coffin, William A. "The Decorations in New Congressional Library," *Century Magazine*, 53 (March, 1897), 694–711.

Cortissoz, Royal. "The Art of Mural Decoration—Its Development in the United States," *Scribner's Magazine*, 77 (May, 1925), 552–60.

―――. "Mural Decoration in America," *Century Magazine*, 51 (November, 1895), 111–21.

Fenollosa, Ernest. *Mural Painting in the Boston Public Library*. Boston, Curtis and Co., 1896.

Fowler, Frank. "The Outlook for Decorative Art in America," *Forum*, 18 (February, 1895), 686–93.

King, Pauline. *American Mural Painting*. Boston, Noyes, Platt, 1902.

Little, Nina Fletcher. *American Decorative Wall Painting, 1700–1850*. New York, E. P. Dutton, 1972.

Low, Will H. "The Mural Painter and His Public," *Scribner's Magazine*, 41 (February, 1907), 253–56.

―――. "Mural Painting—Modern Possibilities of an Ancient Art," *Brush and Pencil*, 11 (December, 1902), 161–77.

"Mural Painting—An Art for the People and a Record of the Nation's Development," *Craftsman*, 10 (April, 1906), 54–66.

"Mural Painting in American Cities," *Scribner's Magazine*, 25 (January, 1899), 125–28.

Peixotto, Ernest. "The Future of Mural Painting in America," *Scribner's Magazine*, 69 (June, 1921), 635–40.

"Recent Church Decoration," *Scribner's Magazine*, 15 (February, 1878), 569–77.

Small, Herbert. *Handbook of the New Library of Congress*. Boston,

Curtis and Cameron, 1899.

Sturgis, Russell. "Mural Painting," *Forum*, 37 (January, 1906), 367–84.

Van Ingen, W. B. "Mural Painting and Dramatic Art," *Scribner's Magazine*, 41 (June, 1907), 765–68.

Van Rensselaer, Mariana G. "The New Public Library in Boston: Its Artistic Aspects," *Century Magazine*, 50 (June, 1895), 260–64.

Walton, William. "Mural Painting in This Country Since 1898," *Scribner's Magazine*, 40 (November, 1906), 637–40.

Whitehill, Walter Muir. "The Making of an Architectural Masterpiece—The Boston Public Library," *American Art Journal*, 2 (Fall, 1970), 13–35.

## X. MUSEUMS, ACADEMIES, COLLECTORS

Addison, Julia de Wolfe. *The Boston Museum of Fine Arts*. Boston, L. C. Page, 1910.

Alexander, John W. "The Need of a National Academy and its Value to the Growth of Art in America," *Craftsman*, 17 (March, 1910), 606–18.

Burr, Anna Robeson. *Portrait of a Banker: James Stillman, 1850–1918*. New York, Duffield Co., 1927.

Carter, Morris. *Isabella Stewart Gardner and Fenway Court*. New York, Houghton Mifflin Co., 1925.

Clark, Eliot C. *History of the National Academy of Design, 1825–1953*. New York, Columbia University Press, 1954.

Coleman, Laurence V. *The Museum in America*. 3 vols. Washington, American Association of Museums, 1939.

Constable, William G. *Art Collecting in the United States of America*. London and New York, T. Nelson, 1963.

Durand-Gréville, E. "La Peinture aux États-Unis: Les Galeries Privées," *Gazette des Beaux-Arts*, 29 (1887), 65–75, 250–55.

Fink, Lois Marie, and Joshua C. Taylor. *Academy: The Academic Tradition in American Art*. Washington, National Collection of Fine Arts, 1975.

Fox, Daniel M. *Engines of Culture: Philanthropy and Art Museums*. Madison, State Historical Society of Wisconsin, 1963.

Harris, Neil. "The Gilded Age Revisited: Boston and the Museum Movement," *American Quarterly*, 14 (Winter, 1962), 545–66.

Havemeyer, Louisine. *Sixteen to Sixty: Memoirs of a Collector*. New York, n.p., 1961.

Henderson, Helen. *The Art Treasures of Washington.* Boston, L. C. Page, 1912.

————. *The Pennsylvania Academy of Fine Arts and Other Collections of Philadelphia.* Boston, L. C. Page, 1911.

Howe, Winifred Eva. *A History of the Metropolitan Museum of Art.* New York, Gillis Press, 1913.

Jarves, James Jackson. "Museums of Art, Artists and Amateurs in America," *Galaxy*, 10 (July, 1870), 50–59.

Johnson, C. Stuart. "The Metropolitan Museum of Art," *Munsey's Magazine*, 6 (November, 1891), 145–54.

Lehrman, Leo. *The Museum: 100 Years and the Metropolitan Museum of Art.* New York, Viking Press, 1969.

McFadden, Elizabeth. *The Glitter and the Gold . . .* New York, Dial Press, 1970.

Meyer, Annie Nathan. "What American Museums are Doing for Native Art," *Century Magazine*, 72 (October, 1906), 922–43.

"Museums of Art as a Means of Instruction," *Appleton's Journal*, 3 (January 15, 1870), 80–81.

Pach, Walter. *The Art Museum in America.* New York, Pantheon Books, 1948.

Perkins, Charles C. "American Art Museums," *North American Review*, 111 (July, 1870), 1–29.

Phillips, Marjorie. *Duncan Phillips and His Collection.* Boston, Little, Brown, 1971.

Preyer, David C. *The Art of the Metropolitan Museum of New York.* Boston, L. C. Page, 1909.

Reid, B. L. *The Man From New York: John Quinn and His Friends.* New York, Oxford University Press, 1968.

Roberts, George. *Triumph on Fairmount: Fiske Kimball and the Philadelphia Museum of Art.* Philadelphia, J. B. Lippincott, 1959.

Saarinen, Aline. *The Proud Possessors.* New York, Random House, 1958.

Seligman, Germain. *Merchants of Art, 1880–1960: Eighty Years of Professional Collecting.* New York, Appleton-Century-Crofts, 1961.

Southworth, Alvan S. "The National Academy of Design," *Frank Leslie's Monthly*, 26 (October, 1888), 385–94.

Tharp, Louis Hall. *Mrs. Jack: A Biography of Isabella Stewart Gardner.* Boston, Little, Brown, 1965.

Tomkins, Calvin. *Merchants and Masterpieces: The Story of the Metropolitan Museum of Art.* New York, E. P. Dutton, 1970.

Towner, Wesley, and Stephen Varble. *The Elegant Auctioneers.*

New York, Hill and Wang, 1970.

Truettner, William E. "William T. Evans, Collector of American Paintings," *American Art Journal*, 3 (Fall, 1971), 50–79.

Walton, William. "Art Institutions in the United States," *Scribner's Magazine*, 50 (August, 1911), 253–66.

Weinberg, H. Barbara. "Thomas B. Clarke: Foremost Patron of American Art from 1872 to 1899," *American Art Journal*, 8 (May, 1976), 56–83.

Whitehill, Walter Muir. *Museum of Fine Arts, Boston: A Centennial History*. Cambridge, Harvard University Press, 1970.

Winkelman, Barnie F. *John G. Johnson: Lawyer and Art Collector*. Philadelphia, University of Pennsylvania Press, 1942.

## XI. IMPRESSIONISM

American Art Association. *Paintings by Claude Monet and Paul Albert Besnard.* . . . New York, J. J. Little Co., 1893.

———. *Works in Oil and Pastel by the Impressionists of Paris, 1886.* New York, J. J. Little Co., 1886.

"Art in Boston: The Wave of Impressionism," *Art Amateur*, 24 (May, 1891), 141.

Baur, John I. H. *Leaders of American Impressionism*. New York, Brooklyn Museum, 1937.

Boyle, Richard. *American Impressionism.* Boston, New York Graphic Society, 1974.

Champa, Kermit. *Studies in Early Impressionism*. New Haven, Yale University Press, 1973.

Child, Theodore. "A Note on Impressionist Painting," *Harper's Monthly*, 74 (January, 1887), 314–15.

Cook, Clarence. "The Impressionist Pictures," *Studio*, n.s. no. 21 (April 17, 1886), 245–54.

Corn, Wanda, M. *The Color of Mood: American Tonalism, 1880–1910*. San Francisco, M. H. De Young Museum, 1972.

Cortissoz, Royal. "Claude Monet," *Scribner's Magazine*, 81 (April, 1927), 329–36.

Domit, Moussa M. *American Impressionist Painting*. Washington, National Gallery of Art, 1973.

Downes, William Howe. "Impressionism in Painting," *New England Magazine*, 6 (July, 1892), 600–603.

Garczynski, Edward Rudolf. "Jugglery in Art," *Forum*, 1 (August, 1886), 592–602.

Garland, Hamlin. *Crumbling Idols*. Chicago, Stone and Kimball, 1894.

Hamilton, Luther. "The Work of the Paris Impressionists in New York," *Cosmopolitan*, 1 (June, 1886), 240–42.

Harrison, Birge. "True Impressionism in Art," *Scribner's Magazine*, 46 (October, 1909), 491–95.

Hoopes, Darlington. *The American Impressionists*. New York, Watson-Guptill, 1972.

Howat, John K., et al. *American Impressionist and Realist Paintings and Drawings, From the Collection of Mr. and Mrs. Raymond J. Horowitz*. New York, Metropolitan Museum, 1973.

Huth, Hans. "Impressionism Comes to America," *Gazette des Beaux-Arts*, 29 (April, 1946), 225–52.

"[Impressionism] From Another Point of View," *Art Amateur*, 28 (December, 1892), 5.

*The Impressionists and the Salon (1874–1886)*. Los Angeles, Los Angeles County Museum of Art, 1974.

Lejeune, L. "The Impressionist School of Painting," *Lippincott's Magazine*, 24 (December, 1879), 720–27.

Mauclair, Camille. "French Impressionism and Its Influence In Europe," *International Monthly*, 5 (January, 1902), 54–75.

———. *The French Impressionists*. New York, E. P. Dutton, 1903.

National Academy of Design. *Special Exhibition: Works in Oil and Pastel by the Impressionists of Paris*. New York, n.p., 1886.

Perry, Lilla Cabot. "Reminiscences of Claude Monet, from 1889 to 1909," *American Magazine of Art*, 18 (March, 1927), 119–25.

Phillips, Duncan C. "The Impressionistic Point of View," *Art and Progress*, 3 (March, 1912), 505–11.

———. "What is Impressionism?", *Art and Progress*, 3 (September, 1912), 702–707.

Pissarro, Camille. *Letters to His Son Lucien*. New York, Pantheon Books, 1943.

Pool, Phoebe. *Impressionism*. London, Thames and Hudson, 1967.

Rewald, John. *The History of Impressionism*. 4th ed. New York, Museum of Modern Art, 1973.

———. *Post-Impressionism From Van Gogh to Gaugin*. 2d ed. New York, Museum of Modern Art, 1962.

Robinson, Theodore. "Claude Monet," *Century Magazine*, 44 (September, 1892), 696–701.

Stark, Otto. "The Evolution of Impressionism," *Modern Art*, 3 (Spring, 1895), 53–56.

Stephens, Henry G. "Impressionism: The Nineteenth Century's

Distinctive Contribution to Art," *Brush and Pencil*, 11 (January, 1903), 279–97.

Venturi, Lionello (ed.). *Les Archives de l'Impressionnisme*. 2 vols. New York and Paris, Durand-Ruel, 1939.

Vollard, Ambroise. *Recollections of a Picture Dealer*. Boston, Little, Brown, 1936.

Waern, Cecilia. "Some Notes on French Impressionism," *Atlantic Monthly*, 69 (April, 1892), 535–41.

Weber, Nicholas Fox. "Rediscovered American Impressionists," *American Art Review*, 3 (January–February, 1976), 100–15.

Weinberg, Louis. "Current Impressionism," *New Republic*, 2 (March 6, 1915), 124–25.

"What is Impressionism?", *Art Amateur*, 27 (November, 1892), 140–41; and 28 (December, 1892), 5.

Wilson, Maude Throckmorton. "Realism versus Impressionism," *Frank Leslie's Popular Monthly*, 34 (September, 1892), 369–71.

# XII.  MODERNISM

Anderson, Margaret Steele. *The Study of Modern Painting*. New York, Century Co., 1914.

"Art Revolutionists on Exhibition in America," *American Review of Reviews*, 47 (April, 1913), 441–48.

Association of American Painters and Sculptors. *International Exhibition of Modern Art. . . .* New York, The Association, 1913.

———. *International Exhibition of Modern Art, Boston*. Boston, Copley Society, 1913.

Barr, Alfred H., Jr. *Matisse: His Art and His Public*. New York, Museum of Modern Art, 1951.

Baur, John I. H. *Revolution and Tradition in Modern American Art*. Cambridge, Harvard University Press, 1951.

Benton, Thomas H. "America and/or Alfred Stieglitz," *Common Sense*, 4 (January, 1935), 22–24.

Blake, Warren Barton. "Crazy-Quilt Art," *Independent*, 73 (December 19, 1912), 1419–21.

Blashfield, Edwin Howland. "The Actual State of Art Among Us," *North American Review*, 191 (March, 1910), 322–29.

———. "The Painting of Today," *Century Magazine*, 87 (April, 1914), 837–40.

Bluemner, Oscar. "'Audiator et Altera Pars': Some Plain Sense on the Modern Art Movement," *Camera Work*, special number

(June, 1913), 25–38.

Blumenschein, Ernest L. "The Painting of Tomorrow," *Century Magazine*, 87 (April, 1914), 845–50.

Boswell, Peyton, Jr. *Modern American Painting*. New York, Dodd, Mead, 1939.

Breeskin, Adelyn. *The Roots of Abstract Art in America, 1910–1930*. Washington, Smithsonian Institution, 1965.

Brinnin, John Malcolm. *The Third Rose: Gertrude Stein and Her World*. Boston, Little, Brown, 1959.

Brinton, Christian. "Evolution, not Revolution in Art," *International Studio*, 49 (April, 1913), xxvii–xxxv.

———. *Modern Artists*. New York, Baker and Taylor, 1908.

———. "Modernism in Art," *Putnam's Magazine*, 5 (February, 1909), 617–22.

Brion-Guerry, L. (ed.). *L'année 1913; les formes esthétiques de l'oeuvre d'art à la veille de la premiére guerre mondiale*. 3 vols. Paris, Editions Klincksieck, 1971–1973.

Brown, Milton W. *American Painting From the Armory Show to the Depression*. Princeton, Princeton University Press, 1955.

———. *The Story of the Armory Show*. Greenwich, Conn., New York Graphic Society, 1963.

Caffin, Charles H. "Henri Matisse and Isadora Duncan," *Camera Work*, 25 (January, 1909), 17–20.

———. "A Note on Paul Cézanne," *Camera Work*, 34–35 (April–July, 1911), 47–51.

Carroll, Donald, and Edward Lucie-Smith. *Movements in Modern Art*. New York, Horizon Press, 1973.

Cheney, Sheldon. *Primer of Modern Art*. New York, Boni and Liveright, 1924.

Chipp, Herschel B. (ed.). *Theories of Modern Art*. Berkeley, University of California Press, 1968.

Cook, E. W. "Progress or Decadence in Art?", *Contemporary Review*, 86 (October, 1904), 538–52.

Cortissoz, Royal. "Egotism in Contemporary Art," *Atlantic Monthly*, 73 (May, 1894), 644–52.

Cox, Edward Godfrey. "The Distemper of Modern Art and Its Remedy," *South Atlantic Quarterly*, 15 (October, 1916), 361–78.

Cox, Kenyon. "Artist and Public," *Scribner's Magazine*, 55 (April, 1914), 512–20.

———. "The 'Modern' Spirit in Art," *Harper's Weekly*, 57 (March 15, 1913), 10.

Crane, Walter. "Modern Life and the Artistic Sense," *Cosmopoli-

*tan*, 13 (June, 1892), 152–56.

Craven, Thomas. *Modern Art*. New York, Simon and Schuster, 1934.

"Cube Root of Art," *Independent*, 74 (March 6, 1913), 492–94.

Davidson, Abraham. "Some Early American Cubists, Futurists, and Surrealists: Their Paintings, Their Writings and Their Critics," Ph.D. dissertation, Columbia University, 1965.

Davidson, Jo. "The Extremists: An Interview," *Arts and Decoration*, 3 (April, 1913), 170–71, 180.

De Zayas, Marius. "Modern Art—Theories and Representation," *Camera Work*, 44 (October, 1913), 13–19.

———. "Pablo Picasso," *Camera Work* Work, 34–35 (April–July, 1911), 65–67.

"Diagnosing Post-Impressionism," *Literary Digest*, 47 (November 8, 1913), 874.

Dodge, Mabel. "Speculations, or Post-Impressionism in Prose," *Arts and Decoration*, 3 (April, 1913), 172–74.

Dow, Arthur Wesley. "Modernism in Art," *Magazine of Art*, 8 (January, 1917), 113–16.

"Drawings by Henri Matisse," *Nation*, 90 (March 17, 1910), 272–73.

Dunlop, Ian. *The Shock of the New*. New York, McGraw-Hill, 1973.

Eddy, Arthur Jerome. *Cubists and Post-Impressionists*. Chicago, A. C. McClurg, 1914.

Eldredge, Charles. "The Arrival of European Modernism," *Art in America*, 61 (July–August, 1973), 35–41.

Ely, Catherine Beach. *The Modern Tendency in American Painting*. New York, F. F. Sherman, 1925.

*The Forum Exhibition of Modern American Painters, March 13–25, 1916*. New York, Anderson Galleries, 1916.

Gallup, Donald (ed.). *The Flowers of Friendship: Letters Written to Gertrude Stein*. New York, Alfred Knopf, 1953.

Golding, John. *Cubism: A History and an Analysis, 1907–1914*. London, Faber and Faber, 1968.

Goldwater, Robert J. *Primitivism in Modern Painting*. New York, Harper, 1938.

Goodrich, Lloyd. *Pioneers of Modern Art in America*. New York, Whitney Museum of American Art, 1946.

Gordon, Donald E. *Modern Art Exhibitions, 1900–1916: Selected Catalogue Documentation*, 2 vols. Munich, Prestel Verlag, 1974.

Gray, Christopher. *Cubist Aesthetic Theories*. Baltimore, Johns Hopkins Press, 1953.

"The Greatest Exhibition of Insurgent Art Ever Held," *Current Opinion*, 54 (March, 1913), 230–32.

Gregg, Frederick James. "The Attitude of the Americans," *Arts and Decoration*, 3 (April, 1913), 165–67.

————. *For and Against: Views on the International Exhibition held in New York and Chicago*. New York, American Association of Painters and Sculptors, 1913.

"Growing Pains of American Art," *Current Literature*, 44 (April, 1908), 393–97.

Hambidge, Jay, and Gove Hambidge. "The Ancestry of Cubism," *Century Magazine*, 87 (April, 1914), 869–75.

Harrison, Birge. "The Future of American Art," *North American Review*, 189 (January, 1909), 25–34.

————. "The New Art in America," *Scribner's Magazine*, 57 (March, 1915), 391–94.

Harrison, Frederic. "Decadence in Modern Art," *Forum*, 15 (June, 1893), 428–38.

Hartmann, Sadakichi. "Once More Matisse," *Camera Work*, 39 (July, 1912), 22, 33.

Haskell, Barbara. *Arthur Dove*. Boston, New York Graphic Society, 1974.

Hoeber, Arthur. "Unrest in Modern Art," *Forum*, 41 (June, 1909), 528–33.

Holley, Horace. "The Background of Matisse," *New Republic*, 2 (February 20, 1915), 74–76.

Homer, William Innes. *Seurat and the Science of Painting*. Cambridge, Harvard University Press, 1964.

————. "Stieglitz and 291," *Art in America*, 61 (July–August, 1973), 50–57.

Hooker, Brian. "Cubing the Circle," *Bookman*, 39 (August, 1914), 672–75.

"Indifference to Art," *Nation*, 75 (September 25, 1902), 240–41.

"Interviewing a Cubist [Picasso]," *Literary Digest*, 46 (April 19, 1913), 890–92.

"Is Post-Impressionism a New Disease or a New Religion?", *Current Literature*, 52 (May, 1912), 584–88.

Janis, Sidney. *Abstract and Surrealist Art in America*. New York, Reynall, 1944.

Kahnweiler, Daniel Henry. *The Rise of Cubism*. New York, Wittenborn, Schultz, 1949.

Kozloff, Max. *Cubism/Futurism*. New York, Charterhouse Books, 1973.

Kris, Ernst. *Psychoanalytic Explorations in Art*. New York, International Universities Press, 1952.

Kuhn, Walt. *The Story of the Armory Show*. New York, n.p., 1938.

Kysela, John D. "The Critical and Literary Background For a Study of the Development of Taste for 'Modern Art' in America, from 1880 to 1900." Master's thesis, Loyola University, 1964.

Laurvik, J. Nilsen. "Intolerance in Art," *American Scandinavian Review*, 1 (January–February, 1913), 11–18.

――――. *Is It Art? Post-Impressionism, Futurism, Cubism*. New York, International Press, 1913.

Loevgren, Sven. *The Genesis of Modernism: Seurat, Gauguin, Van Gogh, and French Symbolism in the 1880's*. Bloomington, Indiana University Press, 1971.

Low, Will H. "The Debt of Modern Art to Ancient Greece," *Scribner's Magazine*, 67 (May, 1920), 637–40.

Luquiens, Huc-Mazelet. "The Post-Impressionistic Revolt," *Yale Review*, 5 (January, 1916), 330–46.

McBride, Henry. "Gauguin's Re-Birth," *Dial*, 69 (October, 1920), 397–400.

MacColl, W.D. "The International Exhibition of Modern Art," *Forum*, 50 (July, 1913), 24–36.

Masheck, Joseph. "Teddy's Taste: Theodore Roosevelt and the Armory Show," *Artforum*, 9 (November, 1970), 70–73.

Mather, Frank J., Jr. "The Armory Show Exhibition," *Nation*, 96 (March 13, 1913), 267–68.

――――. "Art," *Nation*, 94 (June 20, 1912), 622–23.

――――. "The Forum Exhibition," *Nation*, 102 (March 23, 1916), 340.

――――. "The Independent Artists," *Nation*, 90 (April 7, 1910), 360–61.

――――. "The International Art Exhibition," *Nation*, 96 (February 20, 1913), 174.

――――. "Newest Tendencies in Art," *Independent*, 74 (March 6, 1913), 504–12.

――――. "Old and New Art," *Nation*, 96 (March 6, 1913), 240–43.

――――. "Paul Cézanne," *Nation*, 102 (January 13, 1916), 57–58.

――――. "The Present State of Art," *Nation*, 93 (December 14, 1911), 584–87.

――――. "Realism in Art," *Nation*, 102 (February 3, 1916), 129–32.

Meier-Grafe, Julius. *Modern Art*. 2 vols. New York, G. P. Putnam's Sons, 1908.

Mellow, James R. *Charmed Circle: Gertrude Stein and Company*.

New York, Praeger, 1973.

Messer, E. C. "The Trend of American Art," *Art and Progress*, 5 (September, 1914), 383–85.

"The Mob as Art Critic," *Literary Digest*, 46 (March 20, 1913), 708–709.

Moore, George. *Modern Painting*. London, Walter Scott, 1897.

Myers, Bernard S. *Modern Art in the Making*. New York, McGraw-Hill, 1959.

Norman, Dorothy. *America and Alfred Stieglitz*. New York, Doubleday, 1934.

Ogden, Robert Morris. "Post-Impressionism," *Sewanee Review*, 20 (April, 1912), 191–200.

Ozenfant, Amédée. *Foundations of Modern Art*. London, John Rodker, 1931.

Pach, Walter. "Cezanne—An Introduction," *Scribner's Magazine*, 44 (December, 1908), 765–68.

———. "Manet and Modern American Art," *Craftsman*, 17 (February, 1910), 483–92.

———. *Masters of Modern Art*. New York, B. W. Huebsch, 1924.

———. "The Point of View of the 'Moderns,'" *Century Magazine*, 87 (April, 1914 ), 851–64.

Pearson, Ralph M. *The Modern Renaissance in American Art*. New York, Harper and Bros., 1954.

Pène du Bois, Guy. "The Spirit and the Chronology of the Modern Movement," *Arts and Decoration*, 3 (March, 1913), 151–54, 178.

Phillips, Claude. "The Quality of Emotion in Modern Art," *North American Review*, 174 (March, 1902), 348–67.

Phillips, Duncan. "Fallacies of the New Dogmatism in Art," *American Magazine of Art*, 9 (December, 1917), 43–48; and 9 (January, 1918), 101–106.

"Portrait Etchings by Henri Matisse," *Touchstone*, 6 (December, 1919), 133–34.

"Post-Impressionism Arrived," *Literary Digest*, 46 (March 1, 1913), 456–57.

Quinn, John. "Modern Art from a Layman's Point of View," *Arts and Decoration*, 3 (April, 1913), 155–58, 176.

J. R. "The Nude and the Staircase," *Nation*, 96 (May 8, 1913), 465–66.

Richardson, John Adkins. *Modern Art and Scientific Thought*. Urbana, University of Illinois Press, 1971.

Richardson, Tony (ed.). *Concepts of Modern Art*. New York,

Harper, 1974.

Richter, Hans. *Dada: Art and Anti-Art*. New York, Harry N. Abrams, 1965.

Roberts, Mary Fanton. "Science in Art, As Shown in the International Exhibition of Painting and Sculpture," *Craftsman*, 24 (May, 1913), 216–18.

Roosevelt, Theodore. "A Layman's View of an Art Exhibition," *Outlook*, 103 (March 29, 1913), 718–20.

Rutter, Frank. *Evolution in Modern Art: A Study of Modern Painting, 1870–1925*. London, G. G. Harrup, 1926.

Schapiro, Meyer. "The Nature of Abstract Art," *Marxist Quarterly*, 1 (January–March, 1937), 77–98.

———. "Rebellion in Art," in Daniel Aaron (ed.). *America in Crisis*. New York, Alfred Knopf, 1952, 203–42.

Shapiro, Theda. *Painters and Politics: The European Avant-Garde and Society 1900–1925*. New York, Elsevier, 1976.

Showerman, Grant. "The New Painting," *Dial*, 59 (November 25, 1915), 486–88.

Street, Julian. "Why I Became a Cubist," *Everybody's Magazine*, 28 (June, 1913), 814–25.

Swift, Samuel. "Revolutionary Figures in American Art," *Harper's Weekly*, 51 (April 13, 1907), 534–36.

Tridon, Andre. "America's First Aesthetician [Willard Huntington Wright]," *Forum*, 55 (January, 1916), 124–28.

Walker, Don D. "American Art on the Left, 1911–1950," *Western Humanities Review*, 8 (Autumn, 1954), 323–46.

Walton, William. "Is There an Academic Movement in American Art?", *Scribner's Magazine*, 38 (November, 1905), 637–40.

Weber, Max. *Essays on Art*. New York, W. E. Rudge, 1916.

Wees, William C. *Vorticism and the English Avant-Garde*. Toronto, University of Toronto Press, 1972.

Willcocks, M. P. "The New Fear," *Forum*, 49 (April, 1913), 401–405.

Wright, Willard Huntington. "An Abundance of Modern Art," *Forum*, 55 (March, 1916), 318–34.

———. "The Aesthetic Struggle in America, *Forum*, 55 (February, 1916), 201–20.

———. "Art, Promise and Failure," *Forum*, 55 (January, 1916), 29.

———. "Cézanne," *Forum*, 54 (July, 1915), 39–63.

———. "The Forum Exhibition," *Forum*, 55 (April, 1916), 457–71.

———. *The Future of Painting*. New York, B. W. Huebsch, 1923.

———. "Impressionism to Synchronism," *Forum*, 50 (December,

1913), 757–70.

―――. "Modern American Painters and Winslow Homer," *Forum*, 54 (December, 1915), 661–72.

―――. "Modern Art: The New Spirit in America," *International Studio*, Supplement, 60 (December, 1916), 64–65.

―――. *Modern Painting: Its Tendency and Meaning*. New York, John Lane, 1915.

―――. "The New Painting and American Snobbery," *Arts and Decoration*, 7 (January, 1917), 128–30, 152, 154.

―――. "Notes on Art," *Forum*, 55 (June, 1916), 691–706.

―――. "Synchronism," *International Studio*, Supplement, 56 (October, 1915), 97–100.

―――. "The Truth About Painting," *Forum*, 54 (October, 1915), 443–54.

Young, Mahonri Sharp. *Early American Moderns: Painters of the Stieglitz Group*. New York, Watson-Guptill, 1974.

Zilczer, Judith K. "Robert J. Coady, Forgotten Spokesman for Avant-Garde Culture in America," *American Art Review*, 2 (November–December, 1975, 77–89.

―――. "The Aesthetic Struggle in America, 1913–1918: Abstract Art and Theory in the Stieglitz Circle." Ph.D. dissertation, University of Delaware, 1975.

## XIII.   THE "EIGHT" OR "ASHCAN SCHOOL"

Brown, Milton W. "The Ash Can School," *American Quarterly*, 1 (Summer, 1949), 127–34.

Goldin, Amy. "The Eight's Laissez-faire Revolution," *Art in America*, 61 (July–August, 1973), 42–49.

Henri, Robert. "The New York Exhibition of Independent Artists," *Craftsman*, 18 (May, 1910), 160–72.

Hirschfield, Charles. "'Ash Can' vs. 'Modern' Art in America," *Western Humanities Review*, 10 (Autumn, 1956), 353–73.

Homer, William Innes. "The Exhibition of 'The Eight': Its History and Significance," *American Art Journal*, 1 (Spring, 1969), 53–64.

Perlman, Bennard B. *The Immortal Eight*. New York, Exposition Press, 1962.

Read, Helen Appleton. *New York Realists 1900–1914*. New York, Whitney Museum of American Art, 1937.

Young, Mahonri Sharp. *The Eight: The Realist Revolt in American Painting*. New York, Watson-Guptill, 1974.

## XIV. BIOGRAPHICAL STUDIES
*(Alphabetical by Subject)*

Lucas, Edward V. *Edwin Austin Abbey.* 2 vols. New York, Charles Scribner's Sons, 1921.

*Thomas P. Anschutz 1851–1912.* Philadelphia, Pennsylvania Academy of Fine Art, 1973.

*The Paintings and Drawings of Cecilia Beaux.* Philadelphia, Pennsylvania Academy of Fine Arts, 1955.

Braider, Donald. *George Bellows and the Ashcan School of Painting.* New York, Doubleday, 1970.

Morgan, Charles G. *George Bellows.* New York, Reynall, 1965.

Young, Mahonri Sharp. *The Paintings of George Bellows.* New York, Watson-Guptill, 1974.

*Robert F. Blum 1857–1903: A Retrospective.* Cincinnati, Cincinnati Art Museum, 1966.

Brown, Jeffrey R. *Alfred Thompson Bricher, 1837–1908.* Indianapolis, Indianapolis Museum of Art, 1974.

Bowditch, Nancy Douglas. *George de Forest Brush.* Peterborough, N. H., Noone House, 1971.

Gammell, Robert Hale Ives. *Dennis Miller Bunker.* New York, Coward McCann, 1953.

Breeskin, Adelyn D. *Mary Cassatt.* New York, G. Braziller, 1970.

Sweet, Frederick A. *Miss Mary Cassatt: Impressionist from Pennsylvania.* Norman, University of Oklahoma Press, 1966.

Milgrome, Abraham David. "The Art of William Merritt Chase." Ph.D. dissertation, University of Pittsburgh, 1969.

Roof, Katherine M. *The Life and Art of William Merritt Chase.* New York, Charles Scribner's Sons, 1917.

Cortissoz, Royal. "Frank Duveneck and His Munich Tradition," *Scribner's Magazine,* 81 (March, 1927), 216–24.

Duveneck, Josephine W. *Frank Duveneck, Painter-Teacher.* San Francisco, John Howell, 1970.

Young, Mahonri Sharp. "The Two Worlds of Frank Duveneck," *American Art Journal,* 1 (Spring, 1969), 92–103.

Goodrich, Lloyd. *Thomas Eakins: His Life and Work.* New York, Whitney Museum of American Art, 1933.

Hendricks, Gordon. *The Life and Work of Thomas Eakins.* New York, Grossman Publishers, 1974.

Schendler, Sylvan. *Eakins.* Boston, Little, Brown, 1967.

de Gregorio, Vincent John. "The Life and Art of William J. Glackens." Ph.D. dissertation, Ohio State University, 1955.

*Childe Hassam, 1859–1935.* Tucson, University of Arizona Art Museum, 1972.

Henri, Robert. *The Art Spirit.* Philadelphia, J. B. Lippincott, 1923.

Homer, William Innes. *Robert Henri and His Circle.* Ithaca, Cornell University Press, 1969.

Beam, Phillip C. *Winslow Homer.* New York, McGraw-Hill, 1975.

Cox, Kenyon. "The Art of Winslow Homer," *Scribner's Magazine,* 56 (September, 1914) 377–88.

Downes, William Howe. *The Life and Works of Winslow Homer.* Boston, Houghton Mifflin, 1911.

Gardner, Albert Ten Eyck. *Winslow Homer.* New York, Bramhall House, 1961.

Gould, Jean. *Winslow Homer.* New York, Dodd, Mead, 1962.

Knowlton, Helen. *Art-Life of William Morris Morris Hunt.* Boston, Little, Brown, 1899.

Shannon, Martha A. *Boston Days of William Morris Hunt.* Boston, Marshall Jones Co., 1928.

Cikovsky, Nicolai, Jr. *George Inness.* New York, Praeger,

Inness, George, Jr. *The Life, Art, and Letters of George Inness.* New York, Century Co., 1917.

Ireland, LeRoy. *The Works of George Inness.* Austin, University of Texas Press, 1965.

Hills, Patricia. *Eastman Johnson.* New York, Clarkson N. Potter, 1972.

Cortissoz, Royal. *John La Farge: A Memoir and a Study.* Boston, Houghton Mifflin, 1911.

La Farge, John. *Considerations on Painting.* New York, Macmillan, 1895.

Weinberg, Helene Barbara. "The Decorative Work of John La Farge." Ph.D. dissertation, Columbia University, 1972.

Berry-Hill, H. *Ernest Lawson, American Impressionist.* Leigh-on-Sea, U.K., L. Lewis, 1968.

Rhys, Hedley Howell. *Maurice Prendergast.* Cambridge, Harvard University Press, 1960.

*Theodore Robinson, 1852–1896.* Baltimore, Baltimore Museum of Art, 1973.

Bauer, John I. H. *Theodore Robinson, 1852–1896.* New York, Brooklyn Museum, 1946.

Birnbaum, Martin. *John Singer Sargent: A Conversation Piece.* New York, W. E. Rudge's Sons, 1941.

Charteris, Evan. *John Sargent.* New York, Charles Scribner's sons, 1927.

Downes, William Howe. *John S. Sargent*. Boston, Little, Brown, 1925.

Hoopes, Donelson F. *The Private World of John Singer Sargent*. Washington, Corcoran Gallery of Art, 1964.

James, Henry. "John S. Sargent," *Harper's Monthly*, 75 (October, 1887), 683–91.

Kingsbury, Martha. "John Singer Sargent: Aspects of His Work." Ph.D. dissertation, Harvard University, 1969.

McKibben, David. *Sargent's Boston*. Boston, Museum of Fine Arts, 1956.

Mount, Charles Merrill. *John Singer Sargent*. New York, W. W. Norton, 1955.

Ormond, Richard. *John Singer Sargent: Paintings, Drawings, Watercolors*. New York, Harper, 1970.

de Shazo, Edith. *Everett Shinn, 1876–1953*. New York, Clarkson N. Potter, 1975.

Brooks, Van Wyck. *John Sloan*. New York, E. P. Dutton, 1955.

Kwiat, Joseph J. "John Sloan: An American Artists as a Social Critic," *Arizona Quarterly*, 10 (Spring, 1954), 52–64.

*John Sloan, 1871–1951*. Washington, National Gallery of Art, 1971.

St. John, Bruce (ed.). *John Sloan's New York Scene*. New York, Harper, 1965.

Sloan, John. *The Gist of Art*. New York, American Artist Association, 1939.

Matthews, Marcia M. *Henry Ossawa Tanner*. Chicago, University of Chicago Press, 1969.

White, Nelson C. *Abbott H. Thayer*. Hartford, Connecticut Printers, 1951.

White, Henry Cooke. *The Life and Art of Dwight William Tryon*. Boston, Houghton Mifflin, 1930.

Hale, John Douglas. "The Life and Creative Development of John H. Twachtman." Ph.D. dissertation, Ohio State University, 1957.

Soria, Regina. *Elihu Vedder*. Rutherford, N.J., Fairleigh Dickinson University Press, 1970.

Young, Dorothy Weir. *The Life and Letters of J. Alden Weir*. New Haven, Yale University Press, 1960.

McMullen, Roy. *Victorian Outsider: A Biography of J. A. M. Whistler*. New York, E. P. Dutton, 1973.

Sutton, Denys. *James McNeill Whistler: Paintings, Drawings, Etchings and Watercolors*. London, Phaidon, 1966.

———. *Nocturne: The Art of James McNeill Whistler*. Philadelphia,

J. B. Lippincott, 1964.

Weintraub, Stanley. *Whistler: A Biography.* New York, Weybright and Talley, 1974.

*From Realism to Symbolism: Whistler and His World.* New York, Wildenstein Galleries, 1971.

# Index